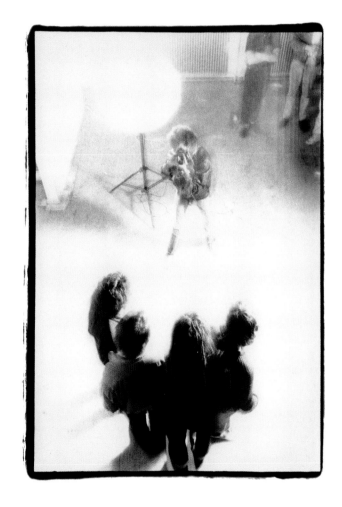

HEYDAY

35 YEARS OF MUSIC
IN MINNEAPOLIS

THE PHOTOGRAPHY
OF DANIEL CORRIGAN

TEXT BY DANNY SIGELMAN

MINNESOTA
HISTORICAL
SOCIETY PRESS

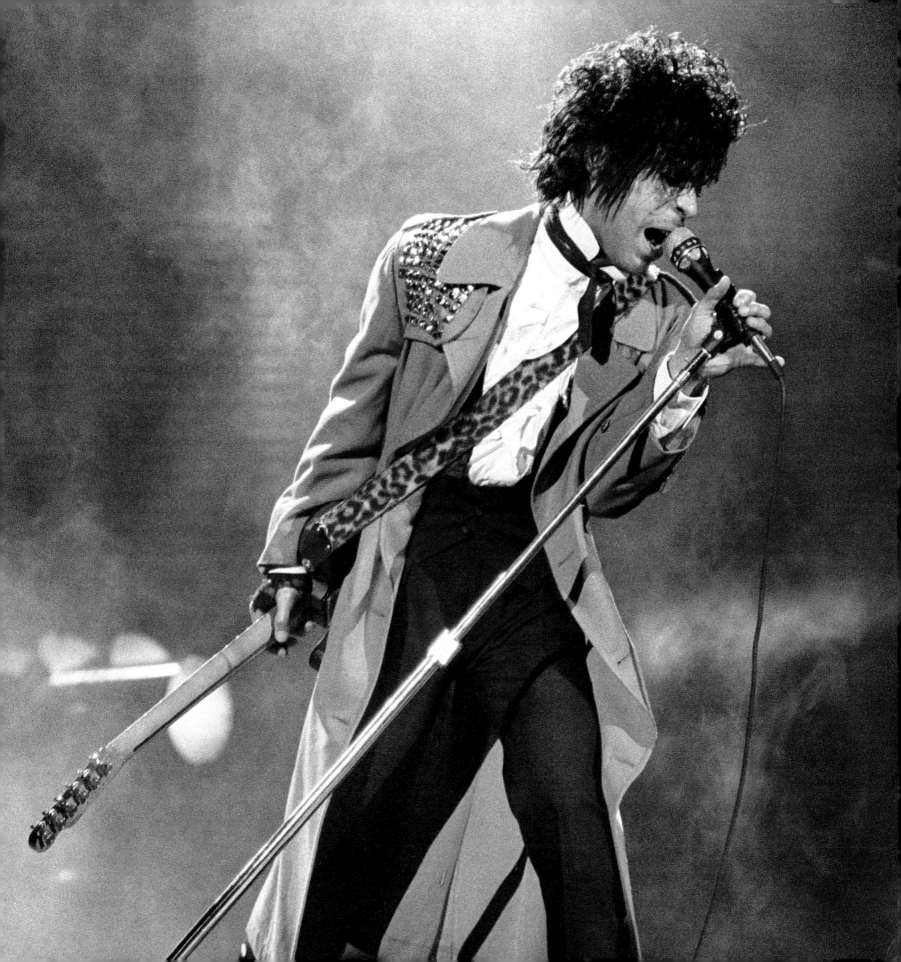

www.mnhspress.org

The Minnesota Historical Society Press is a member of the Association of University Presses.

Manufactured in China

10 9 8 7 6 5 4 3 2 1

∞ The paper used in this publication meets the minimum requirements of the American National Standard for Information Sciences—Permanence for Printed Library Materials, ANSI Z39.48-1984.

International Standard Book Number
ISBN: 978-1-68134-123-1 (paper)

Library of Congress Cataloging-in-Publication Data
Names: Corrigan, Daniel (Photographer), photographer. | Sigelman, Danny, author.
Title: Heyday : 35 years of music in Minneapolis / the photography of Daniel Corrigan ; text by Danny Sigelman.
Description: St. Paul, MN : Minnesota Historical Society, 2016.
Identifiers: LCCN 2016026451 | ISBN 9781681340210 (hardcover : alk. paper)
Subjects: LCSH: Rock music—Minnesota—Minneapolis—Pictorial works. | Rock musicians—Minnesota—Minneapolis—Portraits. | Rock groups—Minnesota—Minneapolis—Portraits.
Classification: LCC ML3534.3 .H39 2016 | DDC 781.6409776/579—dc23
LC record available at https://lccn.loc.gov/2016026451

Heyday was designed and set in type by Ryan Scheife at Mayfly Design, Minneapolis, MN. Acquired, edited, and curated by Josh Leventhal. Photographs prepared for printing by color specialist Timothy Meegan. Design and production management by Daniel Leary. Manufactured in China by Pettit Network, Inc., Afton, Minnesota.

Frontispiece: Daniel Corrigan in the photo studio with Soul Asylum

Title page: Prince at First Avenue

Opposite: A full house at First Avenue for a Bullet for My Valentine show, May 26, 2010

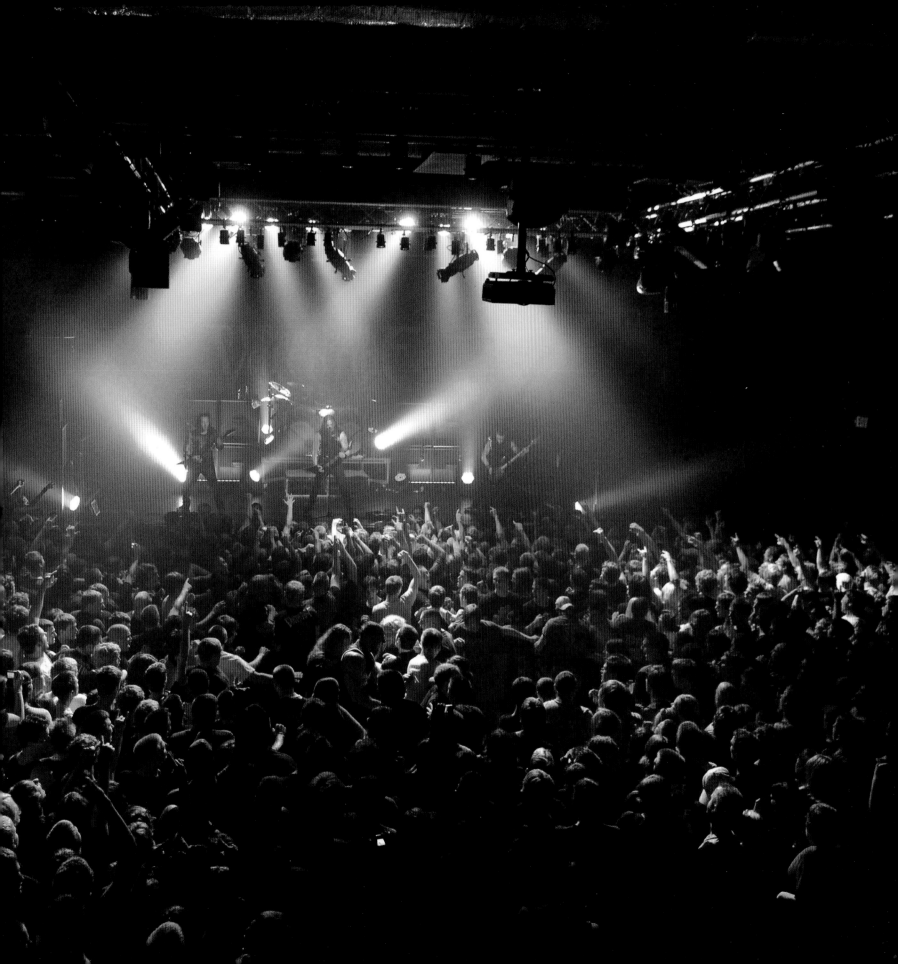

Preface

Saturday, April 23, 2016. These last two nights have seen some intense albeit celebratory mourning since we learned about the passing of our hometown musical hero, Prince Rogers Nelson. Perhaps appropriately, it's also been raining on and off all weekend.

Walking toward downtown from Northeast Minneapolis, I see the 35W bridge lit up in purple. I pass by several churches, apartments, and office buildings that have suddenly all turned purple. From afar, I see the city's skyscrapers and the imposing Block E across the street from First Avenue—the club that Prince exposed to the world through his film *Purple Rain*—also decked out in more purple lights.

In awe of the glory before us, I find myself a bit choked up but manage to get out with a chuckle to my friend, Jennie, "Wow, the sky is all purple, and there really are people running everywhere!"

There's a cleansing mist in the air as we walk toward First Avenue. Streets are blocked off for the nonstop dance party that began the night we all found out we lost him.

It sort of feels like New Year's Eve as we approach the club. Like clusters of purple doves, countless groups of revelers are dotted up and down Seventh Street and wrapping around First Avenue toward the star that bears Prince's name on the wall of the building. People are hugging one another and huddling around the several makeshift sound systems scattered about, all blaring Prince's music. People are passing around roses and bottles of wine, burning incense, and taking selfies. There's endless dancing in the street. White, black, and Puerto Rican, everybody just a-freakin'.

Amidst paper portraits of Prince taped to the wall around his star, an avalanche of purple flowers, cards, and balloons are piled up below. The impromptu memorial practically covers up the neighboring star for Bob Mould—another local music legend who happens to be headlining another sold-out show inside the building tonight.

Inside the club, there's an immediate feeling of electricity and energy. The room has been buzzing all weekend, staying open each night for Prince dance parties until dawn. The Twin Cities' legendary punk band the Suicide Commandos are on stage warming up the audience. Tonight's vibe is punctuated by mixed emotions, but everyone acknowledges the cause for celebration.

For another triumphant homecoming gig, Mould takes the stage and delivers an impassioned and ferocious set. For the encore, Bob and his band are joined by their soundman, who takes over lead vocals, and the Commandos retake the stage as well. The crew delivers an inspired, if valiantly sloppy, punk-rock version of Prince's "When You Were Mine."

Still dazed from the emotional charge, I catch, out of the corner of my eye, my friend, photographer Dan Corrigan.

Dressed in all black, he's wearing big ear protectors that look like old-school radio headphones. He has one camera wrapped around his neck and another with a much longer lens in his hands. He swoops through the dense crowd gathered at the bar and on the floor dancing and singing along, and he ducks into the DJ booth. Like a praying mantis, he stretches his arms into a triangle and rests his camera on top of his camera bag, directed toward the stage.

This night is extra special for those who came for the show, but for Dan it's another night doing his job. Like

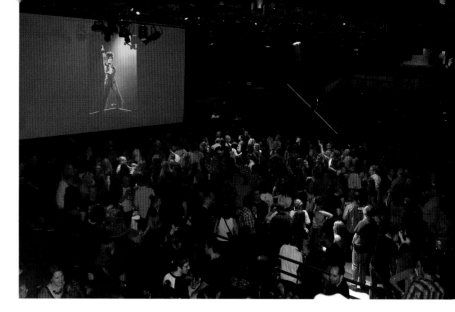

All-night Prince dance party at First Avenue, April 23, 2016

he's done on thousands of previous spirited nights at First Avenue over the past thirty-five years, Dan stands and observes it all, inconspicuously.

Tonight atop the owner's box, it's Dan doing what he does best, capturing yet another powerful, beautiful musical moment in Minneapolis.

Growing up in Golden Valley in the 1980s, I was bit by the music bug at an early age, which meant near-daily sojourns by bicycle to the local record store to scour the bins and discover as much music as I could absorb. Feeling miles away from the action and a bit too young to get into clubs, I relied on listening to the hip community radio station KFAI and picking up the latest punk fanzines and weekly newspapers as my portal into what was happening on the local music scene. It was my way to feel a part of it all.

I gradually veered off the heavy metal path of my youth and broadened my understanding of the hometown sound, picking up on bands like Soul Asylum, Run Westy Run, the Replacements, Hüsker Dü, and the Urban Guerrillas. During the hours spent sitting in my room listening to the music of some of these bands, I kept noticing the name "Daniel Corrigan" appearing as a photo credit on the backs of the record jackets. And I began seeing that name in the local newspapers as well, alongside images illustrating reviews of these bands. The CD age came around, and Corrigan's name seemed all the more prevalent. I figured this Corrigan fellow was a professional photographer who was friends with all these bands. I thought he must be the coolest and luckiest dude around.

When my cousin and I figured out we could just tell our parents that we were going to the movies, we would instead bike to downtown Minneapolis for all-ages shows at 7th Street Entry, the smaller and dingier venue connected to First Avenue's Mainroom. This was where I started seeing what was in all these pictures come to life. The sounds would pulverize us, and we realized there were so many more bands around than we'd ever heard of.

Like the kids in *To Kill a Mockingbird* seeing the mysterious Boo Radley for the first time, I eventually spotted the guy walking around with a camera, capturing all the action at First Avenue: Daniel Corrigan. I'd be at a show and see this person snapping photos, and then I'd wait to see the review in *City Pages*, where his name appeared next to the photos, confirming my hunch.

It wasn't until years later that I formally met Dan. He was assigned to take a photo of me and my college friend John Helgeland for a newspaper feature on, of all things, Swedish indie-pop music. Having Dan walk in with his camera and snap a dozen or so photos, and then seeing the image in the newspaper with his photo credit the following week—it felt like I had arrived.

I gradually got to know Dan better through the years. Since we both basically lived at First Avenue, our mutual love of and work in the music world frequently intermingled. Based on this common ground and a similar fascination with the inner workings of the music scene, it was a natural progression that brought us together to work on this book.

Danny Sigelman (left) with John Helgeland, 1998

Putting *Heyday* together was a delightful if somewhat arduous task. Boxes of photo prints are stacked high in Dan's modest apartment, not in any particular order or organizational scheme. Many of the photos—unmarked and unlabeled—had not seen the light of day for years. Binders filled with negatives, color transparencies, and proof sheets further mystified the process, but, determined to find our favorites and fearful of missing any hidden gems, we went through nearly every one.

Inundated with not just thirty-five years of rock-and-roll photography but also Dan's other visual passions, assignments, and photographic experiments, the expedition into Dan's photo archive offered interesting insights into his career. Weddings, birthday parties, and assigned portraits—of politicians, professionals in business suits, and even pets—are mixed with images from when Dan covered the Minnesota Twins and from when he worked the crime beat, tuned in to a police scanner through all hours of the night. Once an avid rock climber himself, Dan photographed fellow climbers for magazines and promos, all while perched from breathtaking and precarious heights, camera in hand.

Themes emerge in the leftover frames as Dan filled up each film roll: curious textures on the street; people being delicately spied upon by Dan's lens, often without

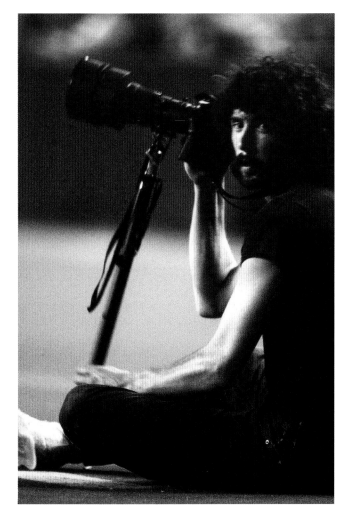

Dan Corrigan at the Metrodome, working the sports beat, 1982

their knowledge; First Avenue coworkers taking smoke breaks or diligently talking on the phone in the office; and candid shots of Dan's son, Felix, at all stages of his young life. An entire book could be dedicated to Dan's series of beautiful women, in various stages of undress, and their cats.

Once Dan moved to digital photography, all bets are off. The ability to shoot without limits engorged the archives of his collection—filling a hard drive with nearly two terabytes' worth of digital images and making the selection process for this book all the more daunting. With

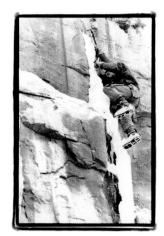

Daniel Corrigan's non-music portfolio covers a wide range of subject matter

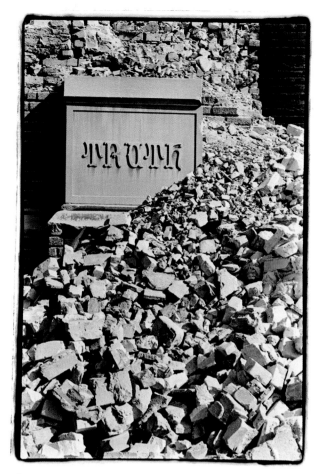

"Truth amidst the ruins."

exhilarating determination, we were rewarded with so many great shots, many of which may have only appeared in the newspaper once before disappearing into the past. To illustrate the history of Minnesota music and to open up this remarkable vault made for a rewarding journey.

What really got the music fan in me riled up was the overwhelming number of outtakes from some of Dan's most well-known photo shoots, many of which have never been seen. I probably enjoyed the images from the Replacements' *Let It Be* cover shoot, during which Bob Stinson pretended to kick a little dog off the roof, a bit too much.

Mixed throughout are artists and bands that may have only been a blip on the music radar but still managed to cast small shadows on the Minneapolis scene. Dan's ability to encapsulate his own style, as it developed through the years, unifies these images into an impressive and heartwarming body of work.

It's a collection we're proud to share, and it's long overdue.

Dan says, "I actually think I have a really bad memory. I think part of that was I thought if I had the photographs I could use them as a crutch. I didn't have to remember anything. The thing about the old pictures, they fire off so many great memories. They are all starting points for a story."

Introduction

At the dawn of the 1980s, the Twin Cities music scene was poised to explode. Out of the foundation of local punk and original rock music built by bands like the Suicide Commandos, the Suburbs, the Hypstrz, and Curtiss A in the late seventies, a new generation of punk, New Wave, no wave, and hardcore acts was shaking up the scene. Hüsker Dü, the Replacements, Loud Fast Rules (later Soul Asylum), and others were fast building rabid local followings and would soon achieve national acclaim, several getting signed to major labels.

At the same time, a vibrant R&B, funk, and soul scene was maturing and forming what would be known as the "Minneapolis sound." The young guitar and songwriting virtuoso Prince was perfecting his innovative and infectious style. Jimmy Jam and Terry Lewis's Flyte Tyme bands and productions were just getting their careers off the ground. Morris Day and the Time, Alexander O'Neal, and others were on the verge of breaking out and bringing a fresh sound to a wider and wider audience.

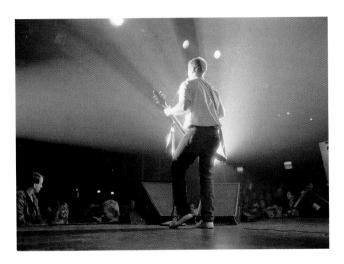

Bob Mould of Hüsker Dü at First Avenue, 1987

In 1981—the same year that Prince released *Controversy* and the Replacements came out with their debut album, *Sorry Ma, Forgot to Take Out the Trash*—the club known as Sam's (and before that, Uncle Sam's) officially became First Avenue and was on its way to becoming one of the nation's premier live music venues. One year earlier, the 7th Street Entry opened as a cramped performance space perfectly suited to the fast-emerging punk and rock scene.

Just a few years earlier, in 1977, Peter Jesperson, Paul Stark, and Charley Hallman had formed Twin/Tone Records. The indie label provided a home for up-and-coming local acts, including the Replacements, the Suburbs, Curtiss A, and, later, Soul Asylum, the Jayhawks, Babes in Toyland, and many others. Twin/Tone was at the center of the "proto-grunge" period in the Twin Cities that would inspire a sound and style that's often credited to Seattle and came along a decade later.

To many, the early and mid-1980s were the heyday of Twin Cities music.

It was within this perfect storm of musical activity and creativity that a young student at the University of Minnesota began taking assignments for the campus newspaper, the *Minnesota Daily*, to photograph concerts to accompany reviews and features in the paper.

Daniel Corrigan hadn't set out to pursue a career in photography when he went off to college. Rather, at the end of his third year at the university, the Spanish and linguistics major was told that he needed to take an art course to get the necessary distribution credits. Not feeling any particular interest in the arts, he initially protested the requirement and tried to petition out of it.

"My dad did not raise me as an artist," Dan recalled. "He encouraged me to be a surveyor—anything to do with water. Cindy Krepps, my advisor back then, said, 'You really need it, and no matter what you do, it won't hurt to have some art experience.' I thought photography had the most practical application for what I was doing. I didn't really have any sort of art ideas. My plan was to work for the CIA."

Over time, of course, Dan developed a deep passion for the art form, and his skills and keen eye continued to mature. Largely by trial and error, he established a signature look for his images. In presenting these musicians to the world, he embraced a raw grittiness, a style and mood that would be duplicated and popularized throughout the 1990s world of rock photography. Corrigan stumbled on the approach of natural presentation and the juxtaposition of everyday simplicity for would-be rock stars, a stark contrast to the excesses that surrounded pop culture and the arena rockers of the 1970s.

Although it could be said that he fell into a career as a rock-and-roll photographer, Dan's love for music goes back to his childhood. The oldest of four children, Daniel Corrigan was born in New York City in 1958 while his father, a Marine veteran who had served in Korea, was studying on the GI bill. Dan's parents, who were originally from the Midwest, moved the family to St. Paul, Minnesota, when Dan was two years old. They eventually settled in Marine on St. Croix, just north of Stillwater.

The Corrigans weren't an especially musical family, but Dan remembers them playing the Band, Johnny Cash, Bob Dylan, and the Beatles on the home turntable. When he was ten years old, his parents took him to see Joe Cocker, Leon Russell, and Dr. John at Parade Stadium in Minneapolis. Dan's musical interest grew, and like others his age, he started his own music collection, ordering cassettes by mail.

As a student at Stillwater High School, Dan played hockey and was, in his words, "kind of a nerd kid"—a good student who excelled in reading. Getting into music became Dan's way of life in high school. He and his best friend, Tom McKean, didn't fit in with any particular crowd. They didn't see themselves as jocks or "burnouts," but somewhere in between.

Daniel Corrigan

"At least for the group I was involved with, music was a really important thing. We'd get together and listen to *Beaker Street,* a radio show out of Little Rock, Arkansas. On certain nights, if the cloud cover was right, we'd get skip off the ionosphere and pick it up. We knew where to park to hear it. We'd listen to all the new rock songs."

Tom had a band, Rex Trapper, and Dan spent a lot of time in the band's practice space, where he developed a fascination with music production. He often helped set up the band's gear, and in between trips to Radio Shack, Dan put together the components to build a lighting rig. He became the "fourth member" of the three-piece group.

"Tom's joke for the band name was that it was Latin for 'King Catch One.' 'Catching one' was our slang for getting stoned, catching a buzz. We did a bunch of barn parties—we'd call them 'barn burners'—and I did all the production for those. I always loved that part of it. Plugging stuff in and moving stuff around, making sure everything worked."

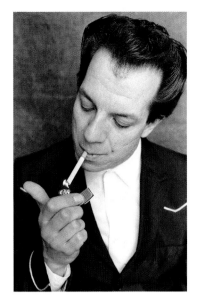
Tom McKean

Alongside his burgeoning rock-and-roll lifestyle, Dan and his brother had a shared interest in shooting, orienteering, and the military. But, having served himself, Dan's father discouraged the two brothers from enlisting. So, upon graduating from Stillwater High in 1976, Dan and his friend Tom moved to the Twin Cities, where he ultimately set his sights on earning a degree in Spanish and linguistics.

The heightened Cold War tension in Central America at the time drew Dan to the field, intent on becoming an international spy or cryptographer. Somewhat ironically, this interest in spies and espionage—combined with his interests in music and the technical aspects of production and with his patient nature—would lend itself perfectly to the field of music photography much later on.

The release of *Never Mind the Bollocks, Here's the Sex Pistols*, in 1977, may have had the greatest impact on Dan and his friends. Inspired by the album's raw and primitive expression, these young men felt that their possibilities were suddenly limitless.

"We waited in line to pick it up at Oar Folkjokeopus record store, and then we ran home to listen to it. It had a huge impact. It opened stuff up a lot. That's how I got to know everyone, because so many people were connecting with that record.

"Before that, Minneapolis had basically been a cover band town. We'd go see bands play songs by other bands. But when the Sex Pistols came out, it showed that anybody can do it. Anybody who's got the nuts to grab their stuff and get up there can do whatever they want. That was so cool."

After enrolling in the photography class at the University of Minnesota, and with encouragement from Tom McKean, Dan began to revel in the photographic process. He fell in love with working in the darkroom. The action of the blank photo paper transforming into an image enthralled Dan.

He was soon hired as a printer at the *Minnesota Daily*. Although he had enough credits to graduate, he managed to stick around in order to further learn the craft of photography and the darkroom. He was hooked.

"When I got my job at the *Daily*, I just loved the whole thing so much. That was what I wanted to do. I worked my way up from lab tech to photographer to editor. I ended up working there for four years. When I started photography I was already three years into my education. Photography blew me away, so I sort of started over again. I totally switched majors. Spanish and linguistics was my major, but I decided to do four more years of every photo class the school had to offer.

"The guy that hired me at the *Daily* was Jeff Wheeler, who later became a photographer for the *Star Tribune*. At the time he was the photo editor at the *Daily*, in charge of hiring photographers. He went through my stuff and said, 'You are a great printer, but I'll never hire you as a photographer.' I still give him shit about that."

Dan started doing jobs for the local weekly *Sweet Potato*, which was renamed *City Pages* in 1981. He became the go-to guy for a variety of freelance work, including music, theater, and sports. Having made a name for himself as a music photographer shooting live concerts, he began doing work for other newspapers and photographing national acts at bigger arenas around town, like the State Theatre, the St. Paul Civic Center, and Met Center.

After graduating from the University of Minnesota in 1983, Dan stayed on to work at the *Daily*, but by this time

he was already a fixture at First Avenue and Twin/Tone Records. Dave Ayres, who would become an A&R man for Twin/Tone, was a year ahead of Dan in school and was friends with Tom McKean. Dave was an editor for the *Daily*'s arts and entertainment section, and when he started working for Twin/Tone, he and Dan made their connection. Dan got to know the other kingpins of the label, Paul Stark and Peter Jesperson, and his relationship with Twin/Tone would be a big boon for Dan's career. He created what would become some of his best-known work doing record covers and promo shoots for the bands on the Twin/Tone label.

As he gained more exposure, Dan got more and more requests from bands, big and small, throughout the 1980s and into the '90s. If your band needed a publicity photo or an album cover image, or if you were on the bill to play First Avenue or the 7th Street Entry, Daniel Corrigan was who you wanted behind the camera.

Throughout his career, he traveled with and shot most of the top bands on the Twin Cities scene, including the Replacements, Babes in Toyland, Soul Asylum, Hüsker Dü, the Jayhawks, the Gear Daddies, Trip Shakespeare, Run Westy Run—the list goes on and on. His reputation extending far beyond Minnesota, Dan would be tapped to document sessions with such varied acts as Uncle Tupelo, and then its offshoots Wilco and Son Volt; Matchbox Twenty; and oddly enough, a Midwest tour by progressive metal band Queensrÿche.

Assignments to photograph international acts coming through the Twin Cities allowed Dan's portfolio and repertoire to grow. The varied experiences of these jobs informed his sense of direction in assembling a photo for each event. Dan has used the skills developed over thirty-five years of shooting music to hone his natural ability to tell a story with a picture.

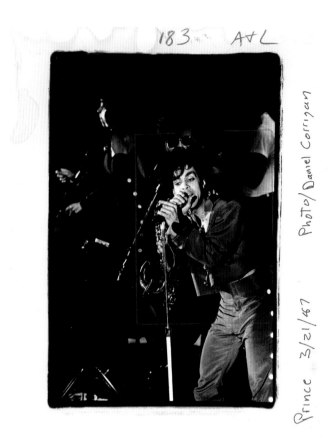

Prince at First Avenue, March 21, 1987

"All that pictures ultimately do is tell a story. That story could be true or false, silly or anything. But it's a story. The pictures that I'm interested in and that I think people recognize are the ones where that rings true.... I bring all the stuff I know about it to make a picture, to tell that story. If I know about stuff and I'm lucky, I make a picture that rings true."

By the mid-2000s, Dan made the inevitable transition to digital photography. Digital cameras, as well as the shift to primarily color photography, altered the aesthetic of much of Dan's work and took him out of the darkroom and put him increasingly in front of a computer screen. Still, his instincts and eye for knowing the right moment and finding the right location from which to shoot have kept him at the forefront of the field and allow his images

Hanson at First Avenue, September 26, 2008

to shine to this day. If Dan's work can teach aspiring photographers anything, it's that patience and personal investment make the shot.

The advent of digital cameras and the ubiquity of smartphones have also changed the business of being a professional photographer. Now just about anyone in attendance at a concert will capture the performance for posterity. Essentially, everybody is a photographer now.

After more than three decades as a professional photographer, Dan limits the amount of work he does in the field simply because there's less demand for it, and the perceived value of an image has decreased as photos of concerts pop up by the hundreds on social media and online photo sites within minutes of a show. Much like musicians and their increased ability to sell their own records without need of a record label or distributor, the need for a professionally made photo has diminished greatly.

Nevertheless, Dan has maintained his role as house photographer for First Avenue, and he continues to shoot a handful of shows every month. His primary responsibility at the club, however, is working for the facilities staff maintaining the building.

Through the radical changes in photography and the music industry, and Dan's role in it all, the Twin Cities music scene remains as vibrant as ever. Dan's passion also remains with the club that he has been a part of for so many years. Forever a music fan, he credits the hardworking musicians of today for carrying the torch and continuing the vibrant musical legacy.

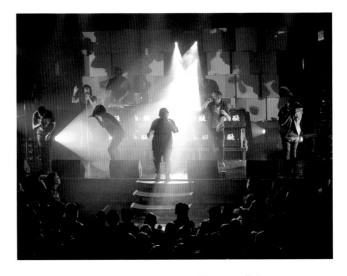

The Doomtree collective—part of Minneapolis's current heyday—at First Avenue, December 12, 2014

"When I lived downtown, I'd walk down First Avenue to the club. At the time I had really long curly hair. As I was leaving a show one night, I saw this couple, and they were like, 'He looks like Jesus!' So I gave them the sign of the cross. They smiled. A block away, I see this other woman, and I overheard her say to her boyfriend, 'He looks like Charles Manson!' I got Jesus and Charles Manson within a block."

Dan Corrigan

In essence, the heyday is today, and every day.

"I will argue vehemently that it wasn't better back then," Dan says. "It's better now. People have more tools to draw on to make their music. They have better avenues to deliver their music to the public. I think that it's only by looking back that there's some sort of nostalgic glow that people find attractive. I'm glad I was there and that I got to see it, but I don't particularly feel nostalgic."

Within this book is a sampling from Daniel Corrigan's extensive portfolio of music photography. Whereas some of the shots were meant for professional and promotional use, at the core, the body of images reflects a personal touch seen through Dan's eyes. What makes them resonate and feel genuine is the connections and experiences Dan brought to composing each one.

"My technique is so simple. In a way, I hated having a photo studio. When the people would come to the door and they don't know me, with the backdrops and lights and all that stuff set up, there was a certain expectation they put into it. Usually what I had to do was take all that stuff away. If they come over and spend some time with me to do a shoot, even if it's in a photo studio, they realize what it really is. It's about the connection between me and the person, or the light and the person. Whatever that is, it's simpler than most people think. So the next time they come in, they know there's not anything they have to be other than themselves."

In virtually every image, Dan reveals his personality as an overseer. A consistent fan of the music and often a close, personal friend with the subjects, Dan brings a mostly self-taught perspective in his field and a reliance on his own patience and instincts.

"This sounds really strange, but I think I'm an empath. I've been able to recognize that without having it drive me crazy. The more I can feel that connection, I can't tell you how important that is. It happens the second you meet a person. I've always loved doing a second shoot with somebody for a portrait, because it gets rid of a lot of expectations."

We're beyond fortunate to have had Daniel Corrigan create this collection of memorable photos. From the beginning of his career to the present day, there's a lot to be taken away from the seasoned eye of a true artist such as Dan. The power of his at times overwhelming collection spills far beyond these pages.

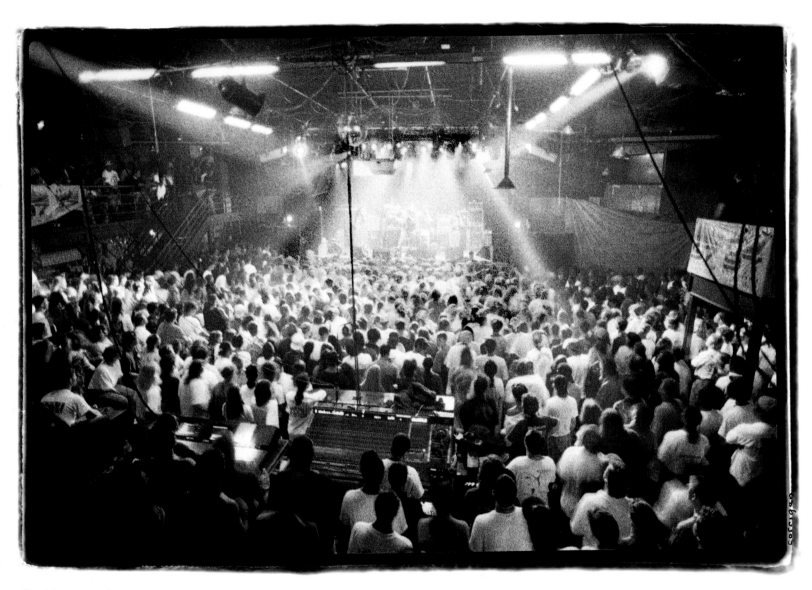

First Avenue main room

HEYDAY

The Suburbs

While living in Stillwater with his mother, Dan grew up in the scene, checking out music at the St. Croix Boom Company, where a lot of Twin Cities bands would come out to play.

In about 1980, just as Dan was getting into photography and working at the University of Minnesota's campus newspaper, the *Minnesota Daily*, he befriended one of Minneapolis's more popular bands, the Suburbs. The hyper five-piece group perfectly captured the mélange of sounds happening in the Twin Cities at the time, creating their own brand of sped-up, funk- and punk-inspired, New Wave dance music.

"Musically, I loved those guys," Dan said about the 'Burbs. "It was such an exciting time. They had a really crazy, frenetic show. They were probably the first band I did a lot of live pictures of. This was before I really knew how to do all the work in the darkroom, so I was shooting color and bringing it all to Pro Color to get developed.

"At the Boom Company, down in the basement where the green room was, there was a huge expanse of space. Since the house had been turned into a bar, the basement hadn't been used at all. So what they did with all the beer cases that came in was, they flattened them and threw them all down the stairs. There was an insane amount of beer cases down there. So I had the Suburbs lay recumbent posed all across them in that room."

After the shoot, being a true fan and friend, Dan offered to put the band up for the night.

"It was a crazy night and after-party. Chan [Poling] asked me, when they showed up, 'Do you have any hard alcohol?'

"Later, he was looking for a place to sleep, so he decided to slip into bed with my mom, and he woke her up. She was like, 'Get the hell out of here!'"

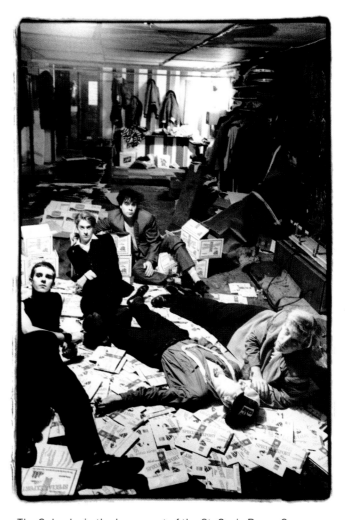

The Suburbs in the basement of the St. Croix Boom Company in Stillwater, 1983

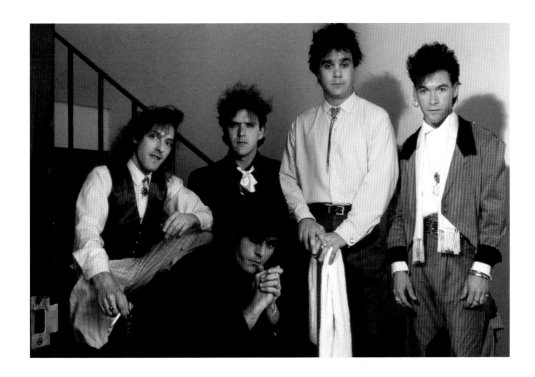

Left: The Suburbs before a performance at the Guthrie Theater in Minneapolis: Bruce Allen, Chan Poling, Hugo Klaers, Beej Chaney, and Michael Halliday (front)

Below: The Suburbs practicing

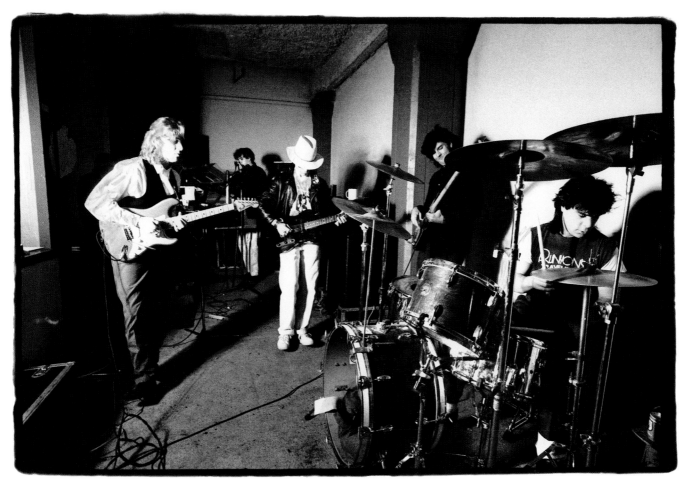

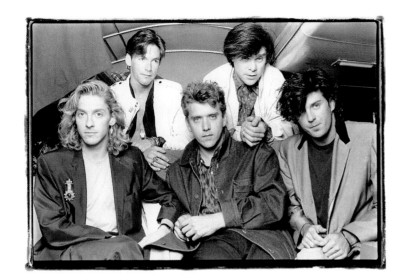

Allen, Chaney, Poling, Klaers, and Halliday,
circa 1986

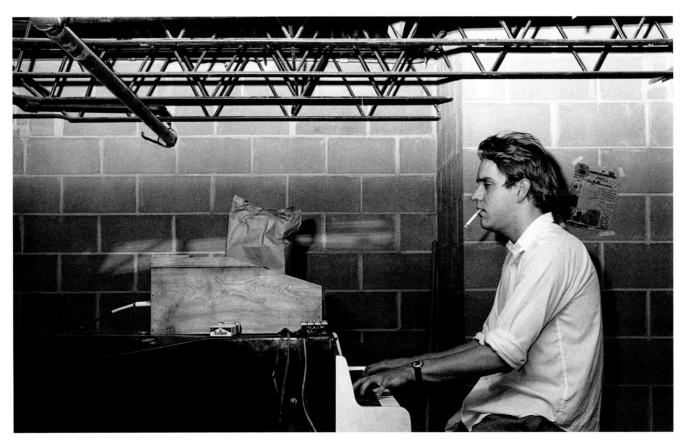

Chan Poling at the piano

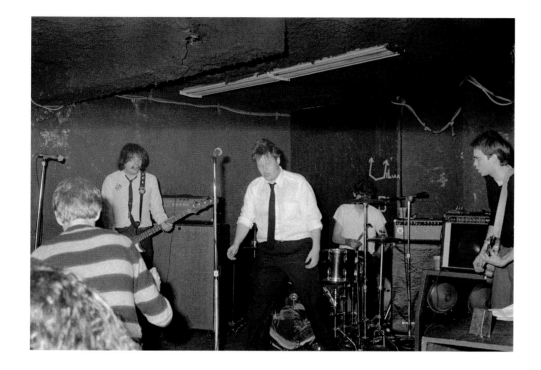

The Hypstrz in the 7th Street Entry, circa 1981

"The Batsons are just straight-up rockers. I remember Billy used to hit himself so hard on his forehead he would bleed. The thing that's curious about the Batson brothers is, there's this pressure building up everywhere. When they get to play, it's like somebody gets to pull the cork out. I think that cork coming out is them playing. I always loved watching them play. It's just such pure rock. They are playing something that belongs to everybody."

The Mighty Mofos, 1984: Billy Batson, Caleb Palmiter, Ernie Batson, Tommy Rey

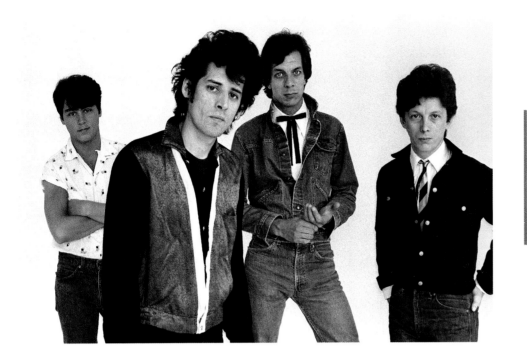

"Johnny Rey and the Reaction was the very first paying band photo I ever did. My friend Tom McKean was in the band and got me the connection. My girlfriend at the time was the manager of Coffman Union, and I did a super cool shoot [there] with them."

Above: Johnny Rey and the Reaction, 1982

Right: Chuck Wow, Minneapolis-based New Wave band, circa 1983

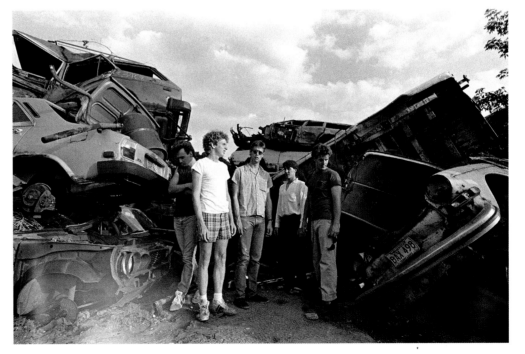

Left: Steve Kramer of the Wallets

Below: The Wallets, mid 1980s

"I loved those guys [the Wallets]. They were more art rock. Very strong performance value. They thought about each show as being a piece of art."

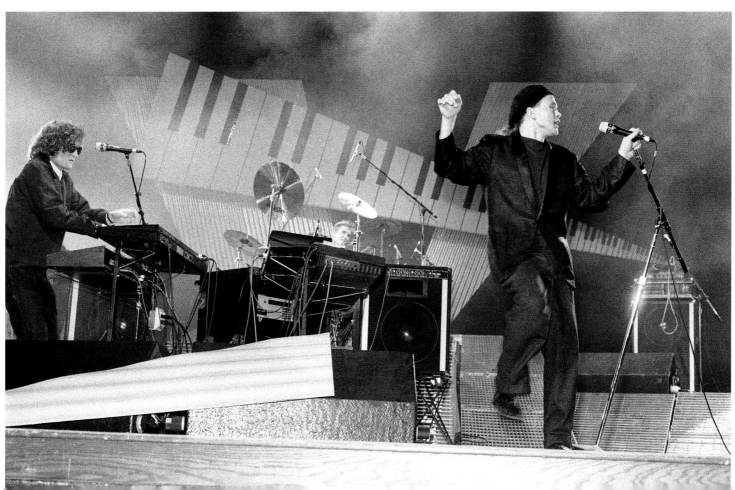

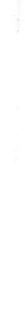

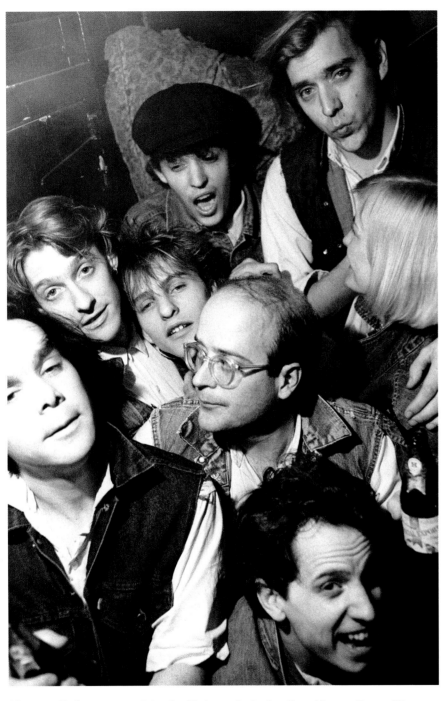

Minneapolis "supergroup" Jumbo Shrimp—featuring Hugo Klaers, Bruce Allen, Tommy Stinson, Bob "Slim" Dunlap, Chris Osgood, Casey MacPherson, Chan Poling, and Terri Poling—in a closet at the First Avenue offices, 1984

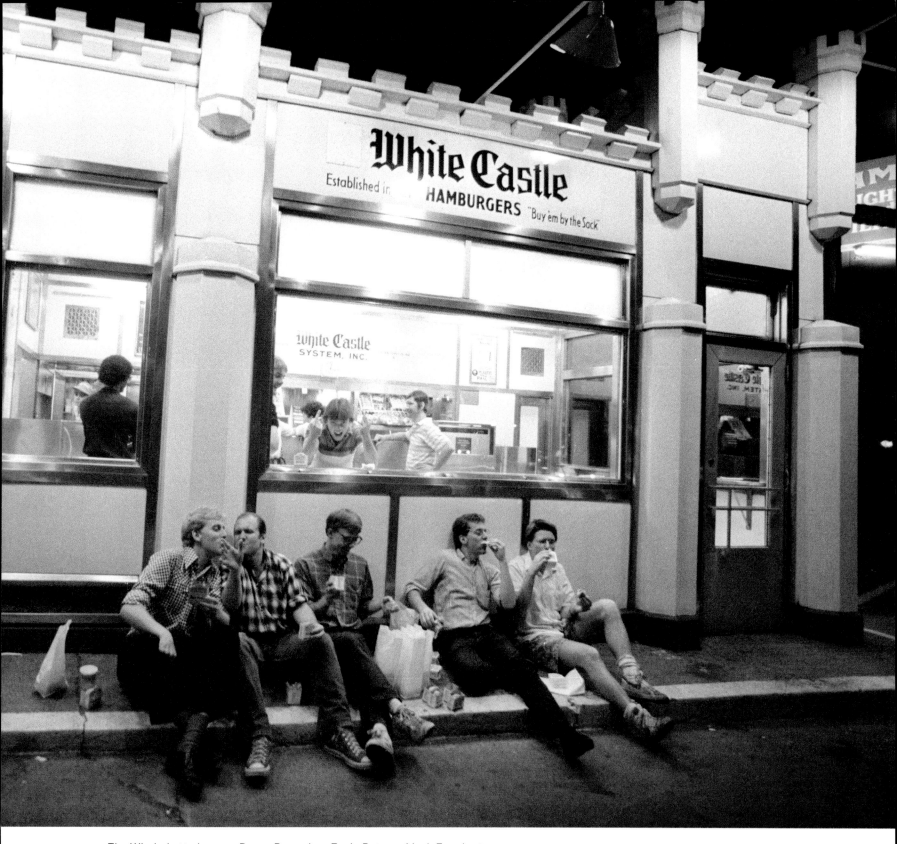

The Whole Lotta Loves—Bruce Browning, Ernie Batson, Mark Engebretson, Roger Seeling, and Scott Browning—enjoy a late meal at White Castle, circa 1983

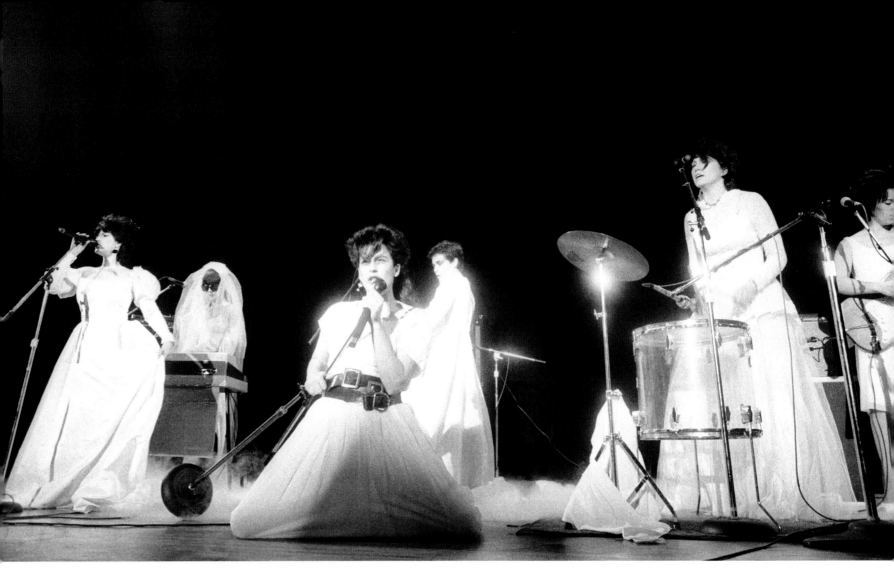

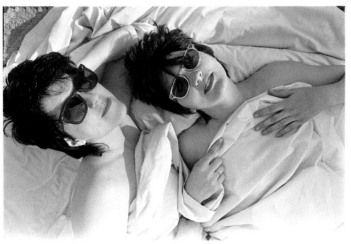

Above: Têtes Noires at First Avenue, 1984

Left: Renée Kayon and Camille Gage
of Têtes Noires, 1984

Left: Peter Jesperson, co-founder of Twin/Tone Records, manager of Oar Folkjokeopus record store, and manager of the Replacements, 1989

Below: Kevin Cole, longtime house DJ at First Avenue and 7th Street Entry, 1989

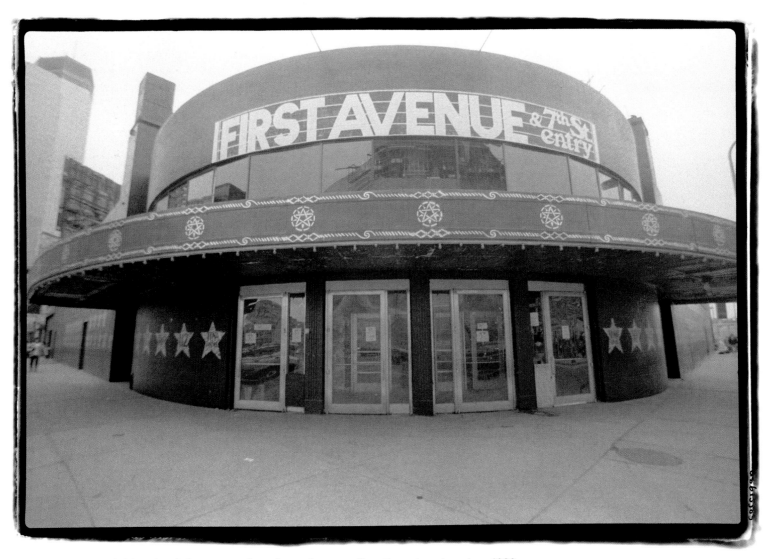

First Avenue—Daniel Corrigan's home away from home for more than three decades, circa 1989

Steve McClellan, longtime general manager and booker for
First Avenue and 7th Street Entry, in the First Avenue office,
November 1988

Entrance to 7th Street Entry

Prince

"I was hired to do a job out at Paisley Park," Dan recalled. "I asked them, 'What do you call him?' They said, 'Don't call him anything!'"

Prince has been virtually synonymous with the Twin Cities music scene ever since he first made a name for himself around town in the late 1970s. If you spent any amount of time working in the scene during his lifetime, you likely have at least one Prince story.

In retrospect, it may not have benefited Dan Corrigan to have established himself as a well-known photographer at First Avenue in the early eighties. In an effort to maintain secrecy for the film production of *Purple Rain*, Prince prohibited all media and photographers from the club during shooting in the fall of 1983—but Dan was the only one specifically listed as being banned from the set. He was the only photographer Prince knew by name.

Dan photographed Prince performances at First Avenue and other venues several times over the years. It wasn't until 1998 that the enigmatic performer invited Dan out to Paisley Park for the opportunity to work one-on-one with the artist himself. Well, almost.

"I'm at my home in Northeast Minneapolis, and I get a call from Paisley Park at 10 p.m.," Dan said. "'Can you get out here at 10:30 p.m.?' they ask. I'm thinking, no way can I get out there to Chanhassen that fast, but I say, 'Yeah, sure, I'll get out there, no problem.'

"I get to Paisley Park, and they put me in this waiting room. I wait there for like four hours until someone comes in and tells me they don't really need me that night. It was more than four hours, so at least I can bill them for a full day.

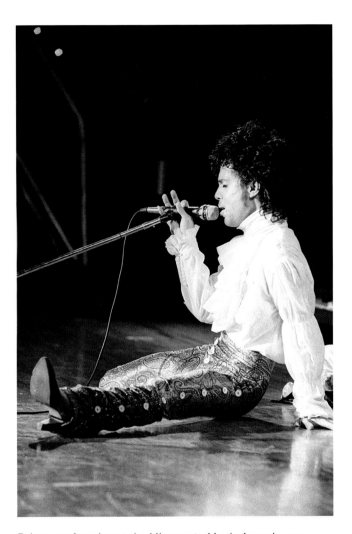

Prince performing at the Minnesota Music Awards, or "Yammies," 1984

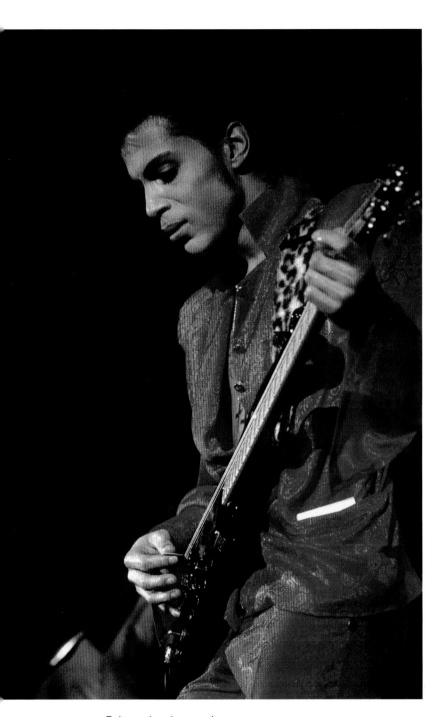
Prince shreds on guitar

"The next night, same thing happens. I go out there, and this time they come back to me in just under four hours, so it was like a half day.

"On the third night, the same thing again—I get the call; I go out to Paisley Park. This time I made sure to bring some snacks, I brought my book. After four and half hours, they come in and bring me into a studio and are like, 'Stand here.'

"So, I'm standing in this spot, just waiting, for two more hours. There's a video shoot going on. I see Prince sitting there, and I'm feeling like I really have to do something. So I take my camera out of my bag, just to get a [light] meter reading in the room so I can be ready when I do start shooting.

"Prince sees me with my camera out and starts waving his Lucite swagger stick at me and shouts, 'Not yet!'

"I put my camera back in my bag and stand there for the rest of my eight hours until they tell me to leave. Essentially, I got paid for two and half days at my full rate, and all I did the entire time was take my camera out once, and didn't take any pictures. That was all I did. I found out years later that I was actually auditioning for a job as his touring photographer. That was a pretty weird experience."

Although Dan didn't get the job, he remembers the experience fondly, and he remained a fan.

Dan's photos of Prince capture the artist during his biggest ascent. Prince's energy and showmanship burst through in the images of various live performances, illustrating a time when Prince truly was developing his craft.

"He is maybe one of the most incredible guitar players I've ever seen," said Dan. "One time he came down to First Avenue after someone must've mentioned his guitar playing was sloppy or something. He did a show where he just shredded for like two and a half hours!"

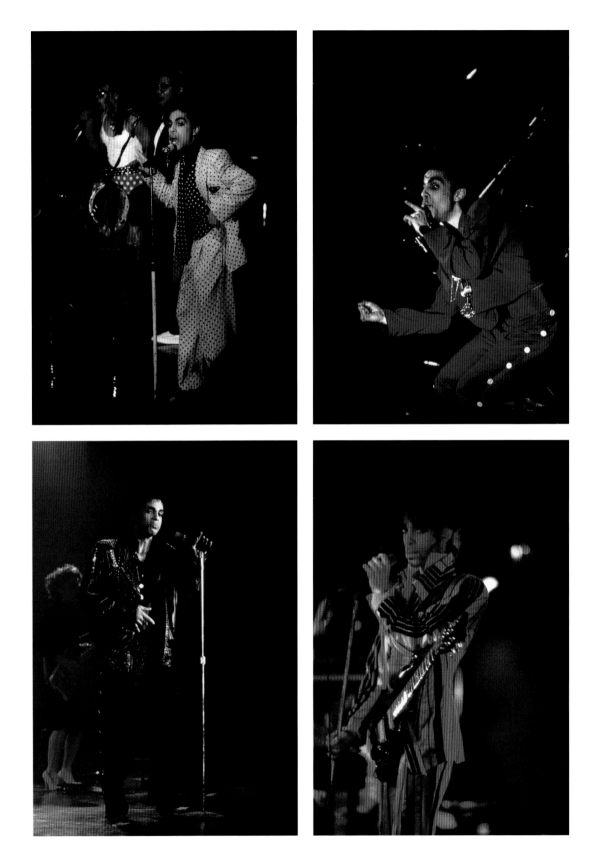

Prince through the years

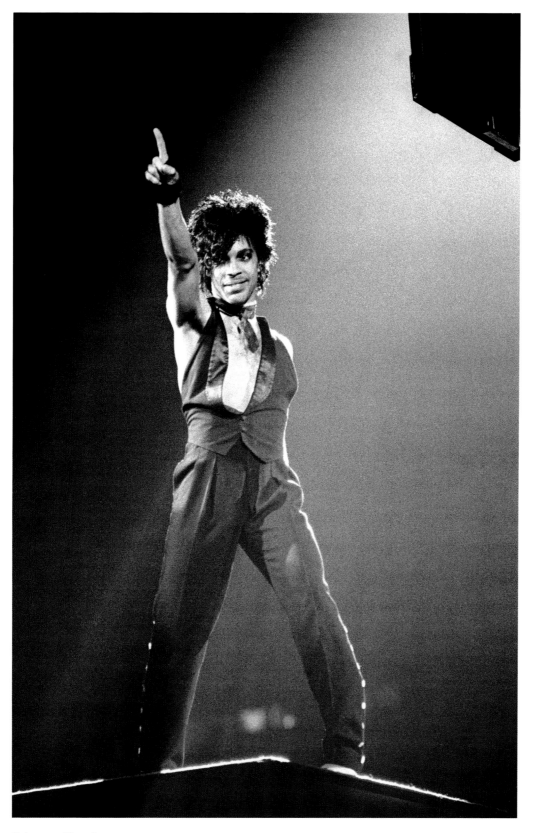

Prince at First Avenue

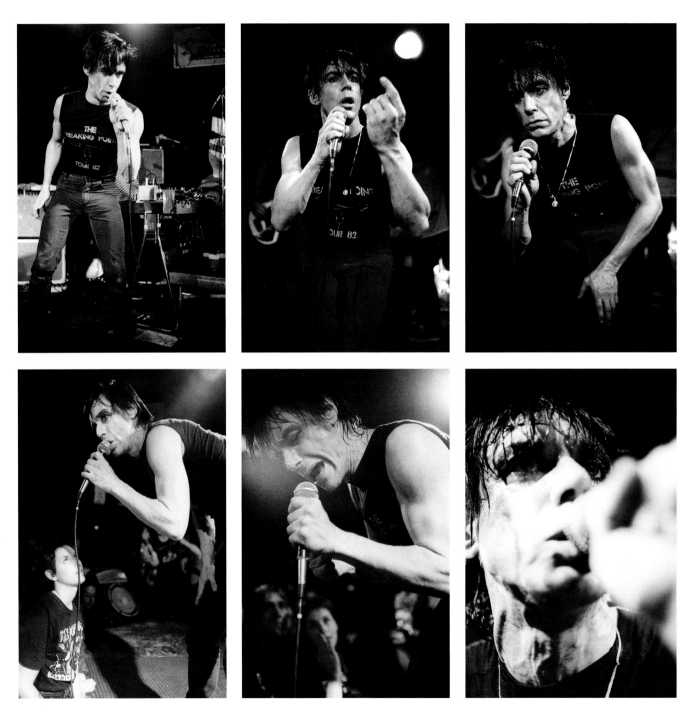

Iggy Pop at Duffy's in Minneapolis, November 7, 1982

Assignment Photography

Early on and again through much of his career, Dan reveled in getting assignments for photographic work. He was often hired to deliver photos of important concerts to accompany a review in one of the various local publications. These gigs allowed him to flesh out the variety of artists that became a part of his portfolio.

Dan's assignment work began with the *Minnesota Daily* in the early 1980s. "I loved the people I worked with at the *Daily* and doing general assignment photography there," he recalled. "Someone gives you a piece of paper—it has a name, a number, and some rough angle of the piece. You go off on your own adventure to get that. I loved that whole process."

Assignment photography also sharpened Dan's skills and knack for problem solving, forcing him to come up with ideas quickly for each image. After taking cues from a stagehand about the particular provisions or limitations for a given show, Dan would find himself in front of the stage with other photographers. There was typically a three-song limit to photograph a concert. With this short window to get the right shot, Dan had to develop strategies for finding the prime position from which to shoot a performance. The chaos of early punk shows also tested his physical fortitude.

"My strategy for live shows—if it's going to be a packed show—was I'd go in before the doors opened. I'd get my spot that I wanted and then stay there the rest of the night. I wouldn't be able to leave to get a drink or go to the bathroom. I'd just stay there."

Occasionally, he'd find a position a little too close to the action. "When Iggy Pop played at Duffy's in Minneapolis, I was dead center in front of the stage the whole night. There was no barricade there, and the stage was pretty low. Iggy did this move where he grabbed the mic stand and went down low to the ground and lifted the mic stand up above his head. He then jumped and spun around, and the mic stand clipped me right in the side of my head. It knocked me senseless. It was so crowded in there, when I fell backwards into people, they shoved me back up toward the stage. I landed face first on the stage. Iggy grabbed me by the chest as I was going down. He had this look in his eyes like, 'Oh my god, are you okay?'

"But he kept performing the song. That little moment really personalized Iggy for me."

When the Clash came to the Twin Cities to play the St. Paul Civic Center, Dan found himself in another unenviable situation amidst the crowd.

"I had to shoot the Clash in St. Paul and got there early to grab a spot on the floor. It was general admission, so I had to worm my way up to maybe twenty people deep from the stage. I was standing next to this drunk guy. He thought it was hilarious to stick his hand in front of my camera. It was really just obnoxious. I finally pushed him out of the way, and he decided to take a swing at me. I was faster than he was, and as I moved out of the way I hit him with the side of my camera—which at the time was a Nikon F2, with a motor drive that had, like, eight double A batteries in it. With the lens, the whole thing was like a brick in my hand, and I hit this guy in the side of the head with it. He just dropped. I hadn't realized it, but he was with some friends, and they were a bit drunk too, and were like, 'Hey! What's going on?'

"So I had to run away. I ducked down and basically duck walked my way off the main floor and went up to the mezzanine. When I got up there, I thought it was a pretty nice angle anyway. I probably shot a dozen pictures or so before security came over and said I couldn't stand on the stairs up there. I knew when I saw the view up there that that was the shot."

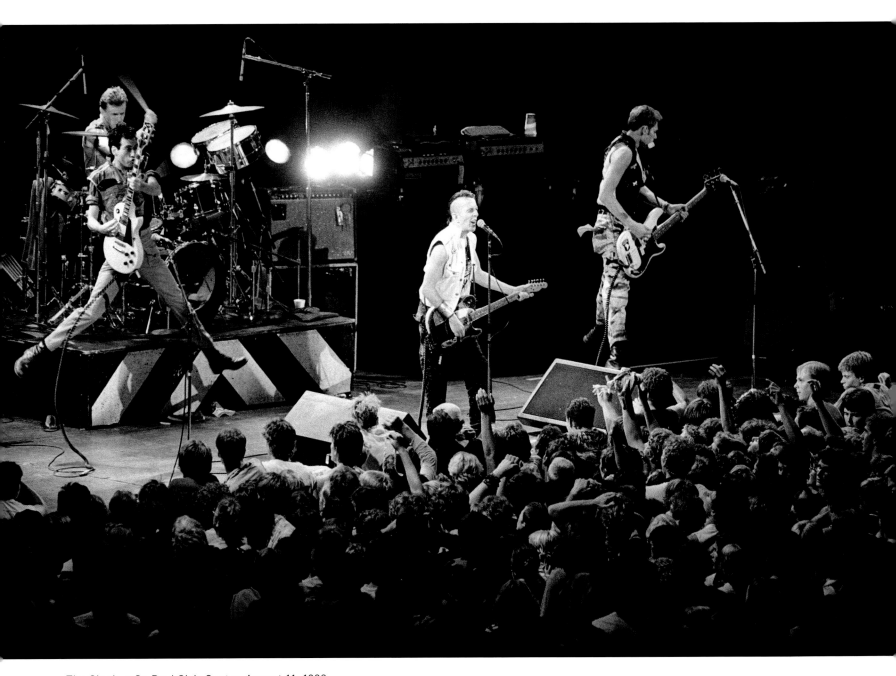

The Clash at St. Paul Civic Center, August 11, 1982

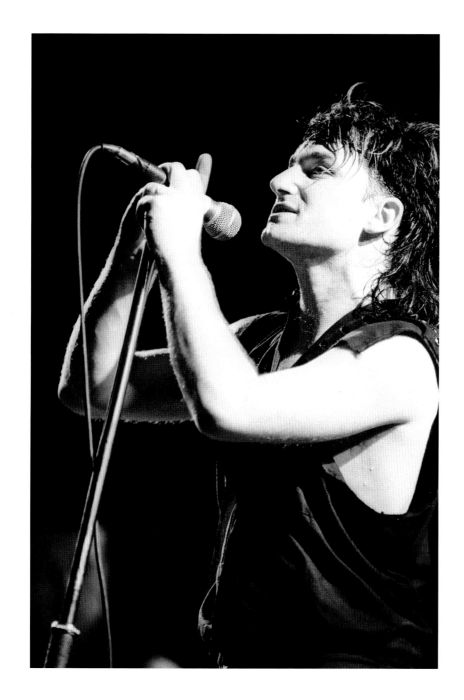

Above: Sting of the Police performing at the Minneapolis Armory, November 1980

Left: Bono of U2 performing at First Avenue, February 21, 1982

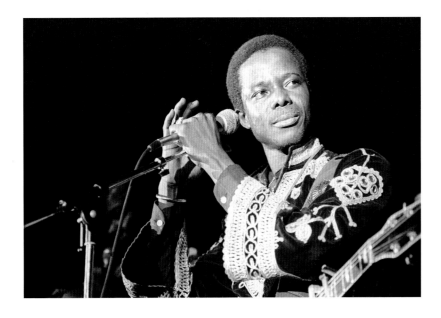

Left: King Sunny Ade at First Avenue, 1983

Below: George Clinton at First Avenue, 1985

Opposite: Elton John at St. Paul Civic Center, September 18, 1984

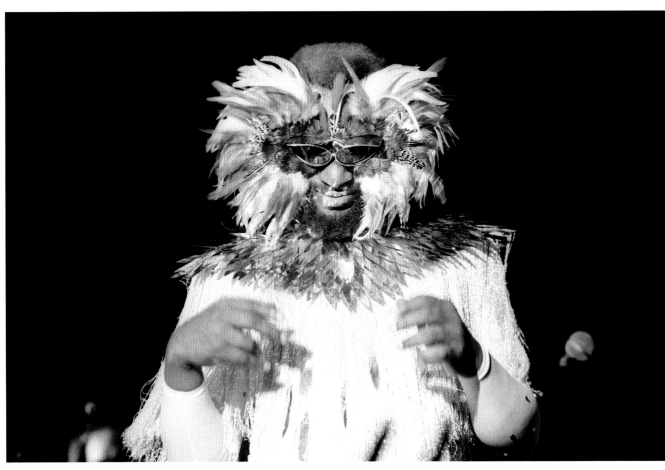

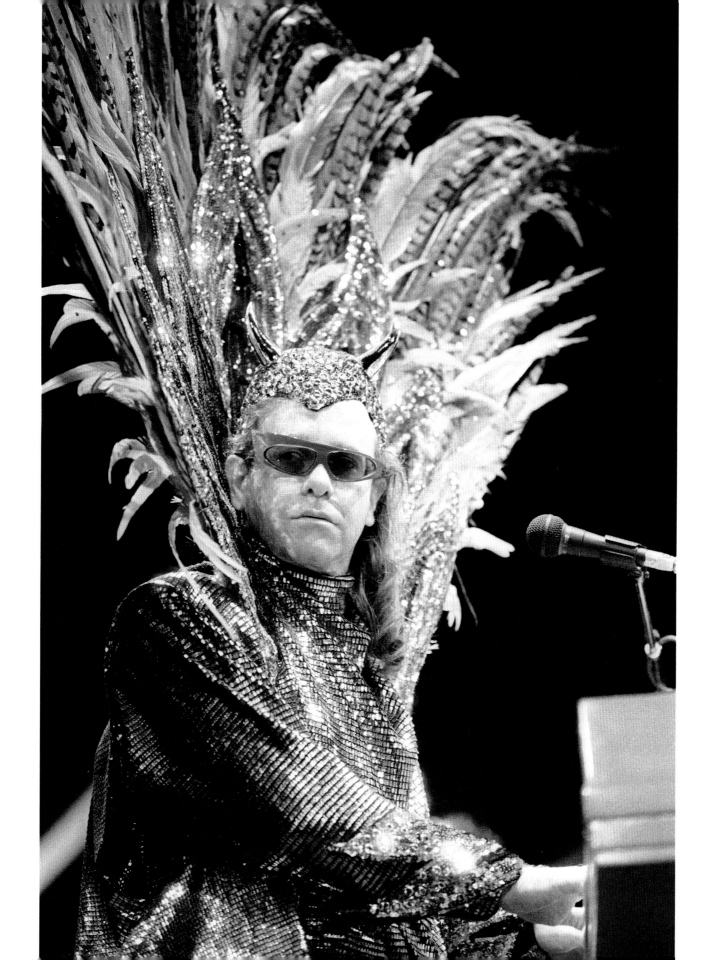

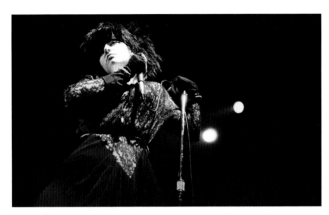

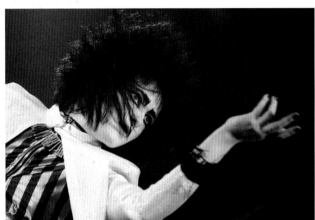

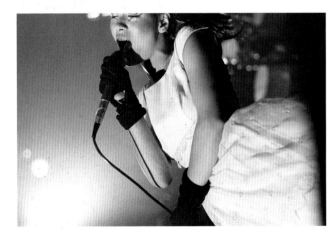

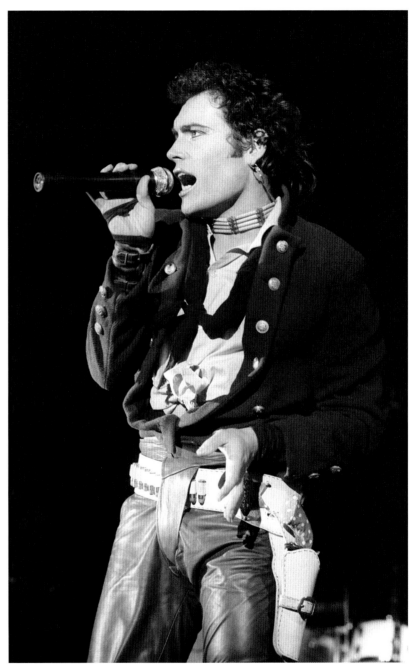

Above, top to bottom: Lydia Lunch at First Avenue, January 23, 1983; Siouxsie of Siouxsie and the Banshees at the Orpheum Theatre in Minneapolis, May 25, 1986; Bow Wow Wow at First Avenue, December 29, 1982

Right/Above: Adam Ant at First Avenue, November 25, 1982

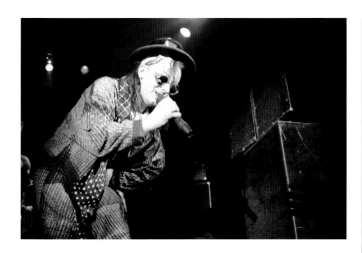

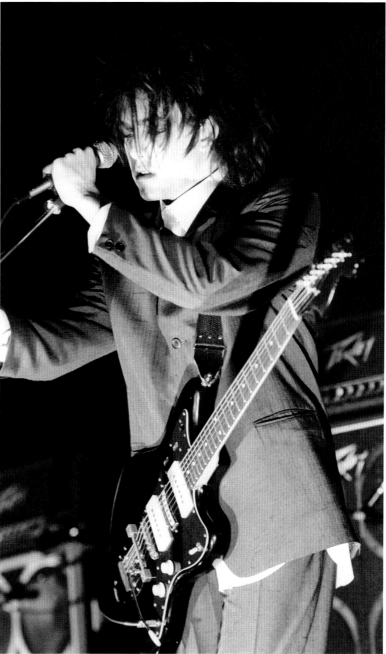

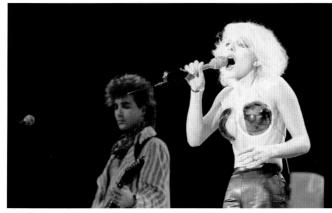

Clockwise from top left: Boy George of Culture Club, 1984;
Robert Smith of the Cure, November 7, 1984; Missing
Persons, circa 1984—all at First Avenue

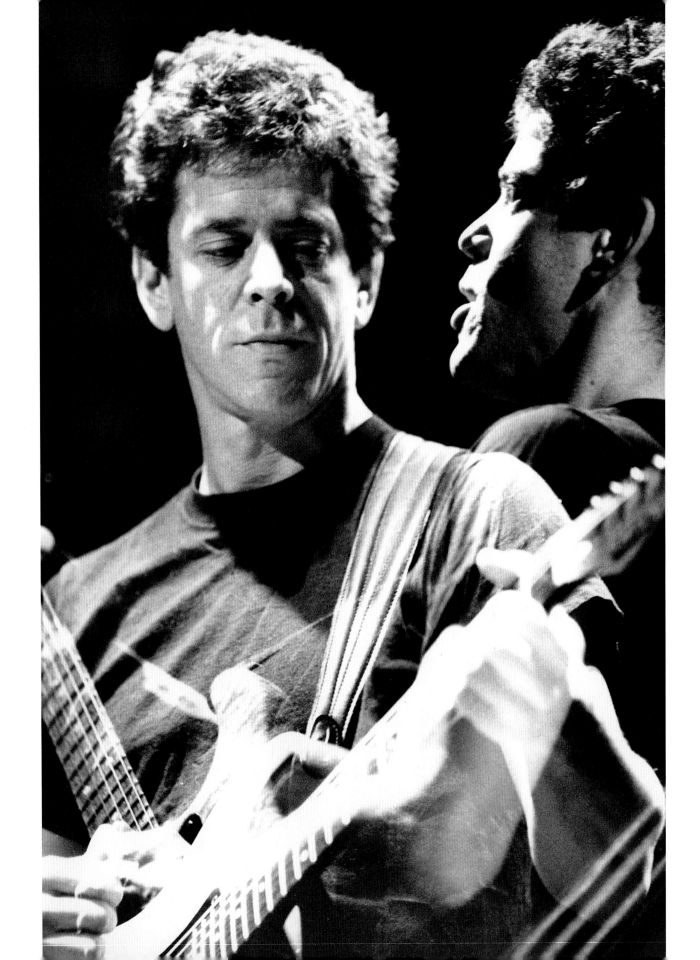

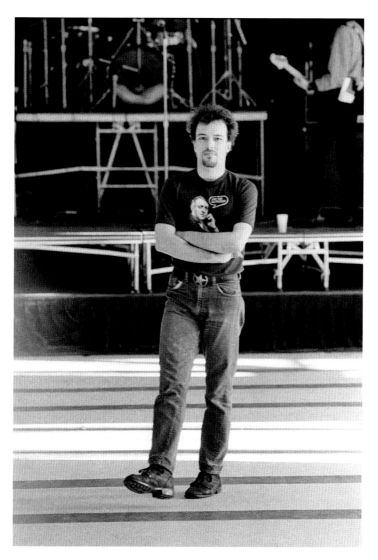

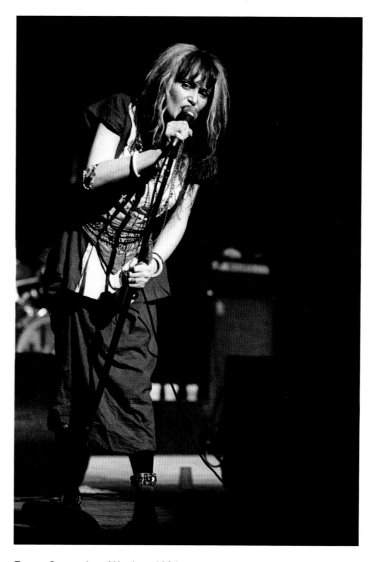

Jello Biafra of Dead Kennedys at the Great Hall in Coffman
Memorial Union, June 1983

Exene Cervenka of X, circa 1984

Opposite: Lou Reed, circa 1984

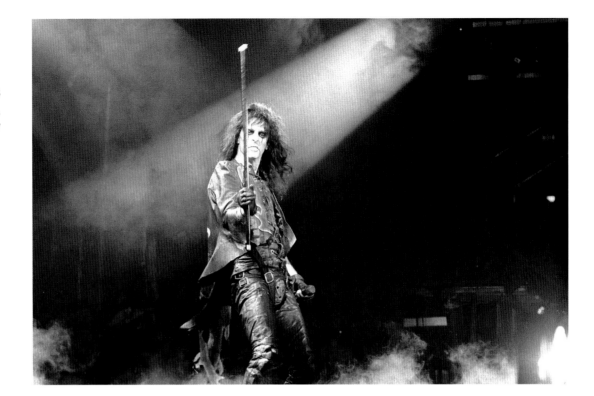

Alice Cooper at Roy Wilkins
Auditorium in St. Paul,
February 1987

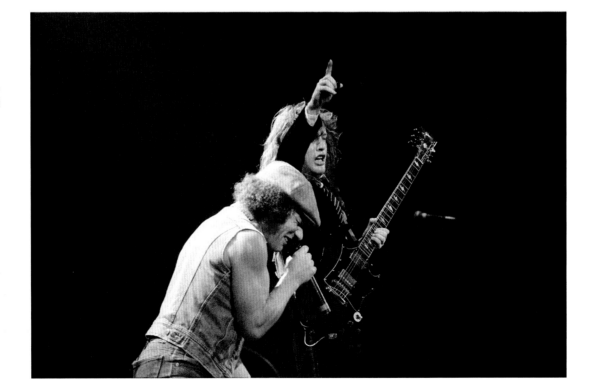

AC/DC at the Met Center,
September 29, 1985

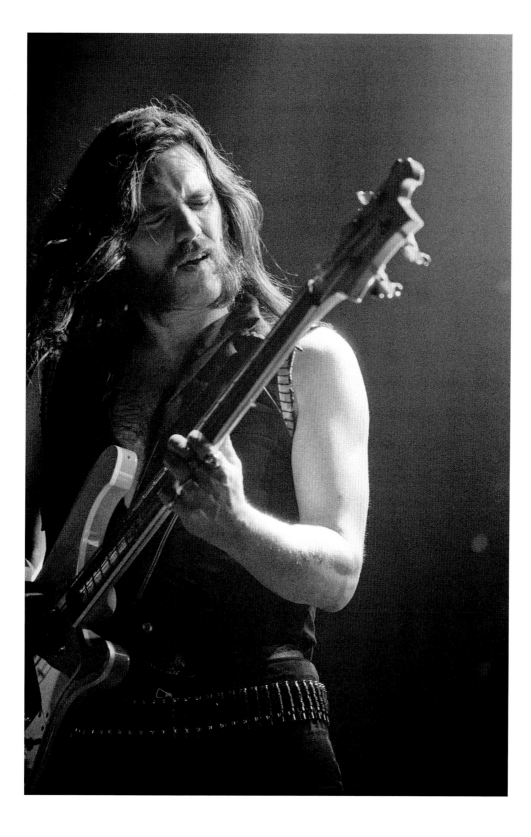

Motörhead's Lemmy

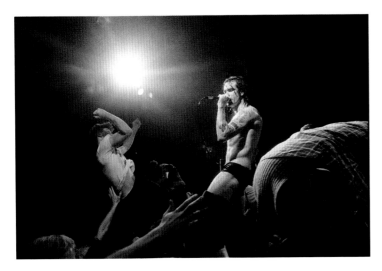
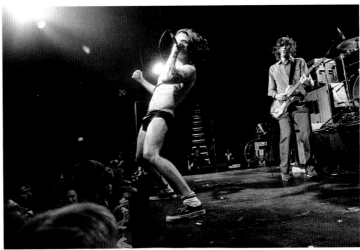
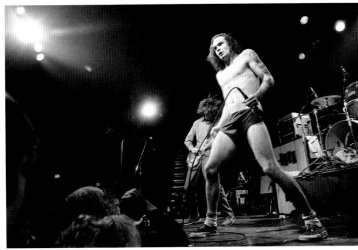
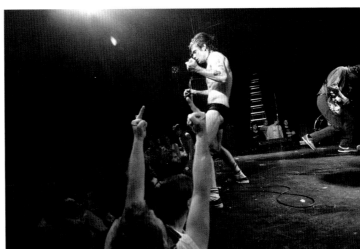

Black Flag at First Avenue, October 3, 1984

Opposite: Henry Rollins poses for a portrait, circa 1986.

"I asked Rollins to stand there, look here. Henry was kind of one of my heroes back then. But I was never a fanboy. I was never overwhelmed by anyone's star power."

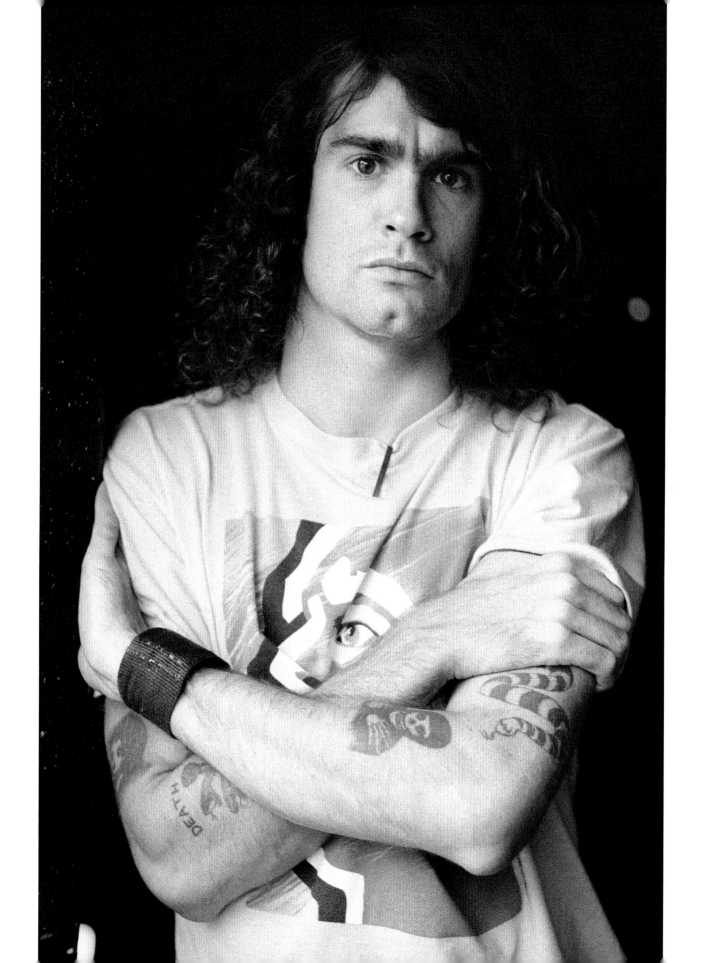

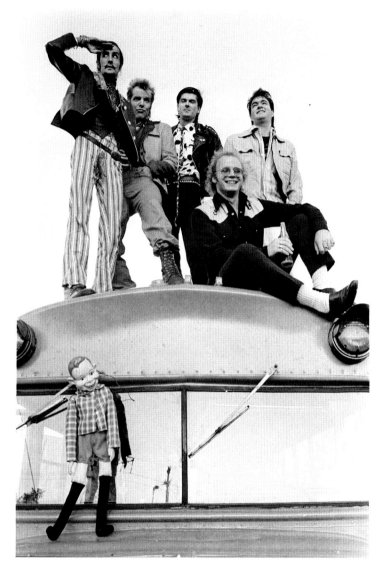

The Slickee Boys, 1984

Jonathan Richman at First Avenue, circa 1985

Opposite: Violent Femmes in St. Paul's Lowertown, 1983

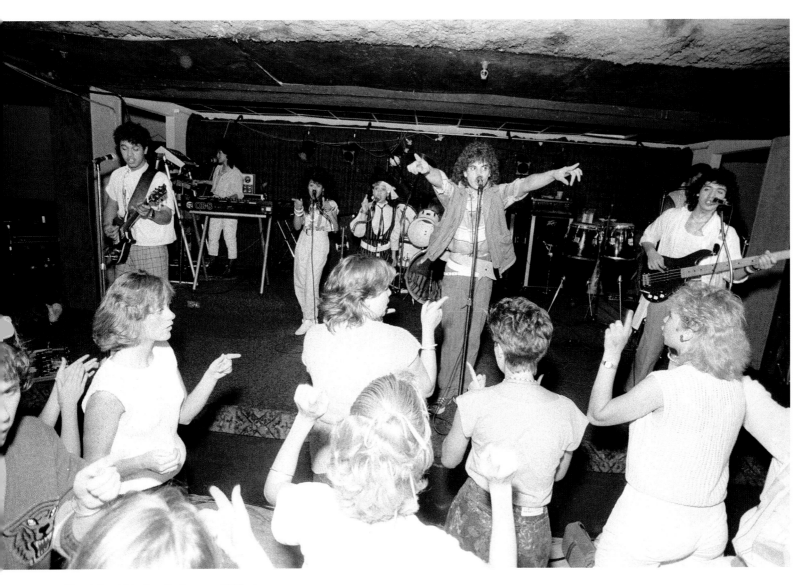

The Jets at Medina Ballroom, 1985

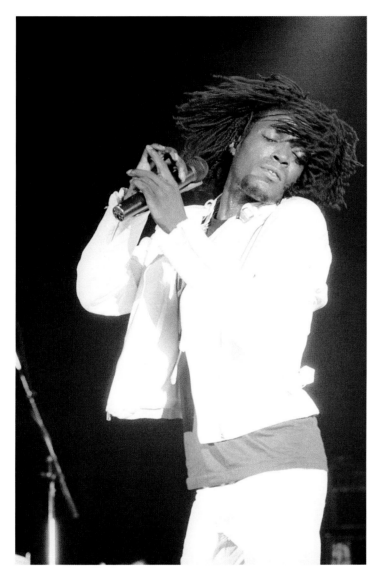

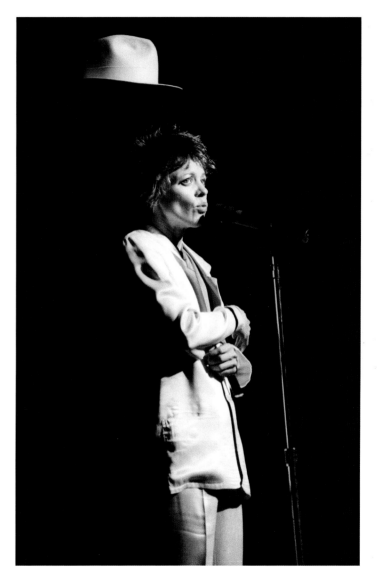

Black Uhuru at First Avenue, August 21, 1985 Laurie Anderson at Walker Art Center, June 1986

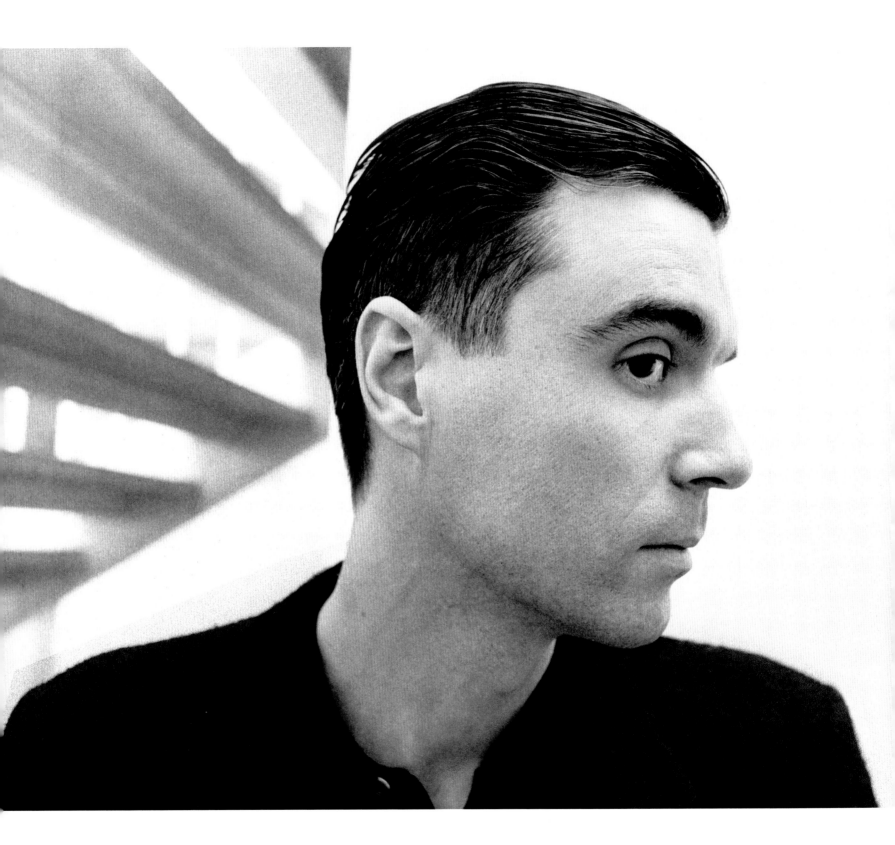

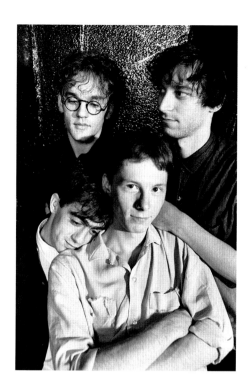

Left: R.E.M., 1984

Below: Michael Stipe and Peter Buck of R.E.M. performing at Roy Wilkins Auditorium in St. Paul, October 14, 1986

Opposite: David Byrne at Walker Art Center, 1984

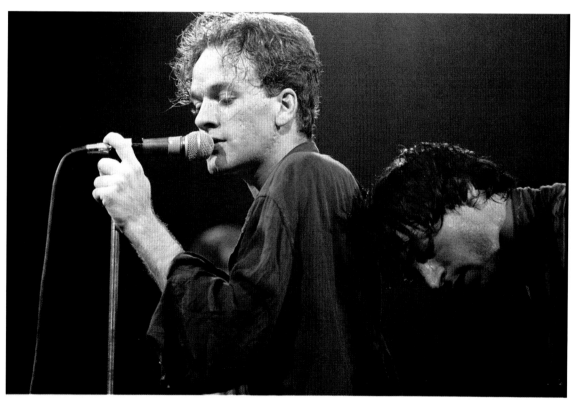

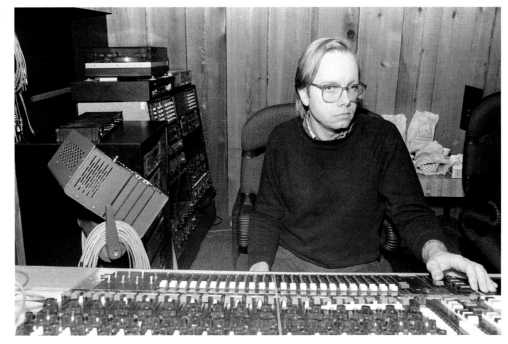

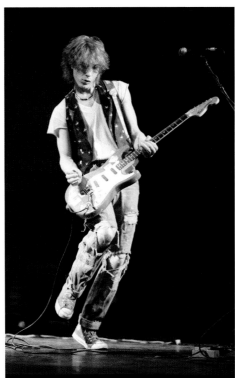

Clockwise from top: Producer and engineer Steve Fjelstad in the Twin/Tone studio, 1984; Dave Foley, 1985; Steve Brantseg of Figures at First Avenue, March 8, 1984

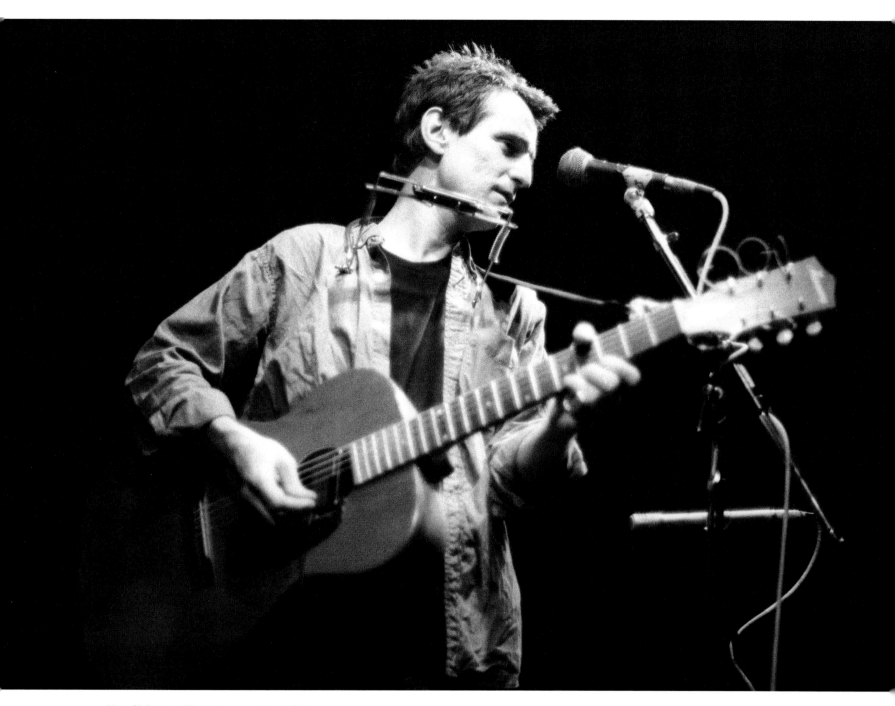

Alex Chilton at First Avenue, circa 1986

The 'Mats

Like pretty much anyone involved in the Twin Cities music scene of the 1980s, Dan developed a relationship with the notoriously sloppy, infamous Minneapolis punk band the Replacements. Dan photographed the band several times throughout their career on stage, but his most recognizable images of the Replacements adorned the covers to the group's 1984 record, *Let It Be,* and 1987's *Pleased to Meet Me.*

The original four-piece band comprised singer/songwriter Paul Westerberg, drummer Chris Mars, and brothers Bob and Tommy Stinson, on guitar and bass respectively. A bit of the allure of the Replacements in the early years was their unpredictability and their penchant for chaos and disorder during their live shows. Though it was like herding cats, Dan was able to harness the band's rambunctiousness in several photo sessions during their initial twelve-year run.

"I was never the hugest fan, but I knew about the Replacements before I started working with them," Dan recalls. "They were famous for the drunken shows. I think I saw three of those before I met them, and I left one of the shows. I remember thinking this was kind of pointless. It was them up on stage just goofing around. It seemed like they all four were playing different songs at one time. You can look back now and say that was really cutting edge and edgy, some sort of brilliant punk statement going on. But at the time, it just seemed like, 'What the fuck are they doing?'"

The Replacements performing at 7th Street Entry, 1984

Gaining some of his greatest exposure in working with the band, Dan landed a feature photo with the 'Mats in *Creem* magazine in 1984. The photo shows the band in the basement of First Avenue's adjacent smaller room, the 7th Street Entry, backed into the graffiti-laden corner.

"Bob had this thing—first time I saw him do it was in the Entry—whenever he walked into a room. I walked down there and saw him hock up this huge loogie and spit it straight up so it stuck to the ceiling. Then he walked away. The loogie would stay up there for a while, but at some point it would randomly come back down. I saw him do that at least a half a dozen times. Whenever I saw him in a room I always looked up to the ceiling before finding a place to stand. He was a character."

Eventually Dan got the gig from Dave Ayers of Twin/Tone Records to make a photograph for the band's next record, *Let It Be*. The idea was to reflect the perception of the band's dangerous sensibilities. However, what would become the final, iconic album cover wasn't Dan's first stab at the cover shot.

The band was set to perform at the University of Minnesota's Coffman Memorial Union. To get the band members to cooperate, Dan told them there were drugs waiting for them at the top floor of the building.

"We had started in the basement, and I just told them we have to go to the top floor in an office I had access to, where I told them we could do lines [of coke]."

Instead, Dan stopped the elevator at one of the middle floors to capture the shot.

"That was a chaotic situation. Including my friend Ivar Nelson, there were six of us in there. When we got in, Ivar opened up the lighting, and we stopped the elevator. The bell is ringing, and they are goofing around. I think I got a dozen frames off before we decided we couldn't do this anymore. Somebody somewhere is wondering what is going on. We went up a floor, and Ivar and I basically left them in the elevator.

"For all my planning, I think I got one good frame. I got my one picture and gave it to Dave Ayers. I thought

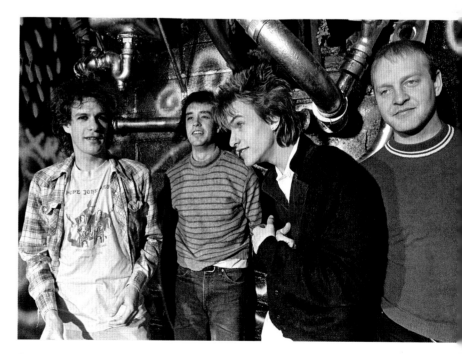

The Replacements in the basement of 7th Street Entry, 1984

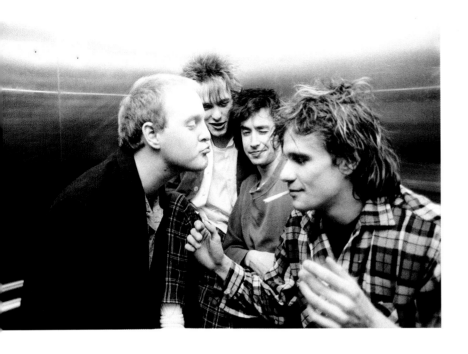

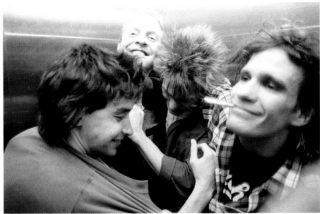

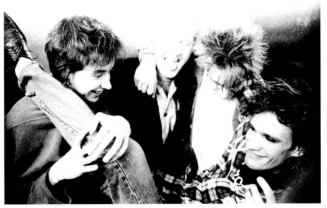

I had a really special picture. I looked at it and thought I had everything I wanted in the picture, the dynamic. But then Ayers said we had to do it again. I don't know that he didn't like it, but I don't think it was what he was looking for."

Later, the folks at Coffman Union wanted to buy a couple prints of the photo and asked Dan to airbrush out the cigarette because, Dan explains, "You know, you aren't supposed to smoke in the elevator." But cooler heads prevailed, and the image hangs near the elevator doors, as is.

Ultimately, Twin/Tone was won over by the now famous rooftop photo at the Stinsons' mother's house in south Minneapolis, where the band was practicing.

"I always loved shooting bands practicing, because they're playing and there's nobody else there. It was the

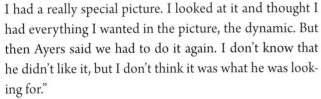

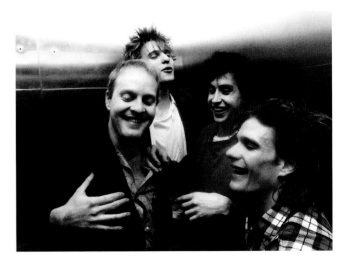

The Replacements in the elevator of
Coffman Memorial Union, February 1985

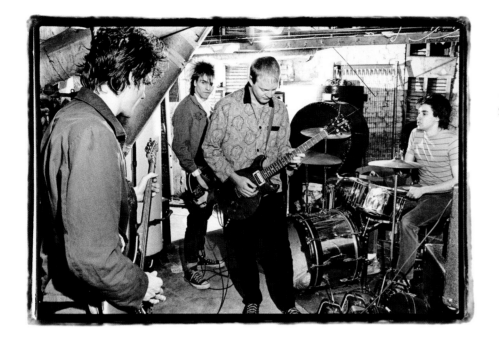

Practicing in the basement of the Stinsons' mother's house, March 1984

classic Minneapolis basement with a gravity furnace, wrapped in asbestos tape, cramped and dirty and dusty, cast-iron laundry sink. If there's such thing as a garage band, they were a basement band. That's really what they were.

"The rooftop was my idea of putting people in confined spaces to limit where they can go. I bet we were up

there for less than a half hour. They were always kind of squirrely. When I'm shooting, I'm trying to be serious. Usually when I get people together, I'm being serious, like, 'Let's just do this.' You know, 'Everybody focus!'

"When the Replacements were put in that situation, they would do the complete opposite."

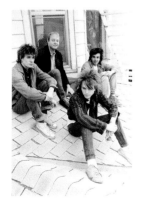 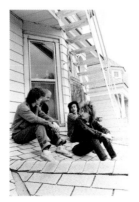 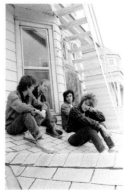 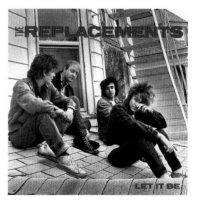

Images from the cover-photo shoot for *Let It Be*, on the roof of the Stinsons' house

43

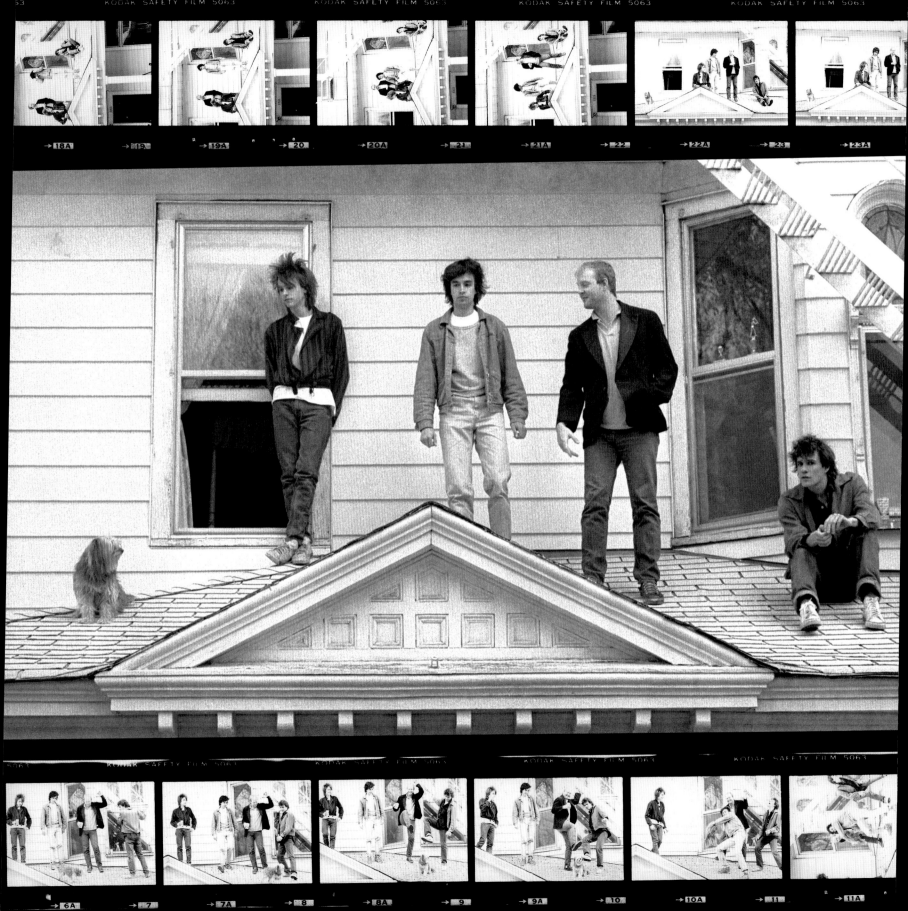

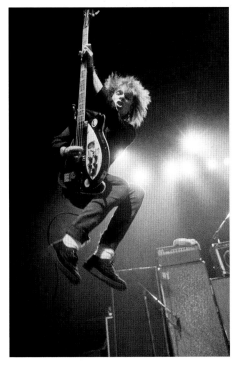

Far left: Tommy Stinson in action on the First Avenue stage, 1984

Left: Paul Westerberg takes a break with some choice beverages, 1983

Below: Tommy and Bob Stinson, August 1983

Opposite: More outtakes from the *Let It Be* photo shoot

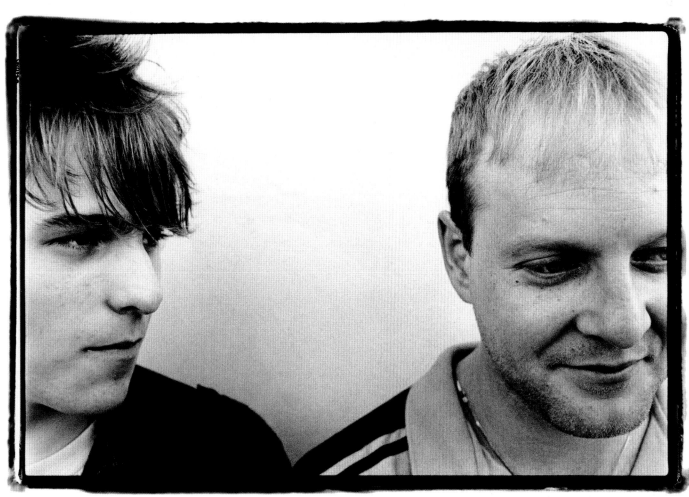

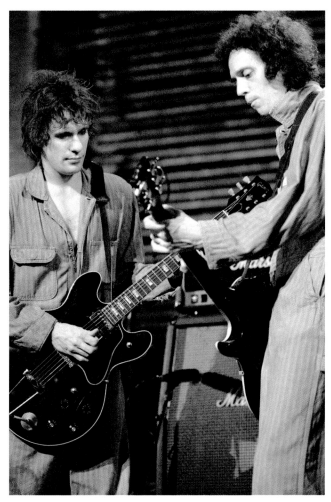

Above left: Bob and Paul, 1984

Above right: Paul with Slim Dunlap, who replaced Bob Stinson in the band in 1986, seen here in 1987

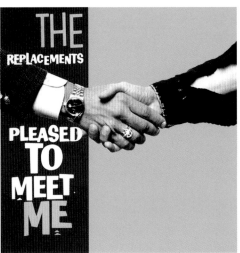

Dan describes the cover photo for *Pleased to Meet Me*: "Paul's hand is the scruffy hand. The other hand is my first wife's brother, my brother-in-law. He went out and had a fifty-dollar manicure. He had this sharp suit. So that was why I thought he'd be perfect for this."

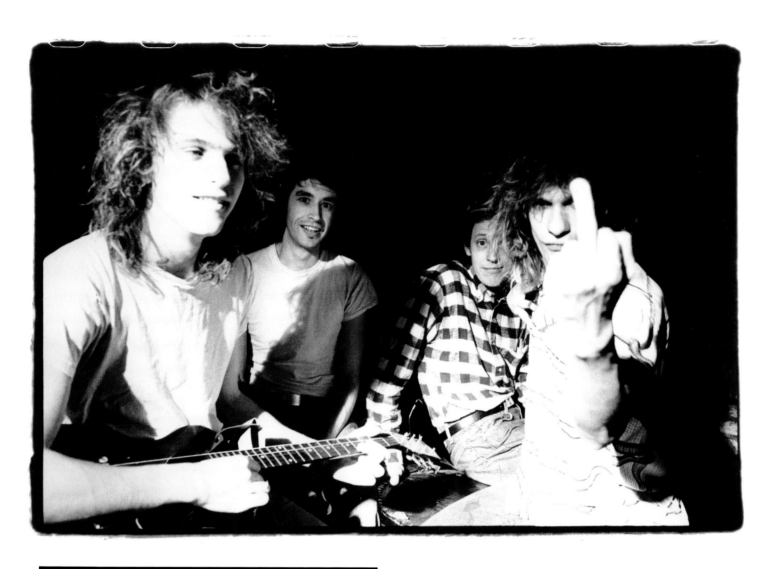

Above: Tommy Stinson, Chris Mars, Bob "Slim" Dunlap, and Paul Westerberg

Left: Tommy gives the photographer a knowing look from the First Avenue stage

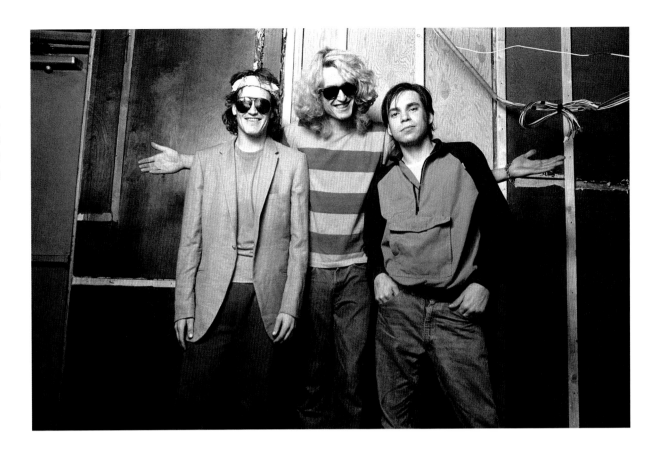

Cris Kirkwood,
Curt Kirkwood,
and Derrick
Bostrom of Meat
Puppets, 1985

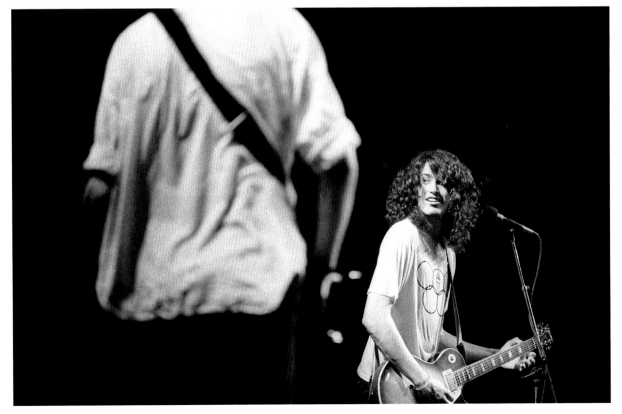

Meat Puppets at
First Avenue, 1986

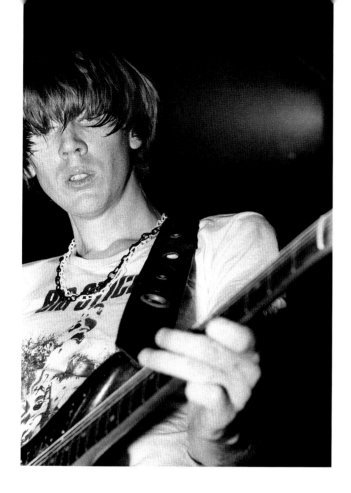

Kim Gordon *(below)* and Thurston Moore *(left)*
of Sonic Youth at First Avenue, July 15, 1986

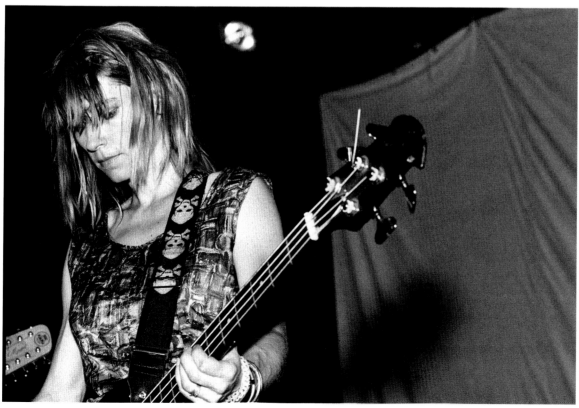

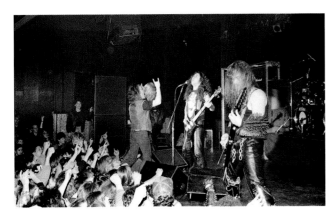

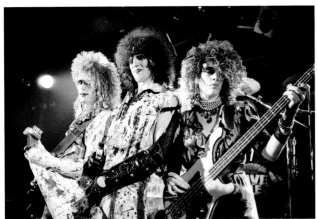

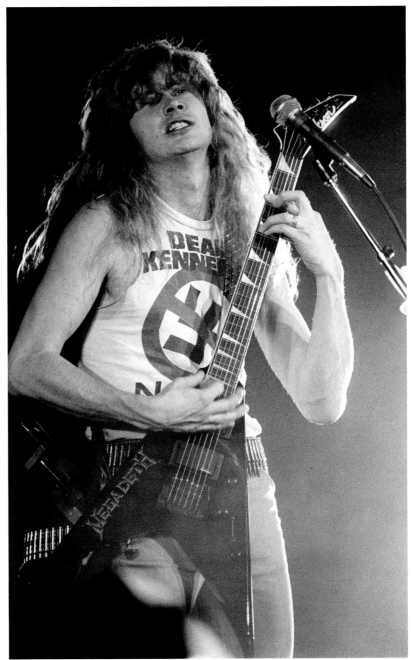

Above, top to bottom: Slayer at First Avenue, November 16, 1986; Slave Raider, March 1986; Stryper at St. Paul Civic Center, April 5, 1987

Right/Above: Dave Mustaine of Megadeth at First Avenue, August 3, 1986

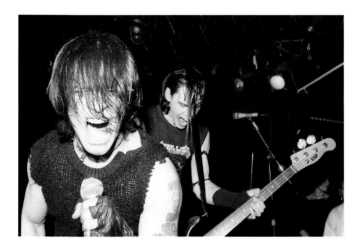

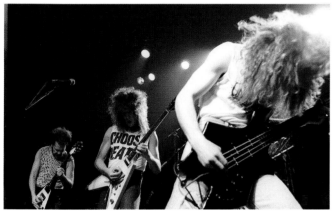

Clockwise from top left: Samhain at 7th Street Entry, April 11, 1986; David Lee Roth at the Met Center, September 1986; Powermad at First Avenue, 1986

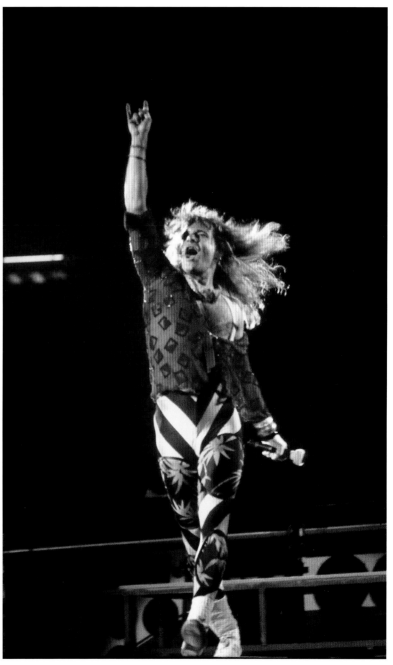

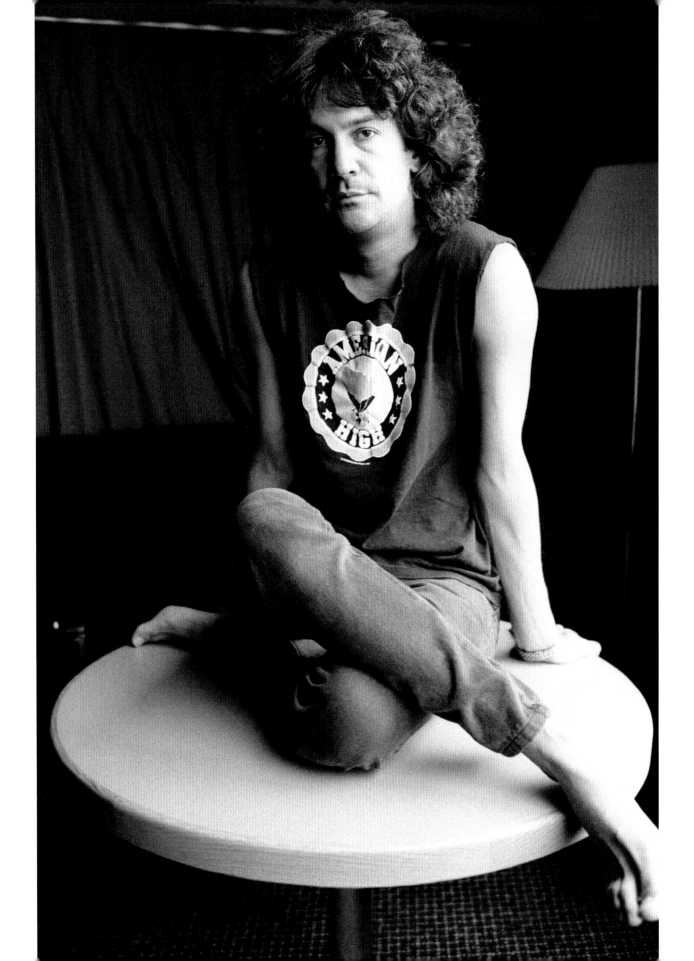

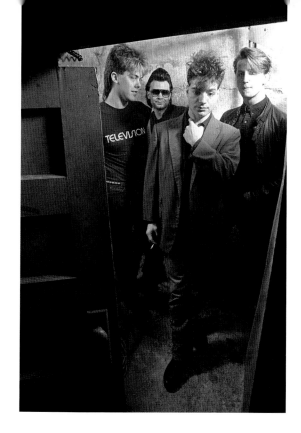

Left: The Phones, 1986

Below: The Clams, 1986

Opposite: Billy Squier, 1986

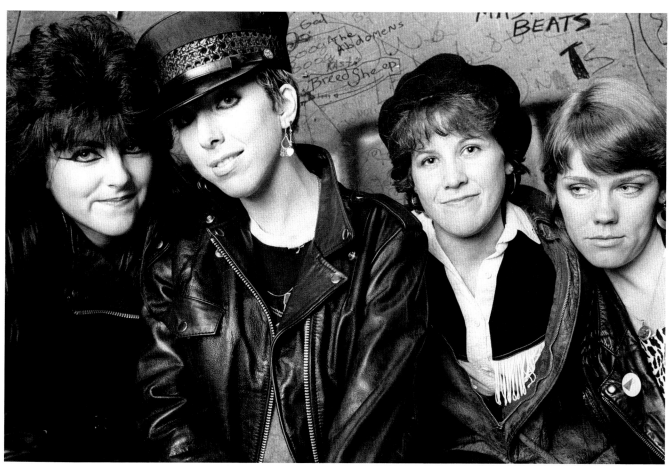

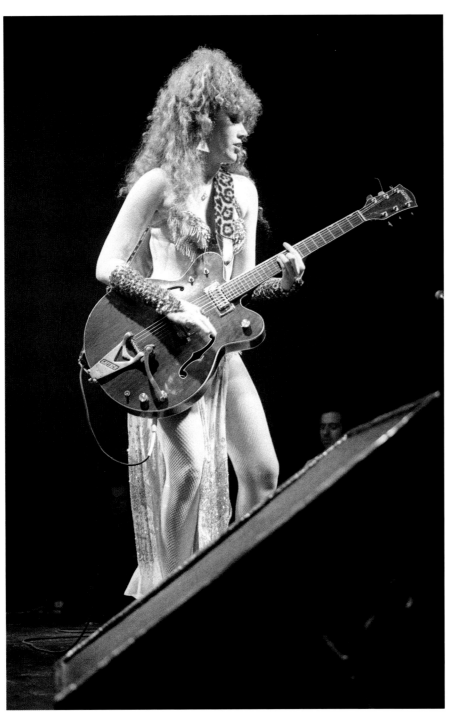

Poison Ivy of the Cramps at First Avenue, July 22, 1986

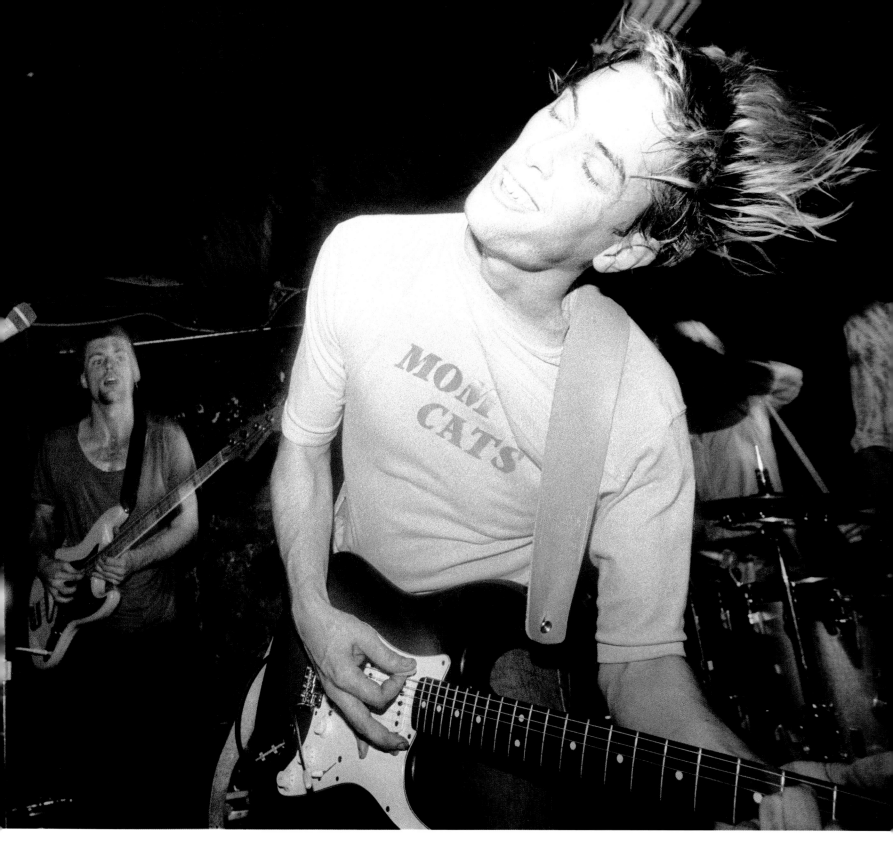

Butthole Surfers at 7th Street Entry, circa 1985

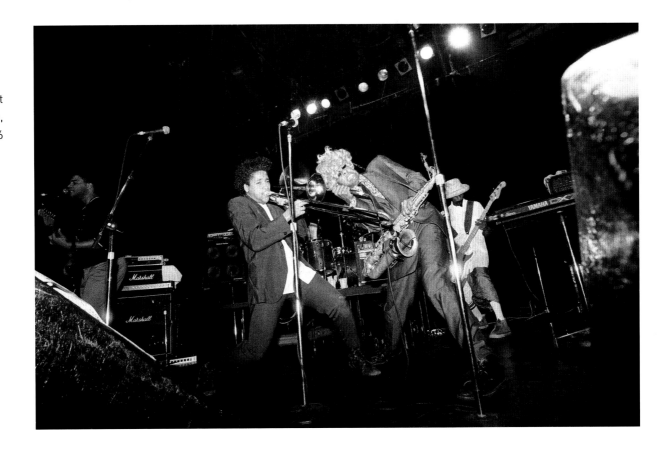

Fishbone at
First Avenue,
November 1986

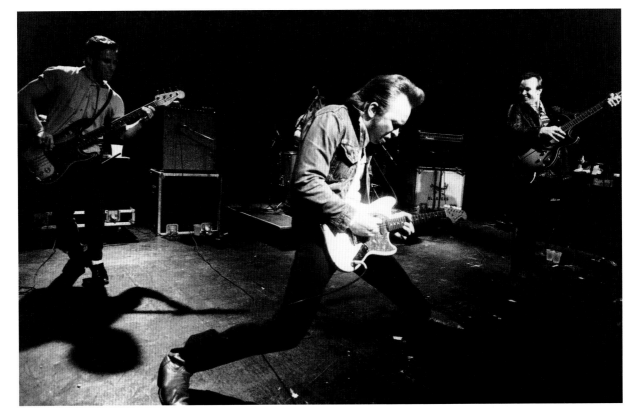

The Blasters at
First Avenue,
circa 1985

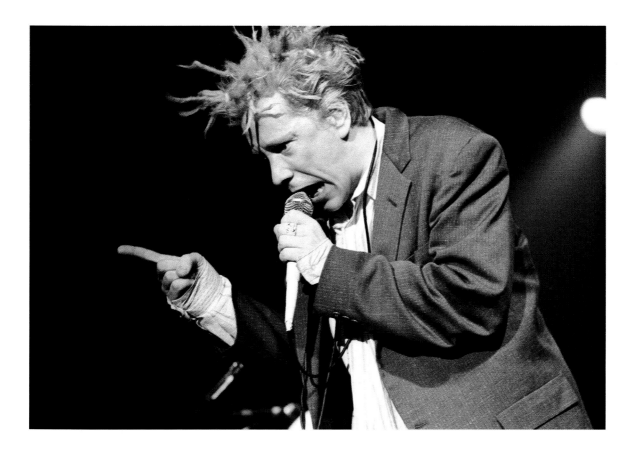

Johnny Lydon of Public Image Ltd., at First Avenue, June 22, 1986

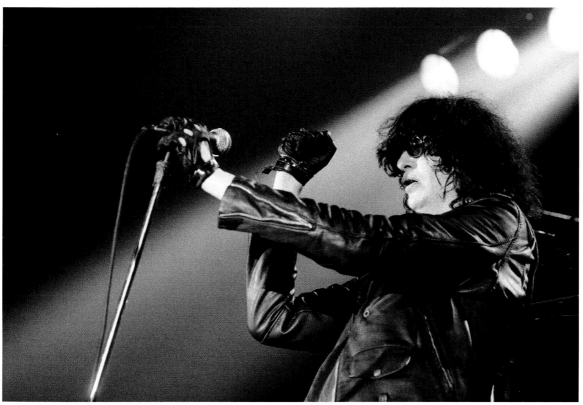

Joey Ramone of the Ramones at First Avenue, July 27, 1986

B. B. King at Orchestra Hall
in Minneapolis, May 23, 1985

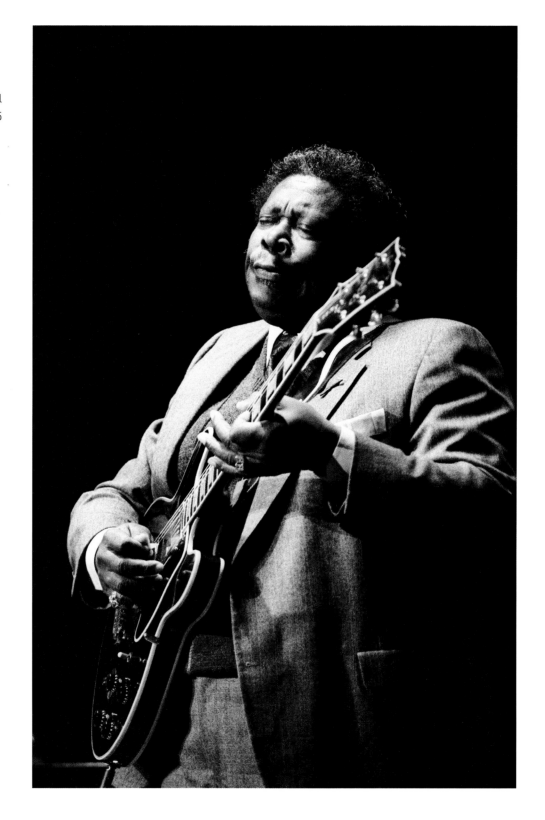

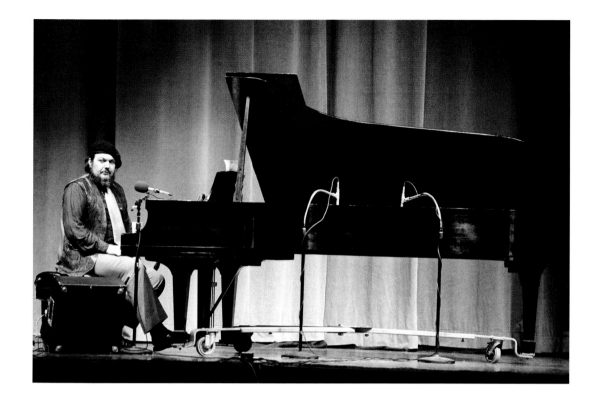

Dr. John

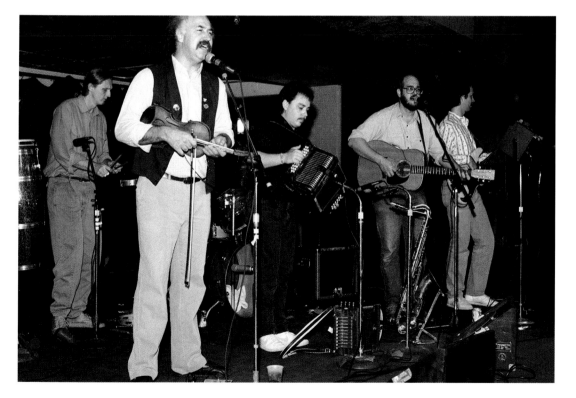

BeauSoleil at Medina Ballroom,
November 1987

"I saw BeauSoleil at Medina
Ballroom, and they
completely changed my
musical experience. I'm a
huge Cajun and zydeco fan,
and it was from that one job."

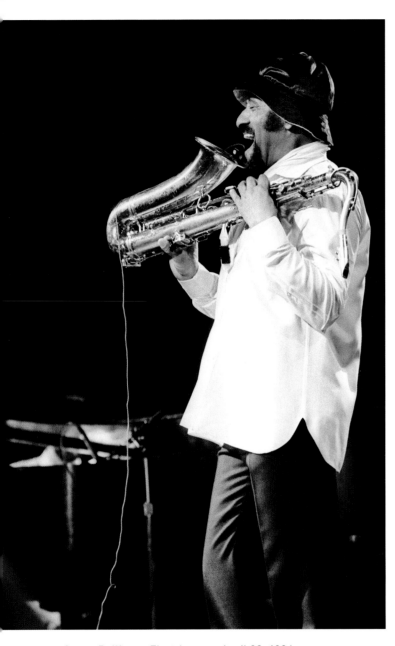

Sonny Rollins at First Avenue, April 23, 1984

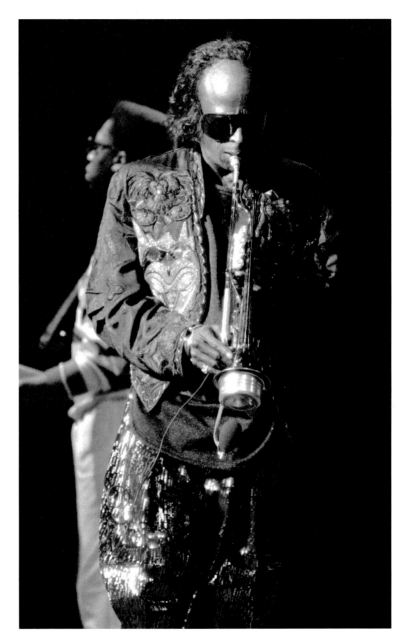

Miles Davis at the Orpheum Theatre in Minneapolis, March 25, 1987

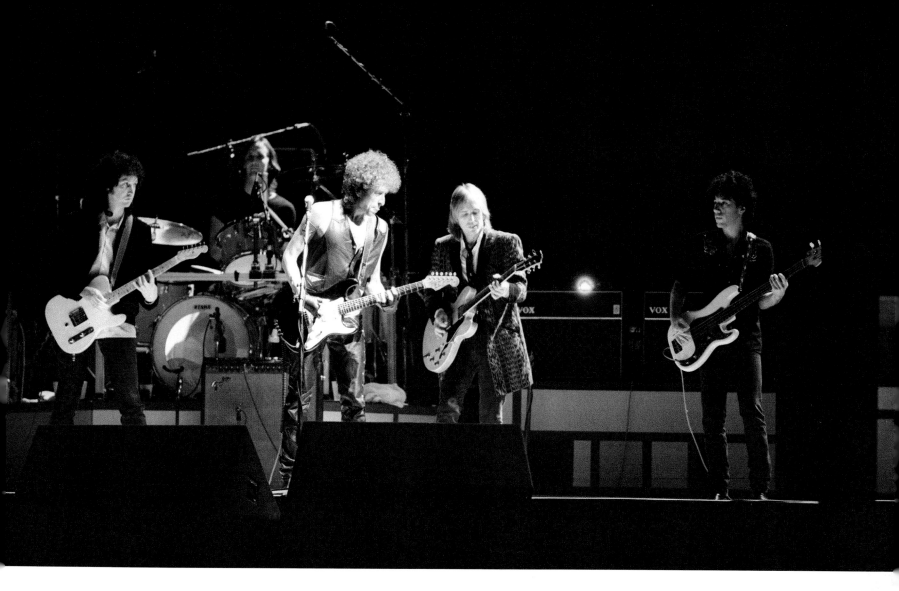

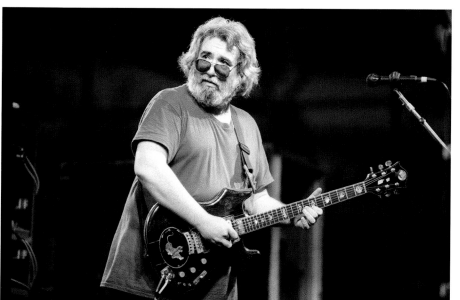

Above: Bob Dylan and Tom Petty at the Hubert H. Humphrey Metrodome, June 26, 1986

Left: Jerry Garcia of the Grateful Dead at the Metrodome, June 26, 1986

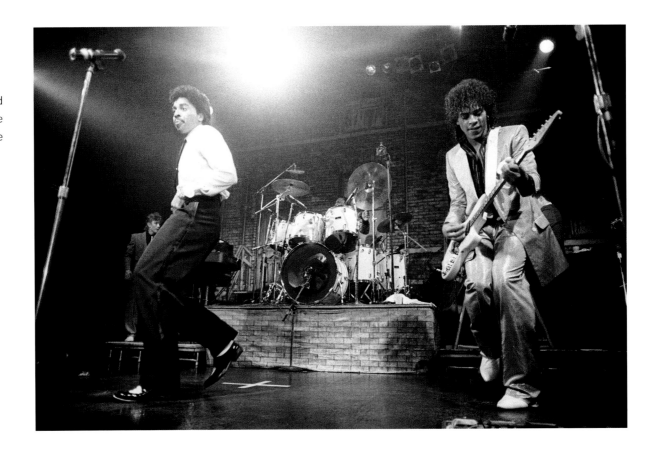

Morris Day and
Jesse Johnson of the
Time at First Avenue

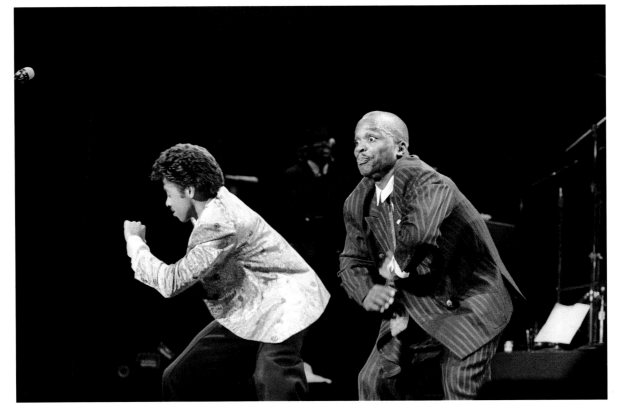

Morris Day and
Jerome Benton of
the Time at First
Avenue, 1987

62

Right: Alexander O'Neal, 1986

Below: Jellybean Johnson, drummer
for the Time and Flyte Tyme

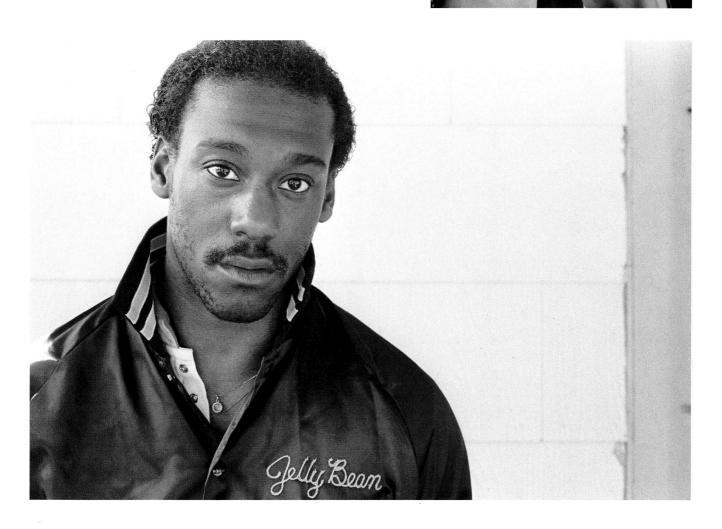

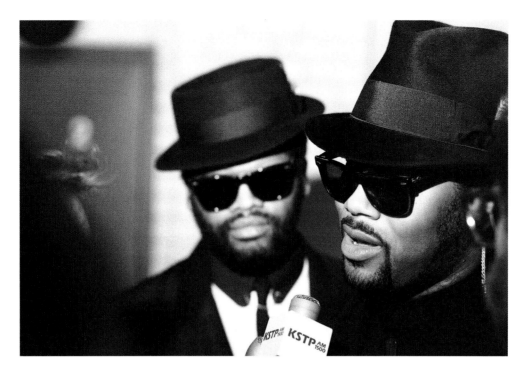

Left: Jimmy Jam, with James "Popeye" Greer

Below: Jimmy Jam and Terry Lewis, 1987

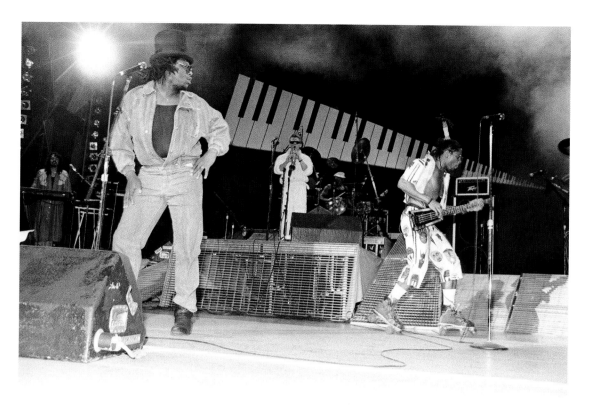

Ipso Facto at the MMA Awards, 1986

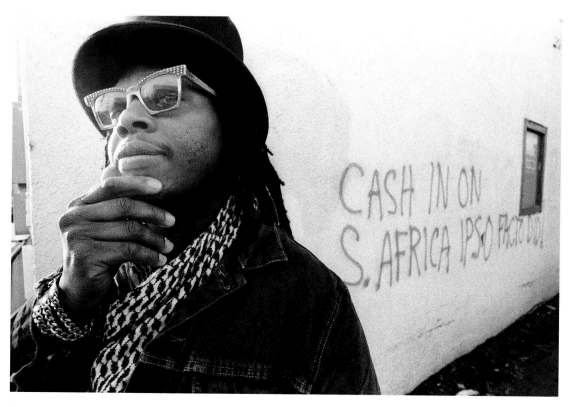

Wain McFarlane of Ipso Facto, 1990

Hüsker Dü

Digging through Dan Corrigan's massive archive of photos taken over the course of thirty-five years, one can see his passion for particular artists come through as he captures their personalities and the place in time when their careers began to take flight.

Along with many other notable Twin Cities bands, Hüsker Dü got its start around the same time that Dan was emerging as a photographer. Not only did this vibrant

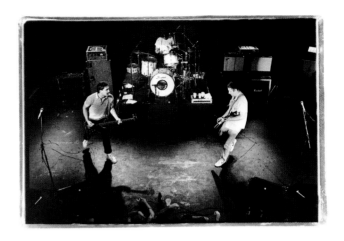

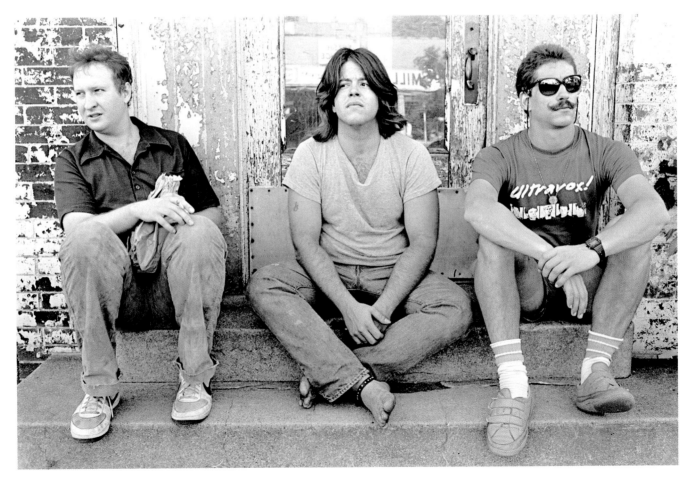

Above: Bob Mould, Grant Hart, and Greg Norton of Hüsker Dü, 1984

Above top: Hüsker Dü at First Avenue

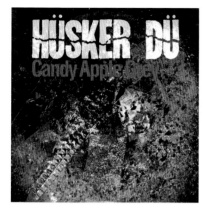

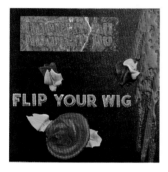
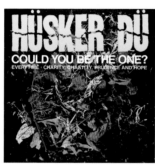

Top row, left to right: Hüsker Dü's *Candy Apple Grey*, photo by Daniel Corrigan, 1986; photo from *Candy Apple Grey* shoot; Hüsker Dü's *Warehouse: Songs and Stories*, photo by Daniel Corrigan, 1987; Polaroid from *Warehouse* shoot, 1987

Bottom row, left to right: Hüsker Dü's *Flip Your Wig*, 1985; Hüsker Dü's *Could You Be the One?*, twelve-inch single, 1987, photos by Daniel Corrigan

period allow Dan to hone his own photographic skills, but his involvement with bands like Hüsker Dü helped to broaden their exposure. The collaboration between Dan Corrigan and the trio of Bob Mould (guitarist, singer, songwriter), Grant Hart (drummer, singer, songwriter), and Greg Norton (bassist) included myriad promo shoots, album cover designs, and live performances.

Among the Hüsker Dü album covers that Dan was instrumental in creating were *Flip Your Wig* (1985), *Candy Apple Grey* (1986), and *Warehouse: Songs and Stories* (1987).

"Shooting *Candy Apple Grey*, that was Grant's idea," Dan explained. "Making that picture for the cover was very complicated. It was a glass case with six different shelves on it stacked four inches apart. There was broken colored glass,

glitter, and other stuff on each layer. Then each layer was lit differently. In the dark room, it was like light painting. You open up the shutter of the camera, which stays open, and take different light sources and apply it to specific areas in measured doses, building up the layers. We had a script for the shot that kept evolving, and we shot a Polaroid to see how it was evolving. I would say, like, 'thirty seconds for light one on level two'—very complicated instructions for each light and how long. We spent about a sixteen-hour day at the Twin/Tone studios on that one picture.

"The cover of *Warehouse* was the same way. It was an experiment, so we would take Polaroids to see what it might look like."

In addition to the photo shoots, Dan had a personal affinity for the members of the band. "Bob is my favorite

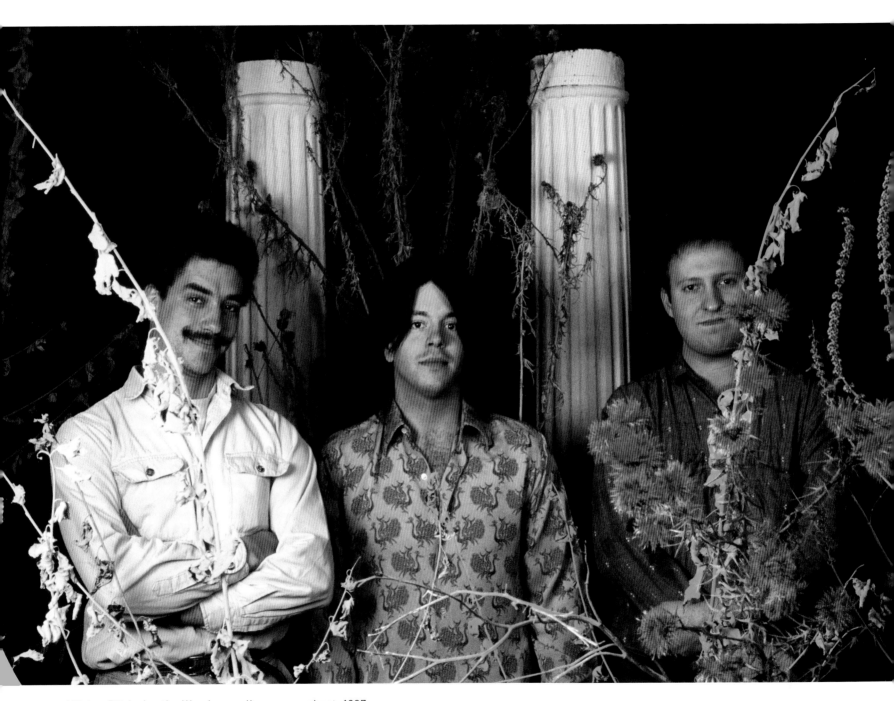

Hüsker Dü during the *Warehouse* album cover shoot, 1987

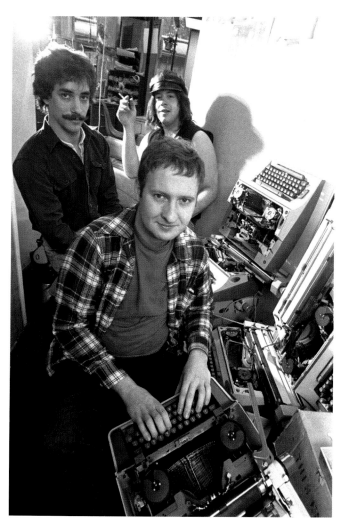

Clockwise from above left: Hüsker Dü in the offices of the *Minnesota Daily*, 1984; Hüsker Dü, 1984; Bob Mould

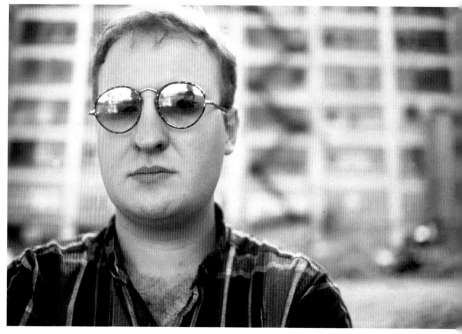

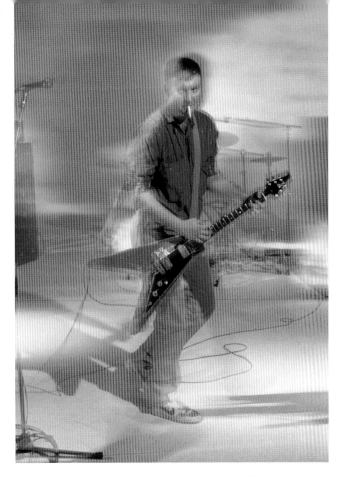

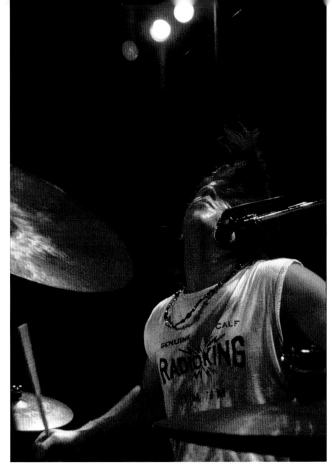

Clockwise from top left: Bob Mould on guitar; Grant Hart on drums; Greg Norton on bass

musician that I worked with. The work that I did with those guys was cool. And Grant's a really creative guy. Working with Grant in that aspect was pretty interesting. Grant was primarily behind the art. Bob would have had to sign off on it. It wasn't just Grant making all the decisions.

"When they broke up, I was probably the saddest fan. They had just signed [to Warner Bros.], and so there was going to be some money coming in, and I was their photographer. I knew their sensibilities enough. If they needed somebody, it was just logical for me to work with them."

Dan continued to photograph Bob, Grant, and Greg with their bands following the breakup of Hüsker Dü, and his catalog of Bob Mould photos is perhaps as extensive as any artist he has photographed.

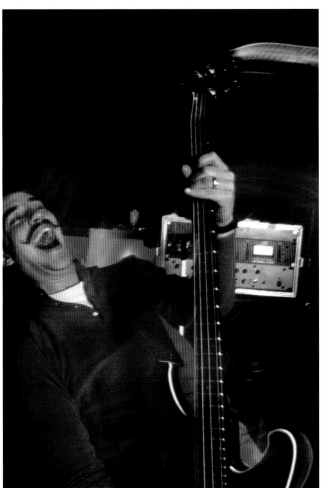

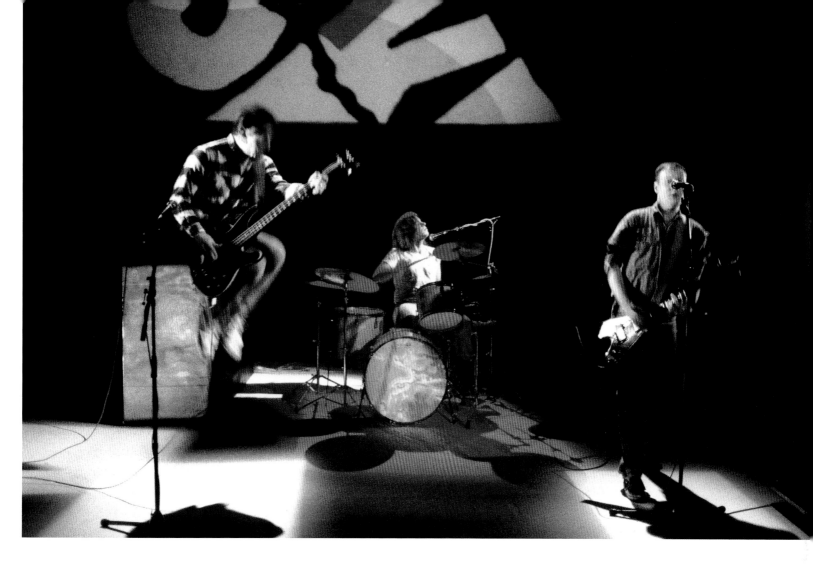

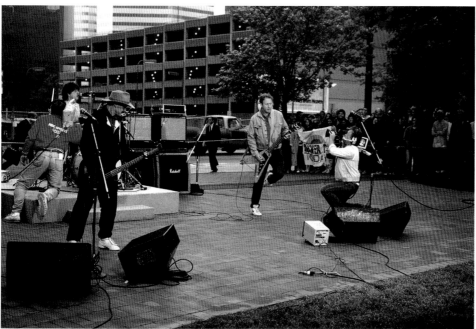

Above: Hüsker Dü during video shoot for "Could You Be the One?," 1987

Left: Hüsker Dü during a *Today Show* appearance in Minneapolis, May 20, 1987

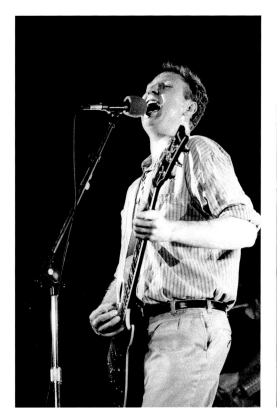
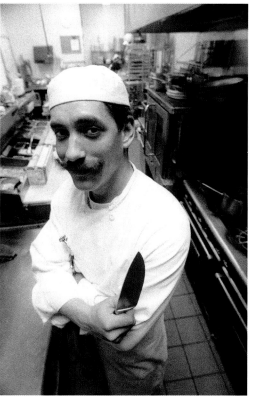
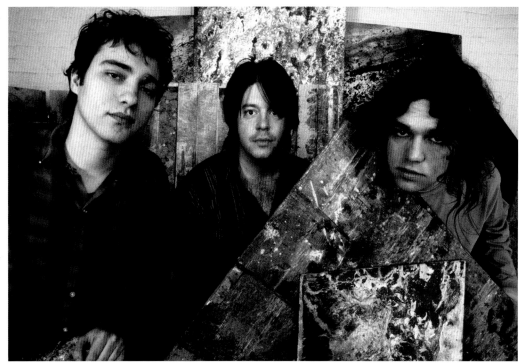

Clockwise from top left: Bob Mould, 1989; Greg Norton, 1993; Grant Hart and Nova Mob, circa 1990

Otto's Chemical Lounge, 1986

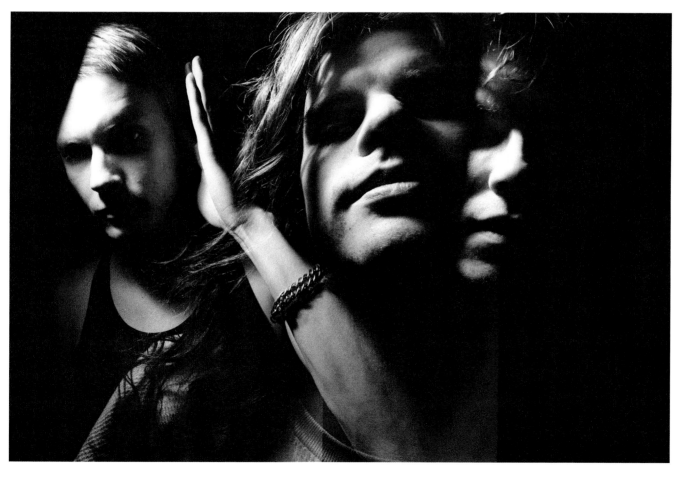

The Blue Hippos, 1987

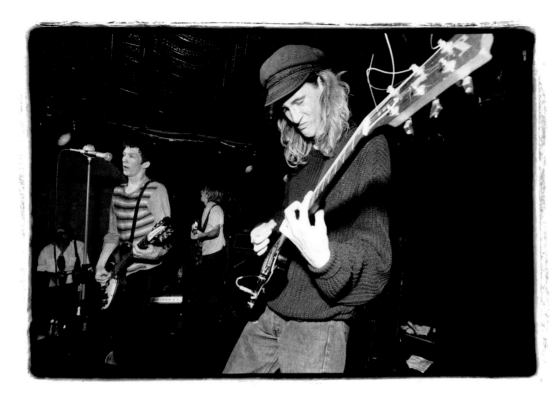

The Magnolias at 7th Street Entry, August 1986

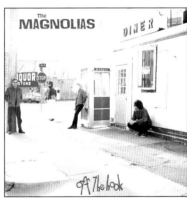

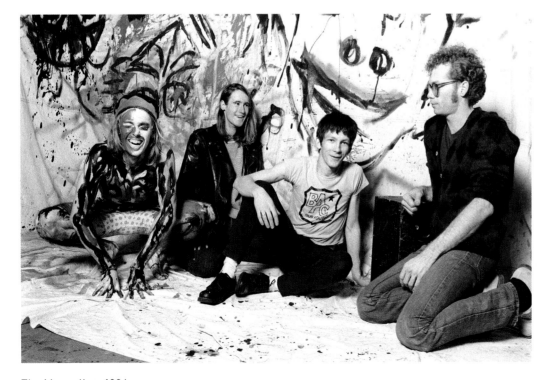

The Magnolias, 1986

From top to bottom: Back cover of the Magnolias' *For Rent*, 1988; the Magnolias' *Dime Store Dream*, 1989; the Magnolias' *Off the Hook*, 1992, photos by Daniel Corrigan

Run Westy Run, 1987

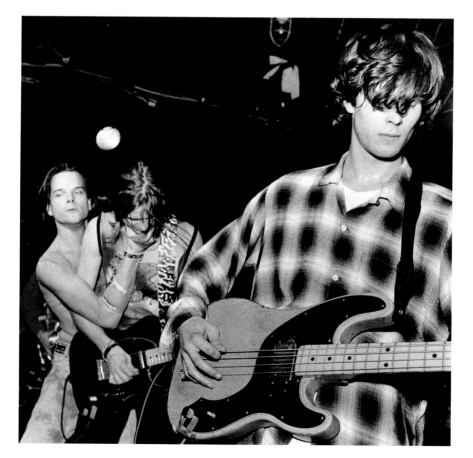

Run Westy Run at 7th Street Entry,
October 1986

"I was a big fan of Run Westy Run,
which was pretty complicated.
They had their crazy aspects, but
there was some substance."

Trip Shakespeare, 1987

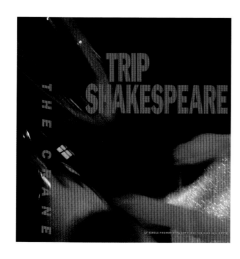

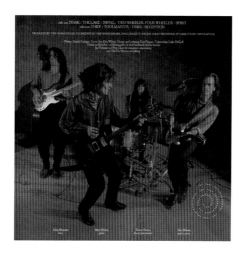

Far left: Trip Shakespeare's *The Crane* twelve-inch single, photo by Daniel Corrigan, 1990

Left: Back cover of Trip Shakespeare's *Are You Shakespearienced?*, photo by Daniel Corrigan, 1989

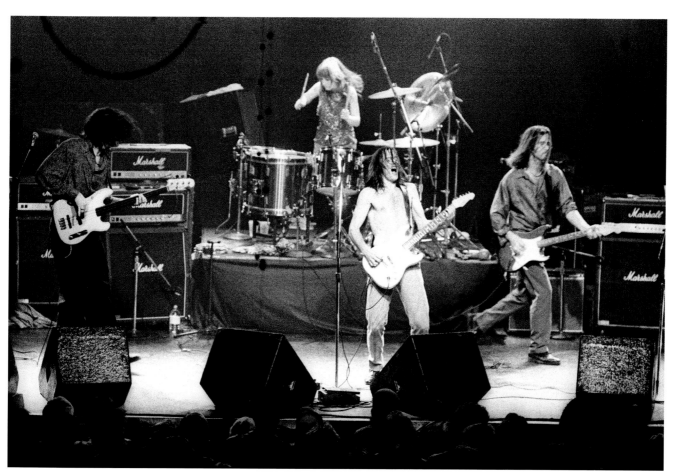

Trip Shakespeare at First Avenue, January 1992

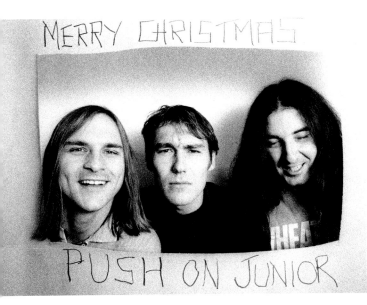

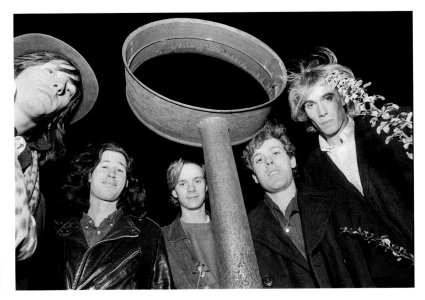

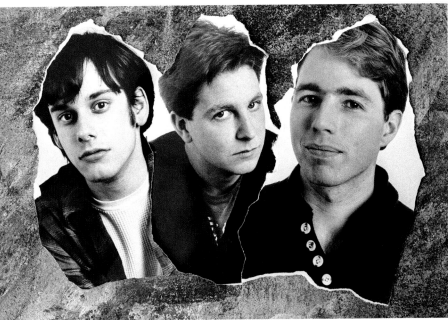

Clockwise from top left: Push On Junior, 1994; Widgets, 1986; Laughing Stock, 1985; Playhouse, 1987

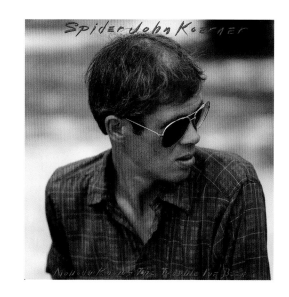

Right: Spider John Koerner's *Nobody Knows the Trouble I've Been*, photo by Daniel Corrigan, 1986

Below: Spider John Koerner, 1988

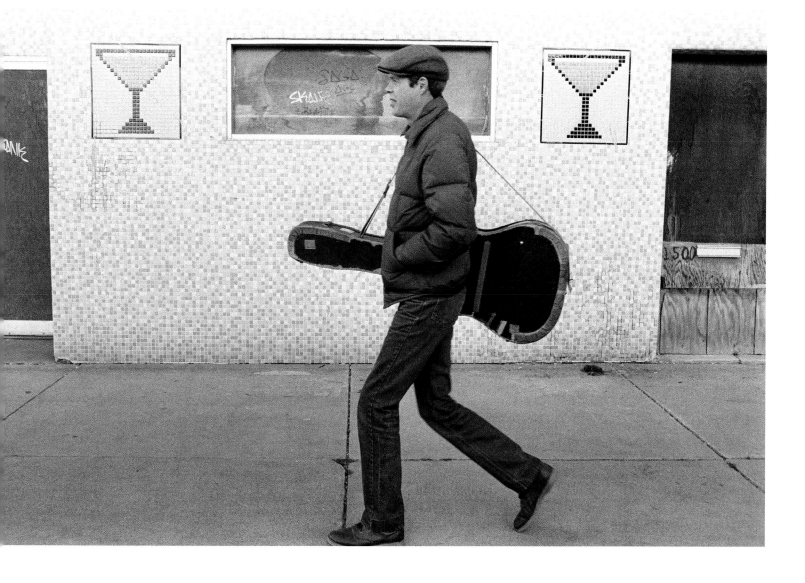

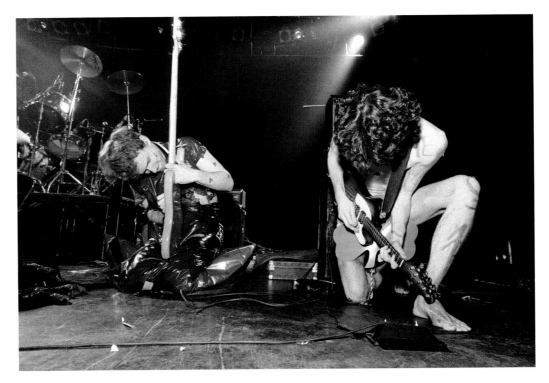

Paddy and the Fetal Pigs, at First Avenue's Club Degenerate, March 17, 1987

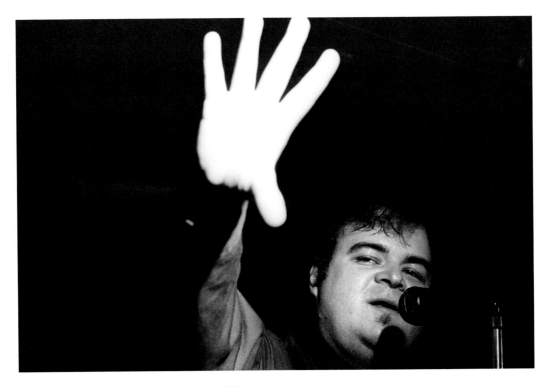

David Thomas of Pere Ubu, December 1988

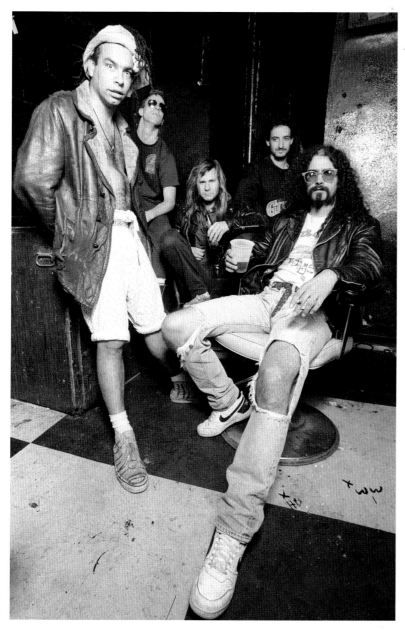

Faith No More, 1987

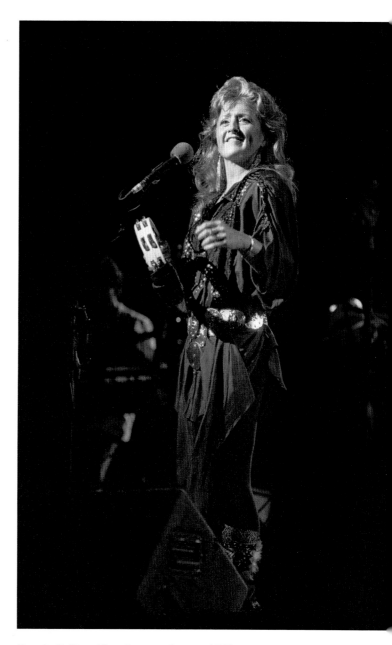

Bonnie Raitt at First Avenue, August 1987

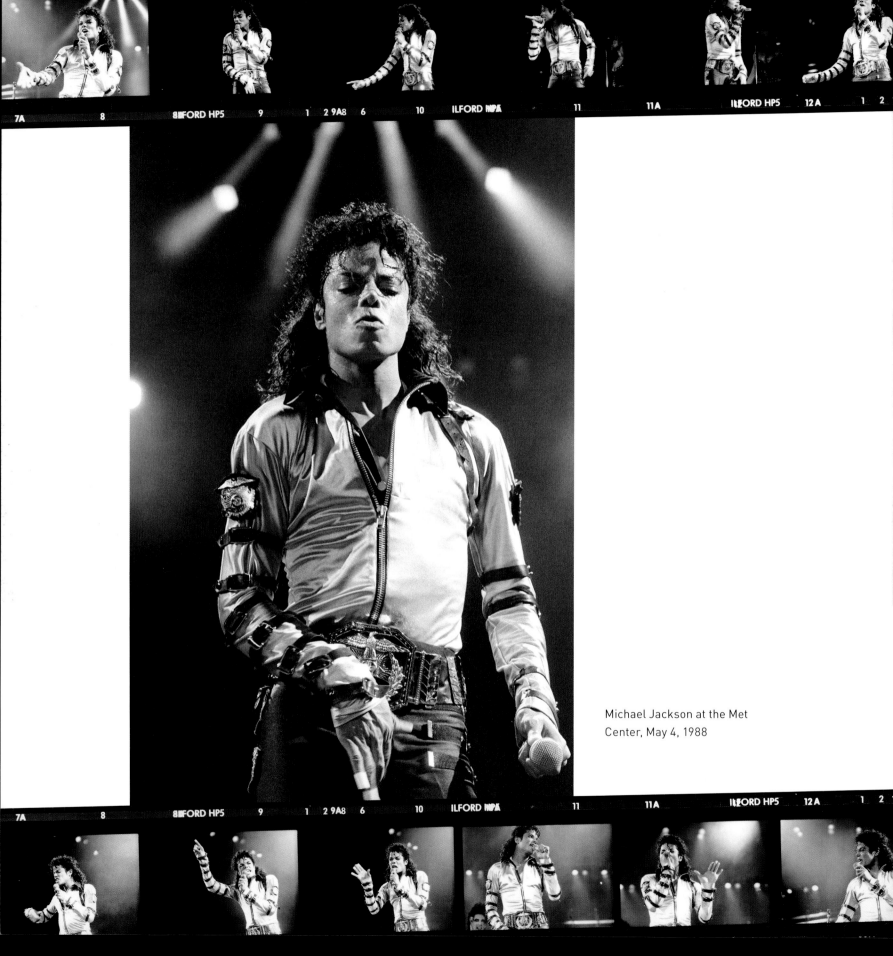

Michael Jackson at the Met
Center, May 4, 1988

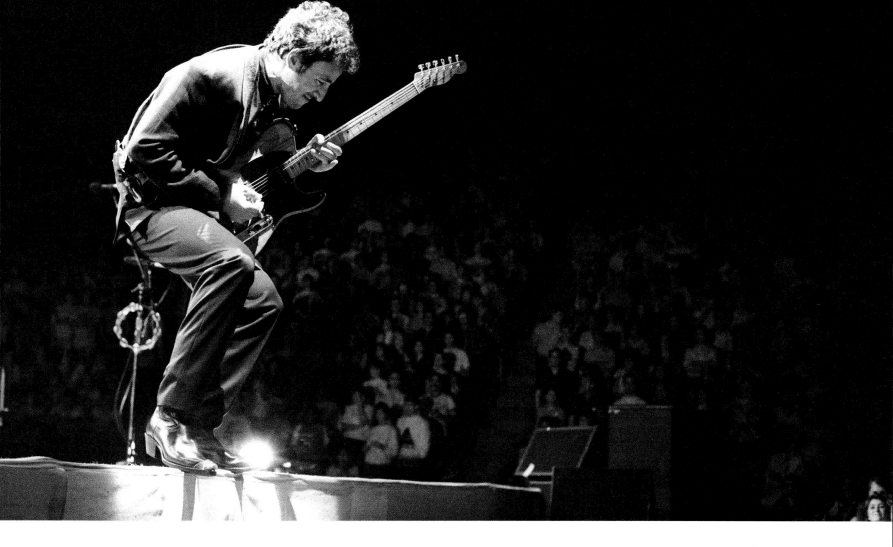

Above: Bruce Springsteen at
the Met Center, May 10, 1988

Left: Fans getting ready for the
Springsteen concert

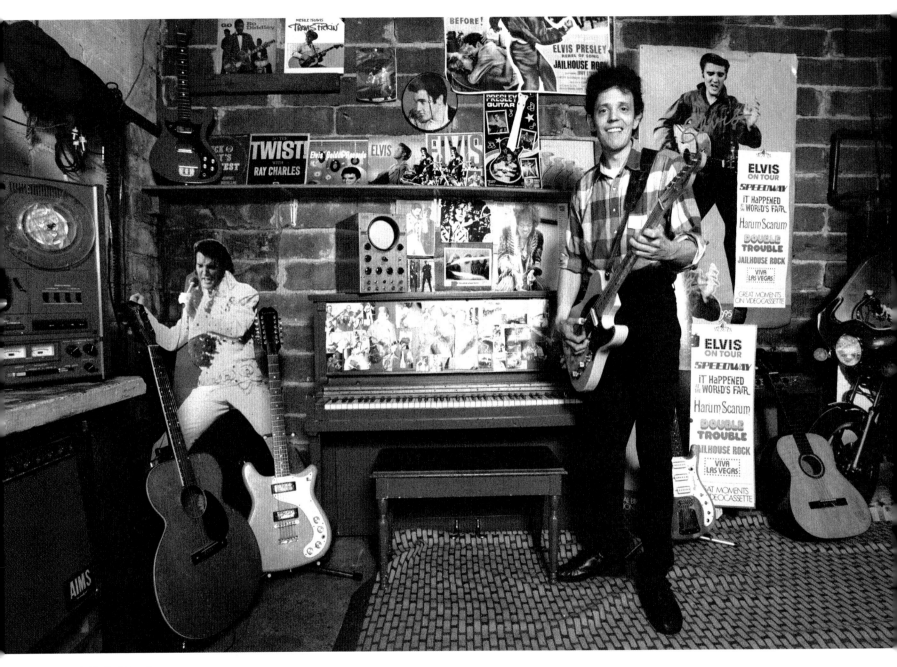

Bob "Slim" Dunlap

"First time I met Curtiss A, I got an assignment to do some pictures with him for a story. He was friends with my old roommate Tom McKean, so I knew about him, mainly that he was a character. So, the first words out of my mouth when I met Curt were, 'Are you really as big of an asshole as everyone says you are?' He just kind of laughed and said, 'Yeah!' We've been friends ever since."

Curtiss A (Curt Almsted) in his basement (*top*) and in the basement of the Uptown Bar (*above*), 1989

Babes in Toyland

At the dawn of the 1990s, Minneapolis had its own Nirvana in the female punk-rock trio Babes in Toyland. With singer/guitarist Kat Bjelland, drummer Lori Barbero, and bassist Michelle Leon, Babes in Toyland energized the stage with raw and riotous aggression.

Formed in 1987, the trio was signed to the local Twin/Tone Records, and they enlisted Dan to create the cover image for the band's debut record, 1990's *Spanking Machine*. Dan had some ideas for what would become the band's iconic photo, perfectly capturing the subtle feminism and playfulness juxtaposed with the cold, hard edge embodied in the band's music.

Dan described the photo shoot: "We laid out on the floor all these dolls that they had collected, and with this scaffolding I had in my studio, I was able to shoot down on the band. I was probably six feet above them. I always liked the idea of limiting the space that people are in. It goes sideways and up and down. But also front and back. This was a way of compressing that space."

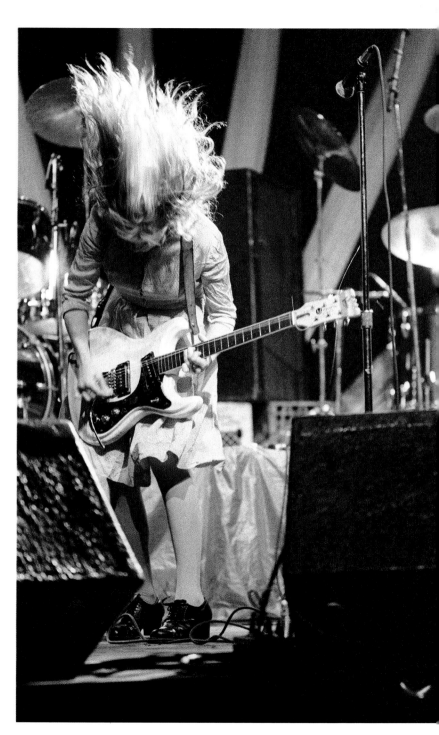

Michelle Leon, Lori Barbero, and Kat Bjelland of Babes in Toyland, 1988

Kat Bjelland of Babes in Toyland at First Avenue, 1990

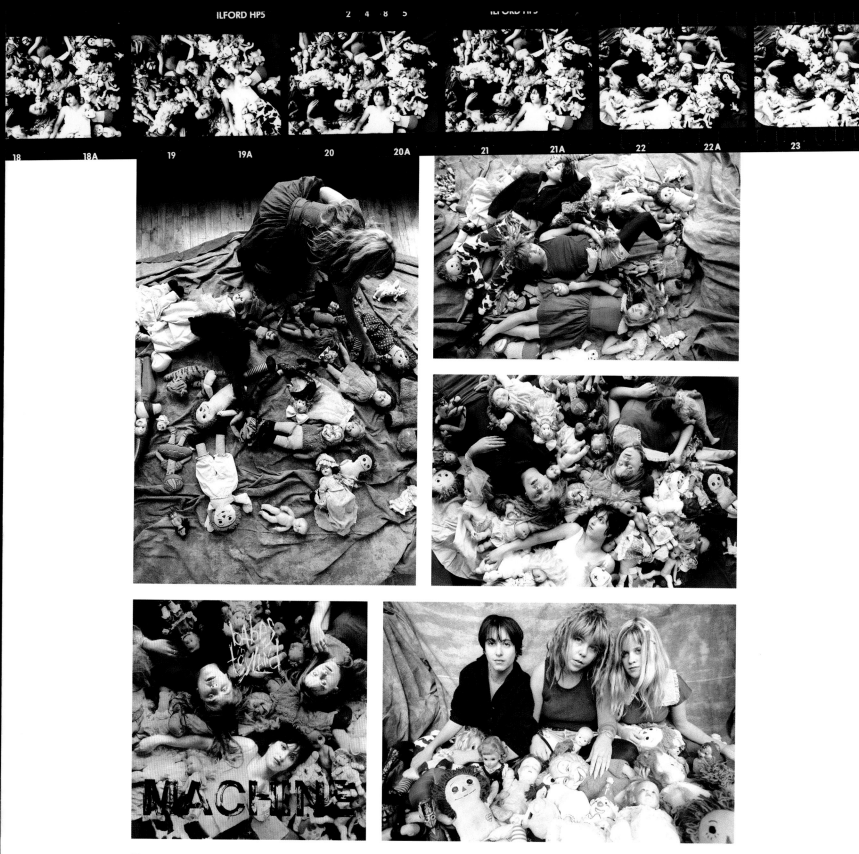

Photos from the cover shoot for Babes in Toyland's *Spanking Machine*, 1990

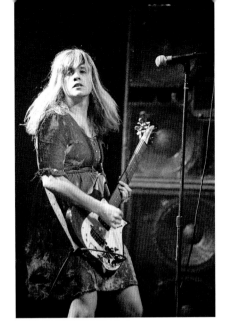 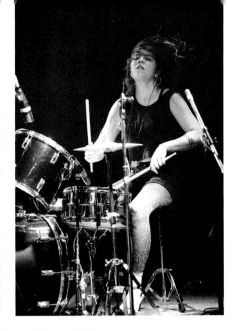

Above left to right: Kat Bjelland, October 1990; Michelle Leon, March 1991; Lori Barbero, March 1991

Below: Babes in Toyland behind the old Loring Bar in Loring Park, Minneapolis, July 1989

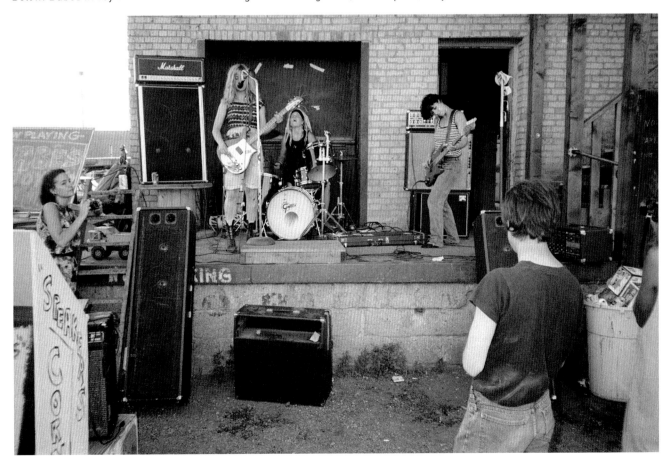

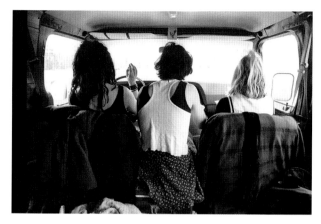

"I went on the road with Babes in Toyland for a Midwest tour after *Spanking Machine*. I got along very well with all three of them. Lori is such a mainstay. The moment I met her we became really good friends. I went to some super-fun parties at her house. I got to see Lifter Puller play in her basement."

On the road with Babes in Toyland, April 1990

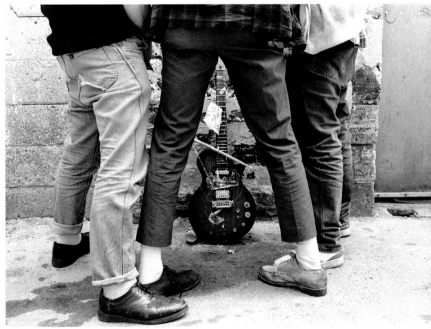

Clockwise from top left: Roy G Biv, 1988; Roy G Biv's eponymous album, 1989; Agitpop, 1989; Agitpop's *Stick It!*, 1989, photos by Daniel Corrigan

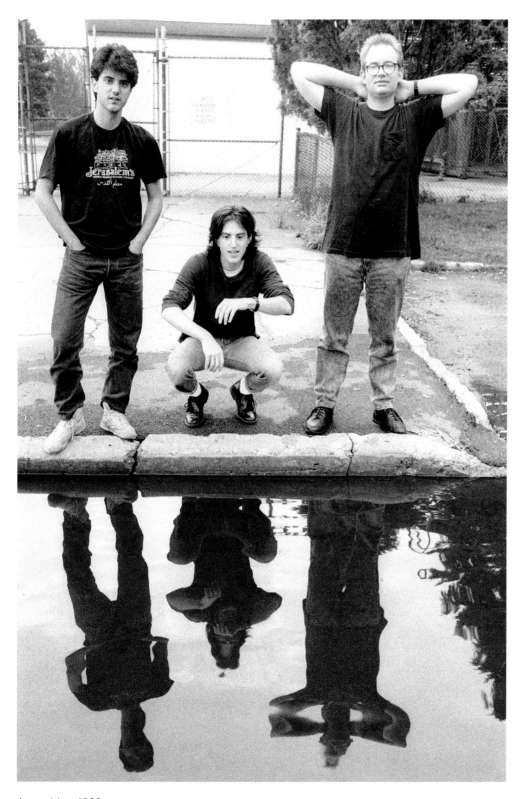

Arcwelder, 1989

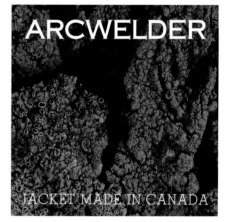

From top to bottom: Tiltawhirl's *This*, 1989 (Arcwelder was originally known as Tiltawhirl); Arcwelder's *Jacket Made in Canada*, 1991; Arcwelder's *Entropy*, 1996, photos by Daniel Corrigan

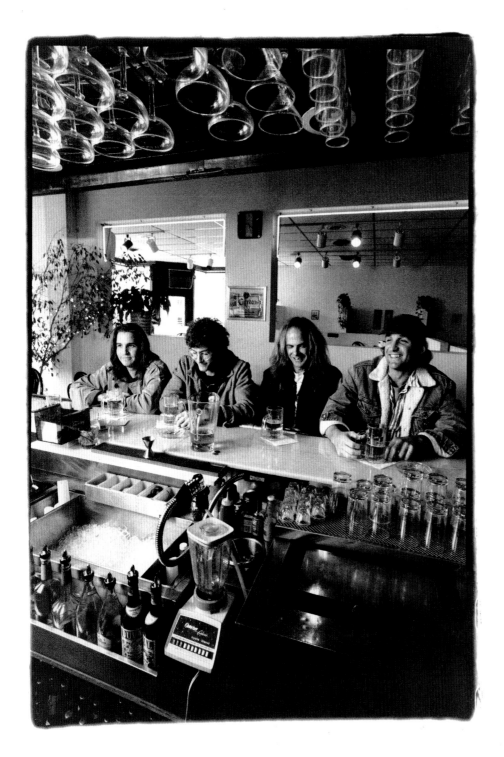

The Gear Daddies at Leaning Tower of Pizza,
May 1989

"The idea of the Gear Daddies was they
were a working man's band, like they had
just gotten off the shift at Hormel. I had the
idea of doing a picture from the bartender's
point of view, with them sitting at a bar.
They said they go to the Leaning Tower of
Pizza all the time in Uptown Minneapolis,
so it should be no problem to do it there.

"We show up and I have lights, equipment,
everything. I thought we were all squared
away, but the bartender hadn't heard
anything about it. I had it all set up and
get the band in place and am shooting. In
the background through my lens I see this
guy coming in, waving his arms. It was
the owner, and he was like, 'What the hell
is going on here?!' Nobody had cleared
anything with him. I had to shut it down.
But I managed to get the picture."

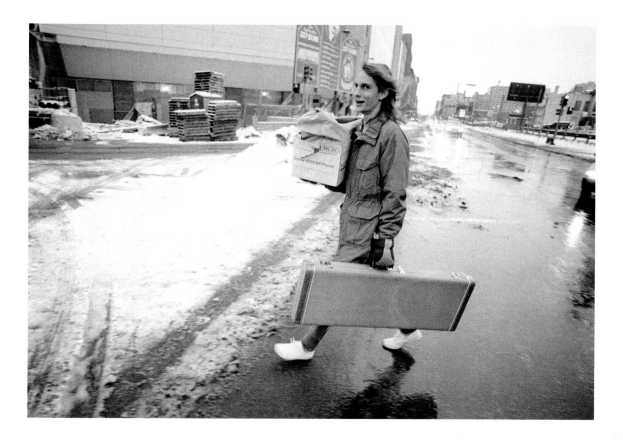

Willie Wisely crossing
First Avenue in
Minneapolis, 1990

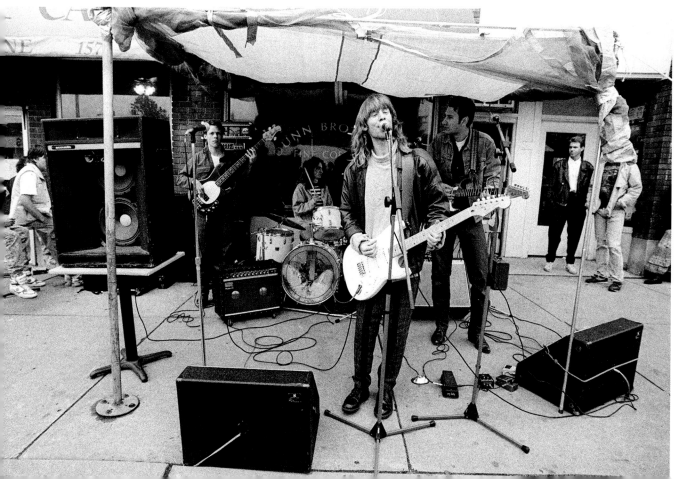

The Picadors, June 1990

The Jayhawks, 1990

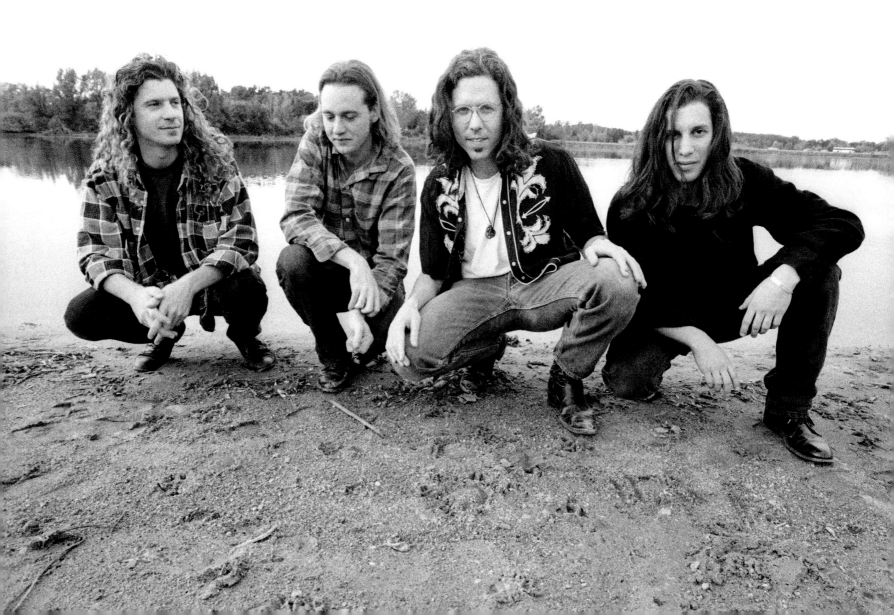

From left to right: The Jayhawks during the photo shoot for the *Blue Earth* album, 1989; the Jayhawks' *Blue Earth*, photo by Daniel Corrigan, 1989

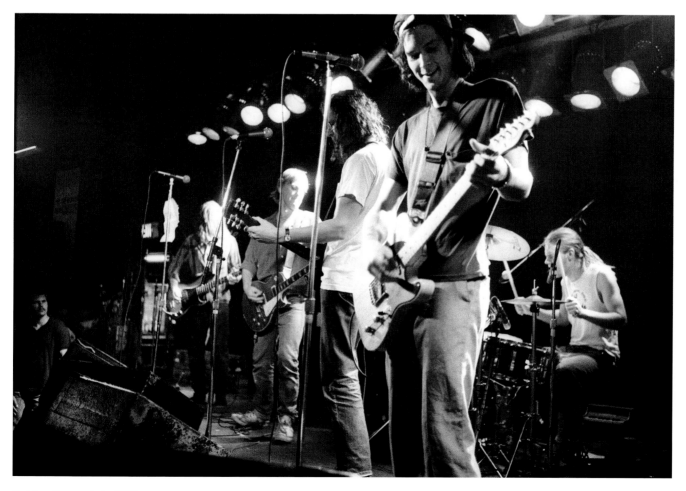

Golden Smog, July 1990

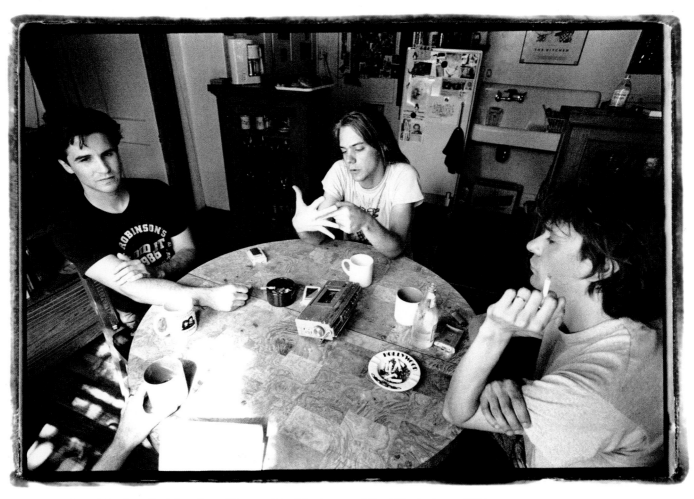

Martin Zeller of the Gear Daddies, Dave Pirner of Soul Asylum, and Paul Westerberg, 1990

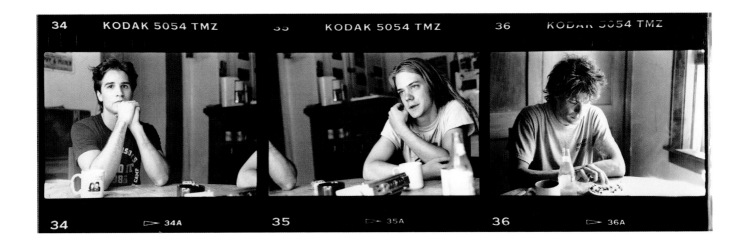

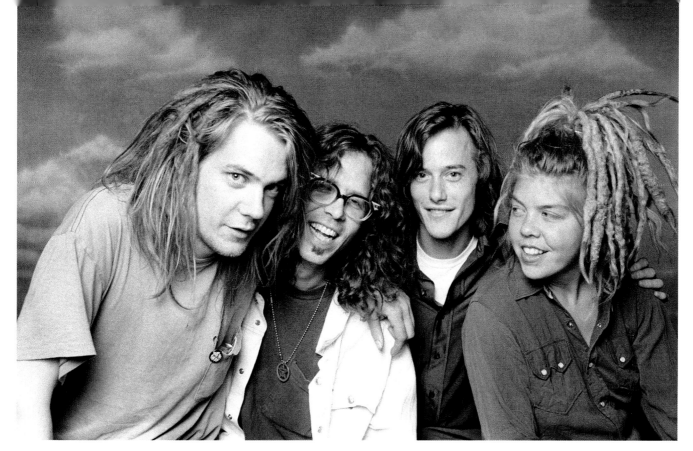

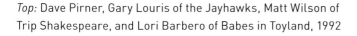

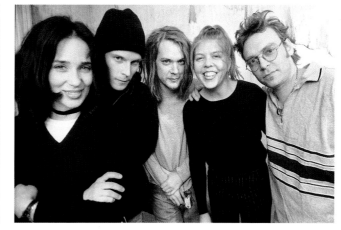

Top: Dave Pirner, Gary Louris of the Jayhawks, Matt Wilson of Trip Shakespeare, and Lori Barbero of Babes in Toyland, 1992

Above left: Slug of Atmosphere, writer Rod Smith, Bill Sullivan of the 400 Bar, Lori Barbero, and Kim Randall of No Alternative Records, 1998

Above right: Singer/songwriter/violinist Jessy Greene, Kraig Jarret Johnson of Run Westy Run, Dave Pirner, Lori Barbero, and Karl Mueller of Soul Asylum, 1999

Beginning in the early 1990s, as local bands were gaining greater national attention and exposure, the *City Pages* weekly alternative newspaper began running a semiannual event at which a writer would moderate a get-together of musicians, record label representatives, and other "scene makers" to discuss the Minnesota music scene.

Soul Asylum

Dan worked with the band Soul Asylum extensively, especially during its early days, and he considers the members of the band to be good friends. The band's nascent period—as it transformed from its Loud Fast Rules origins in 1981 to blasting off as Soul Asylum just a few years later—coincided with Dan's burgeoning career as a rock photographer.

The Minneapolis four-piece punk and proto-alternative band was led by singer/songwriter Dave Pirner and guitarist Dan Murphy, with Karl Mueller on bass and Grant Young on drums. The band hired Dan for several photo

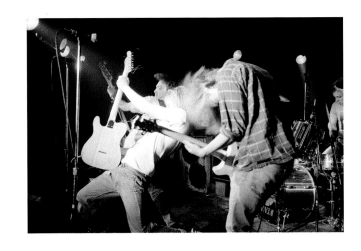

Above: Soul Asylum at 7th Street Entry, May 24, 1987

Right: Karl Mueller, Dan Murphy, Dave Pirner, and Grant Young of Soul Asylum, 1985

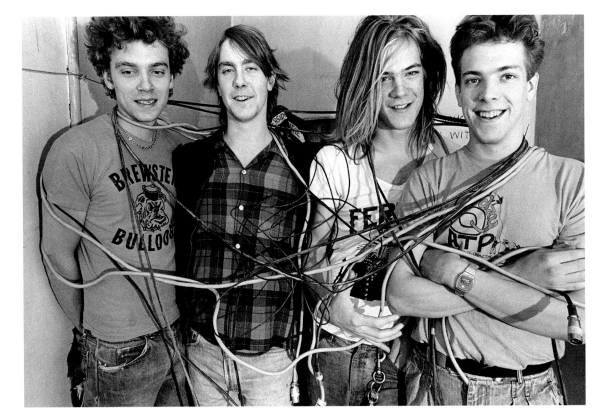

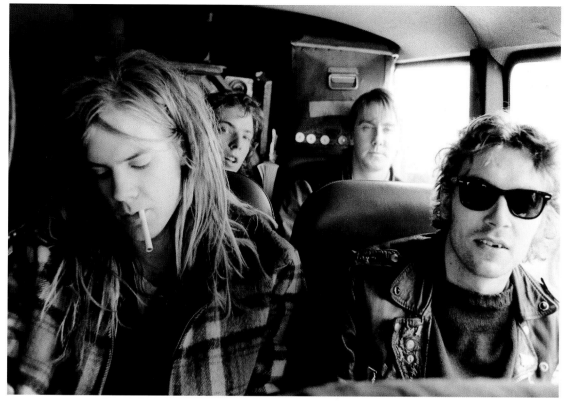

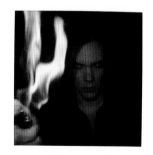

Above: In the van with Soul Asylum

Right: Dave Pirner having fun with a lighter while on the European tour

shoots in the mid-eighties, and he documented many of their live shows.

In February and March of 1988, Dan traveled with the band during a thirty-two-day European tour. Lugging around a suitcase full of film, Dan was primarily along for the ride to gather images and footage for what would become the video for the band's 1988 hit, "Sometime to Return."

Falling in line with the hallmark style for so-called alternative bands of the 1980s, the video featured a frenetic, seemingly random editing of blanched 16 mm film. It fast became an MTV staple, gaining Soul Asylum mass

exposure. The video, assembled by Dan and edited by filmmaker Rick Fuller, shows the band in all its glory on the road abroad and back on its home turf in Minneapolis. The video reflects much of Dan's photographic style, almost like a series of still images coming to life.

The European tour brought other adventures and misadventures. "Our first night was in Amsterdam and it was Grant's birthday," Dan recalled. "We went into the red-light district to try to find a prostitute to give Grant a spanking for his birthday, but we couldn't find someone who would do it and let us watch. We ended up getting way beyond ourselves. We all

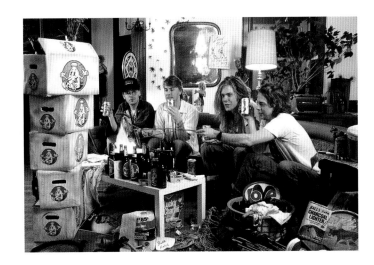

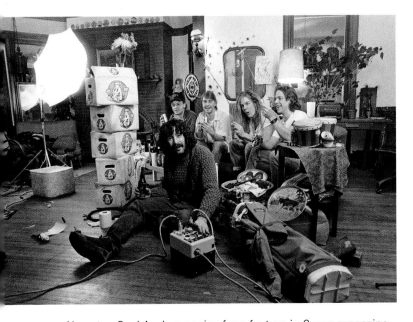

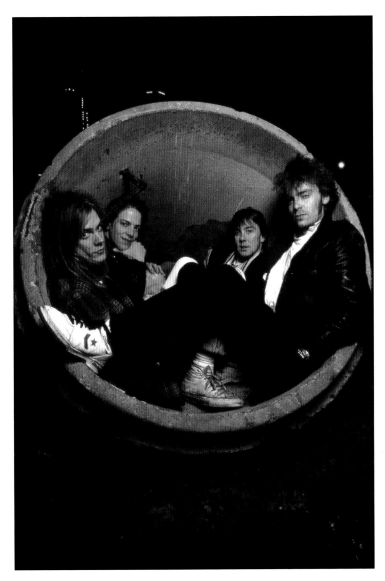

Above top: Soul Asylum posing for a feature in *Creem* magazine

Above: The photographer and his subjects (photo by Geoff Hansen)

Soul Asylum confined in a concrete pipe

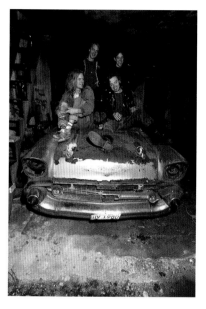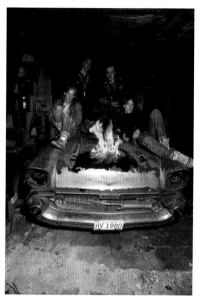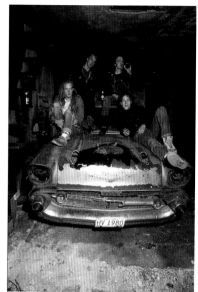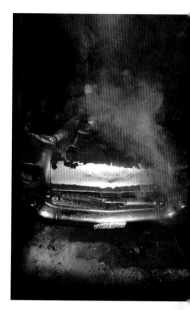

The nearly ill-fated garage photo shoot, 1986

crammed into a cab to find our way home. The fare was like a hundred dollars. The next day we realized we actually had been right across the bridge from where we were staying, but the driver took us all around the city for forty-five minutes to rack up the fare from a bunch of drunk Americans."

As trusting friends, the guys in Soul Asylum were ideal candidates for Dan's photography experiments, especially his quintessential technique of confining his subjects in uncomfortable or even dangerous situations. Dan consistently found success with Soul Asylum, his work bearing fruit in some of their most iconic shots—even if it meant nearly blowing up the band.

"I was really interested in doing pictures with fire,"

Dan explained. "Karl had this old car in this really tight garage. There was no finish on the car, so it was okay to put lighter fluid on it. It was kind of cold outside, so we closed the garage door. The band is sitting up on top of the car, and I'm putting lighter fluid on the hood and lighting it on fire and then I'd go back and do some pictures. The fluid would burn off, so I'd add more, and they were there just posing and joking around. I'd keep spraying the fluid, but at some point, it wouldn't stick. So I'm thinking, 'Where is this going?' Finally, I realize that the hood of the car was heating up, and so the fluid was just evaporating. It's filling up this enclosed space we're in. I'm like 'holy shit' and quickly open the door to air it out. That's when I almost blew up Soul Asylum."

The cover photo of *Clam Dip & Other Delights* parodies Herb Alpert's *Whipped Cream & Other Delights*. "It's always something when somebody wants to redo some previous work. I saw the picture, and trying to copy it was actually pretty simple. But the idea of Karl sitting in clam dip, we had to figure out the mechanics of that. We ended up getting gallon buckets of lard and mixing the lard with coffee to get the right color. We also had about two dozen jars of clam dip and then a whole bunch of fish parts, and put it all together. Dan Kalail was doing the art direction. Karl had to sit there for a long time; he was such a good sport. My studio smelled like fish for about two weeks."

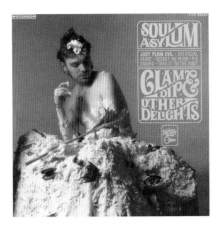

Soul Asylum's *Clam Dip & Other Delights* EP, photo by Daniel Corrigan, 1989

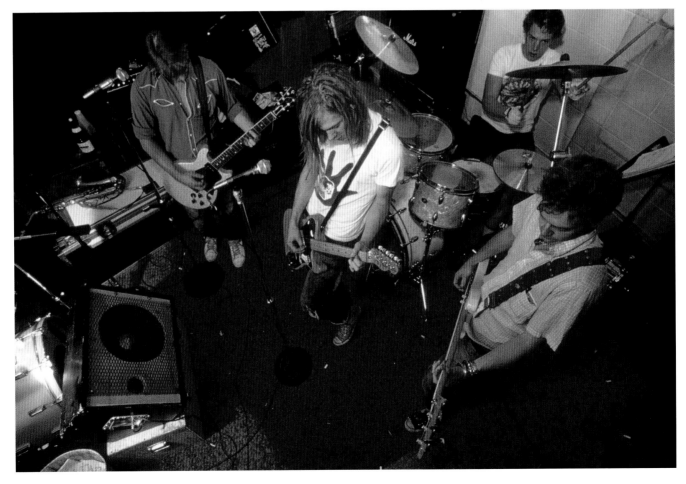

Soul Asylum practicing

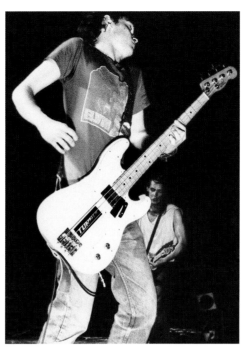

"I really loved Karl. He was such a gentle and kind soul, really smart and quirky. When we were in Europe, we had to go through East German customs to get to Berlin. I was with Karl, and there was this really stern East German guard. He asked us to empty our pockets. Karl was famous for this—he had on jeans, a T-shirt and probably a dress shirt, a flannel shirt, a jean jacket, and then some overcoat. He was kind of a packrat, and all his pockets were filled with shit: knickknacks, shot glasses, pens, papers, all manner of stuff, just the craziest stuff. I look over at the guard and he's just smiling, like 'How did you have all this stuff in your pockets?'"

Dan Murphy, 1990

Karl Mueller

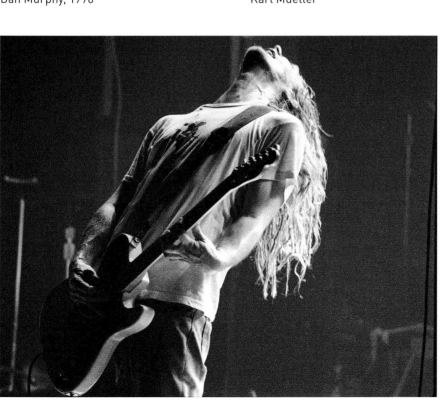

"In the Entry, I swear I saw Dave Pirner levitate during a guitar solo. I saw this happen right in front of me: he rose up off the ground."

Dave Pirner, 1992

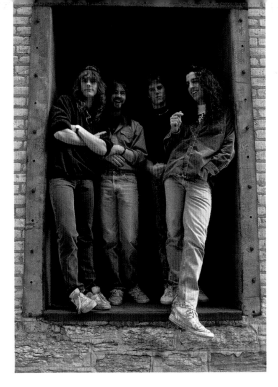

Coup de Grace, circa 1990

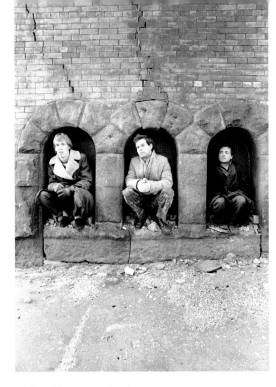

Violent Femmes, 1983

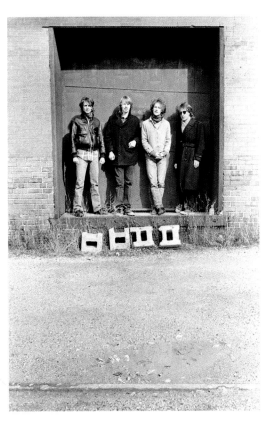

Figures, 1986

Rapscallion, 1989

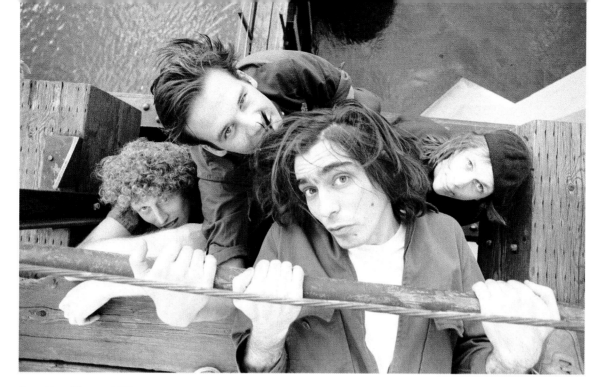

Breaking Circus, 1987

Cattle Prod, 1989

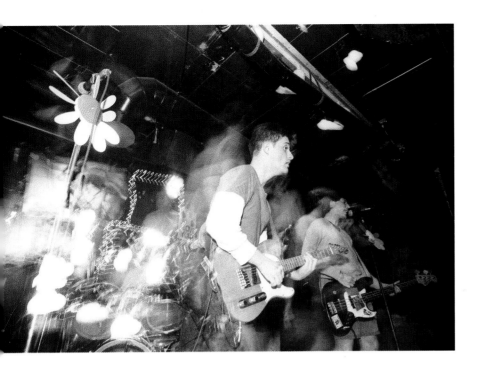

Left: Volcano Suns at the Uptown Bar, November 1988

Below left: Steve Albini, 1994

Below right: Todd Trainer, 1990

Opposite: Flour on top of the Gold Medal Flour building in Minneapolis, 1989

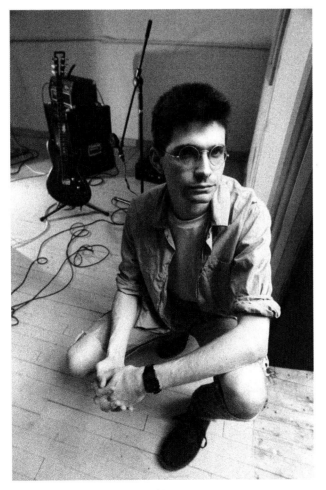

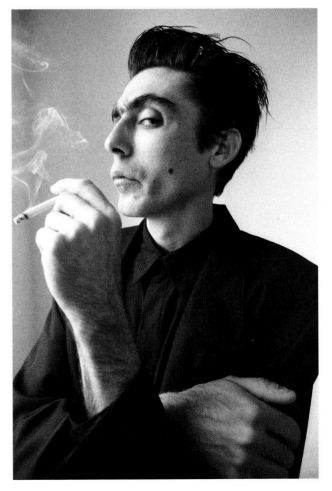

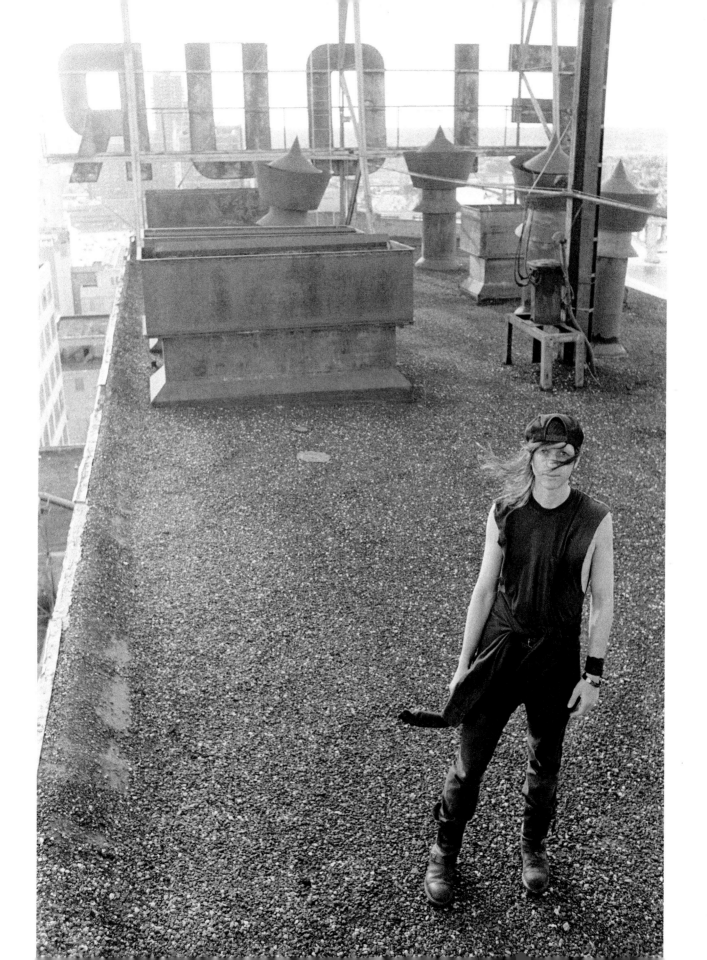

Rifle Sport at 7th Street
Entry, 1988

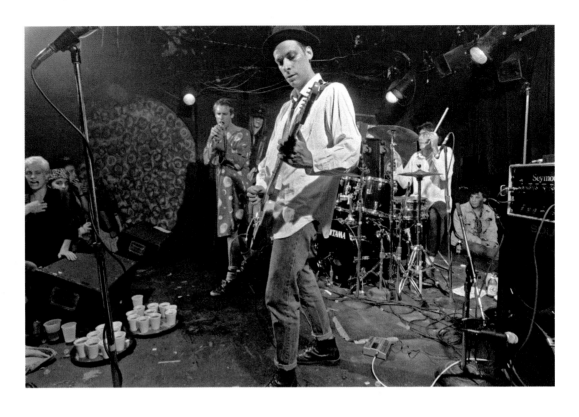

Shellac, 1994

Opposite: Big Trouble House, 1990

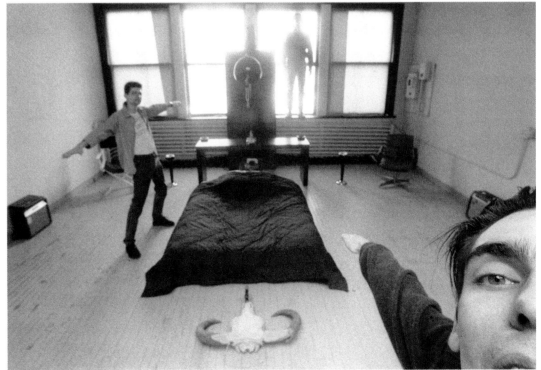

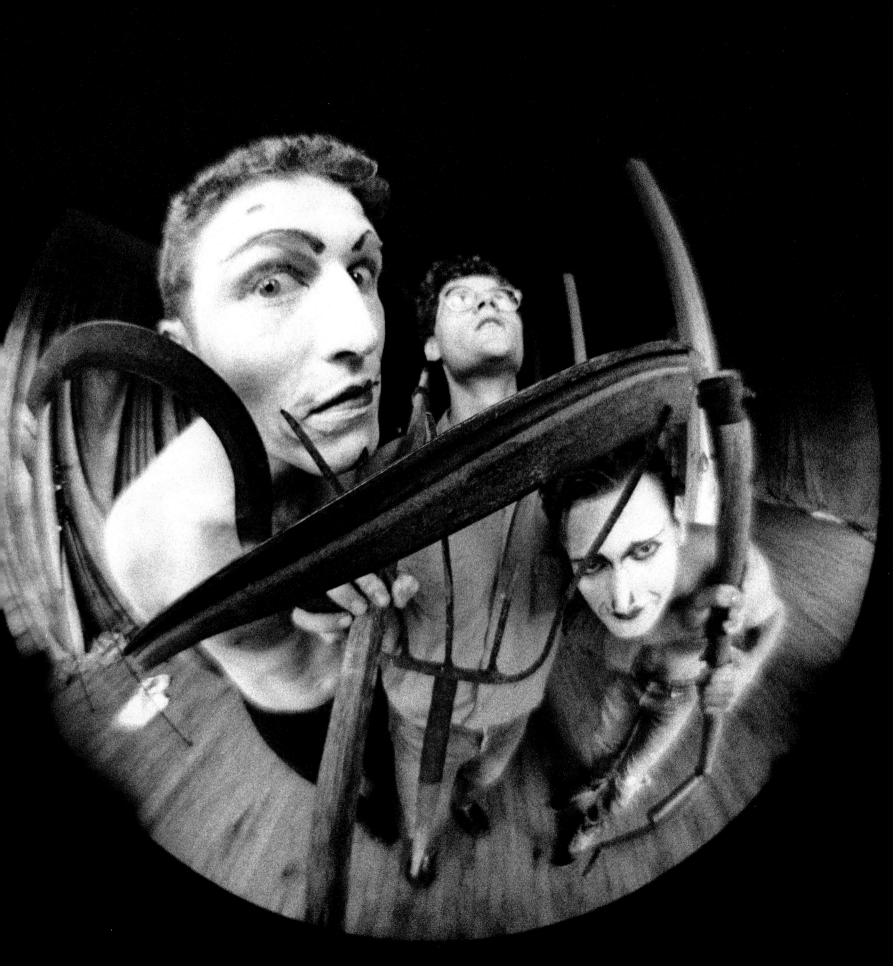

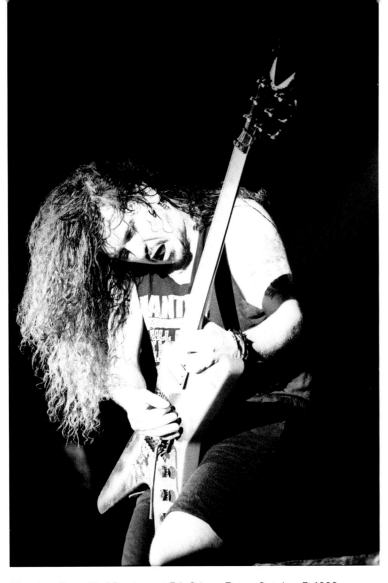

Dimebag Darrell of Pantera at 7th Street Entry, October 7, 1990

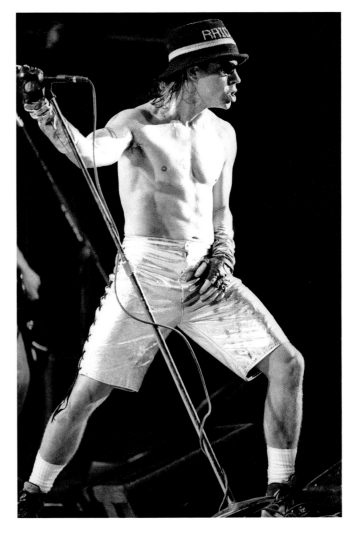

Anthony Kiedis of Red Hot Chili Peppers at St. Paul Civic
Center, November 30, 1991

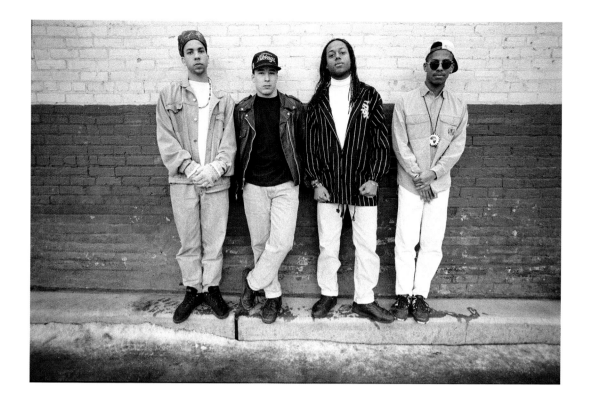

Soul Reaction, 1992

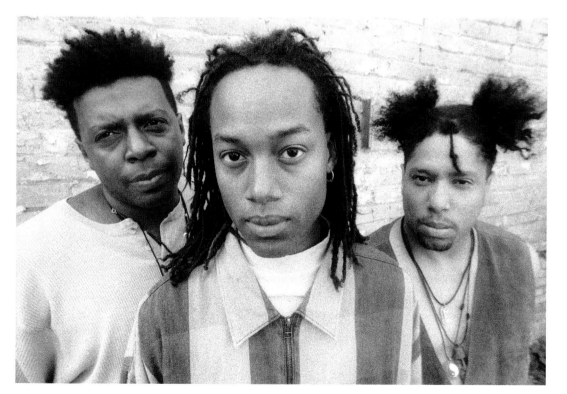

Tribe of Millions, 1995

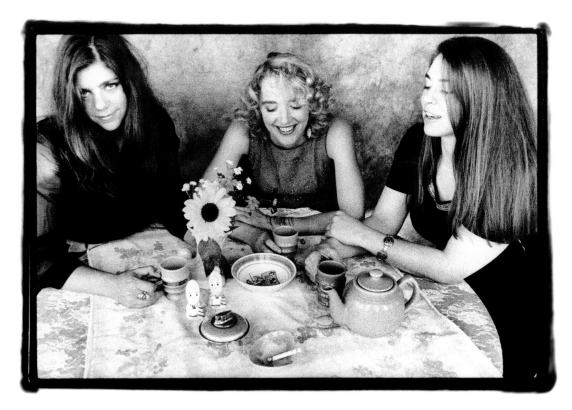

Zuzu's Petals, 1990

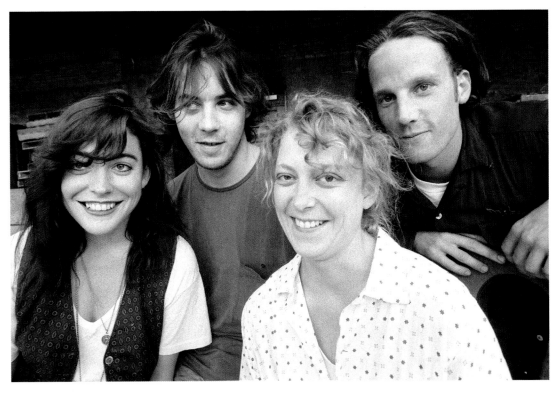

Dutch Oven, 1991

Left: Walt Mink's *Miss Happiness*, photo by Daniel Corrigan, 1992

Below: Walt Mink at First Avenue, 1993

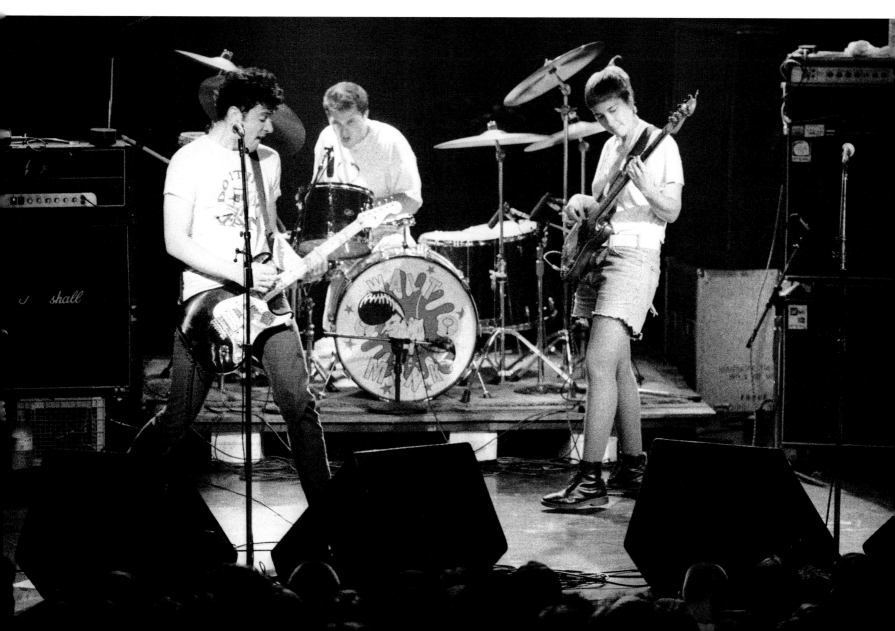

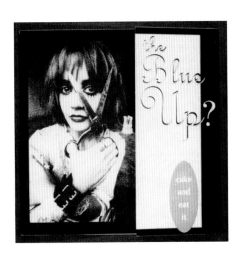

The Blue Up?'s *Cake and Eat It*, photo by Daniel Corrigan, 1992

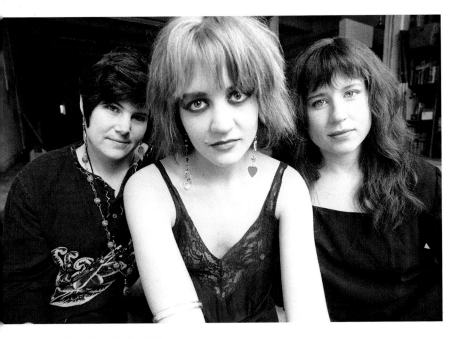

The Blue Up?, 1992

Rachel Olson (later Ana Voog) of the Blue Up? at First Avenue, 1992

Juliana Hatfield at 7th Street Entry, July 1992

Uncle Tupelo

Being a fly on the wall and documenting the process of making a record or traveling with a band on the road have brought about some of Dan's favorite experiences. He hooked up with indie-Americana band Uncle Tupelo when they came through the Twin Cities during their early years. Led by co-songwriters Jeff Tweedy and Jay Farrar, the band was initially a trio but grew to be a five-piece.

After releasing three records under the indie Rockville Records label, Uncle Tupelo signed to Sire Records for their fourth album. Dan was hired to shoot the band during the making of their major label debut, 1993's *Anodyne*.

The album was recorded in May of that year at the small Cedar Creek studio in Austin, Texas, and Dan's photos capture the grittiness and down-to-earth quality of the studio and the band in its element.

"Uncle Tupelo was so fun because I got to hang out with them a lot. I was with them for three weeks. It was always nice to spend that amount of time with a band. After a while, if you do it right, you aren't even there. They don't even see you anymore. They're comfortable enough it isn't just a photographer.

"I have been so fortunate that my job has allowed me to see so much incredible music. Uncle Tupelo were the type of guys that if they weren't doing anything they would just sit down and play their instruments. I got to listen to them jam for like an hour and a half. It was like a private concert just for me."

Despite producing one of the era's quintessential Americana recordings, Uncle Tupelo disbanded in early 1994, following growing tension and the proverbial "creative differences" between Tweedy and Farrar. The two

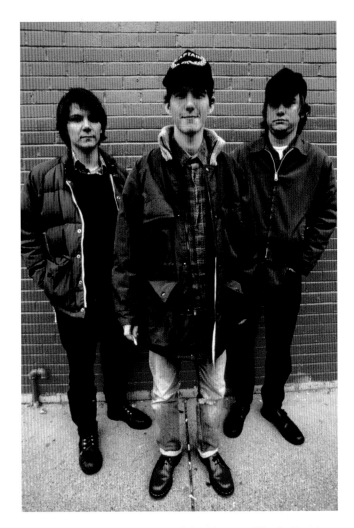

Jeff Tweedy, Mike Heidorn, and Jay Farrar of Uncle Tupelo

split off to form their own new bands, Tweedy in Wilco and Farrar in Son Volt. Both would hire Dan to shoot photos for their debut records, released in 1995.

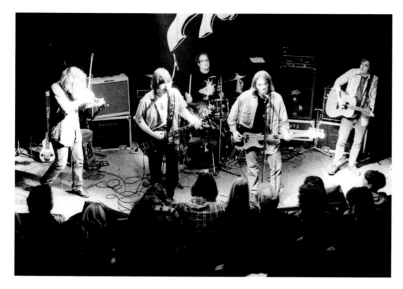

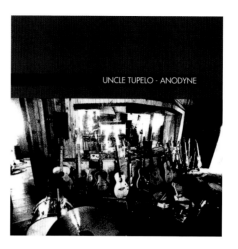

Uncle Tupelo's *Anodyne*, photo by Daniel Corrigan, 1993

Uncle Tupelo during their European tour, November 1993

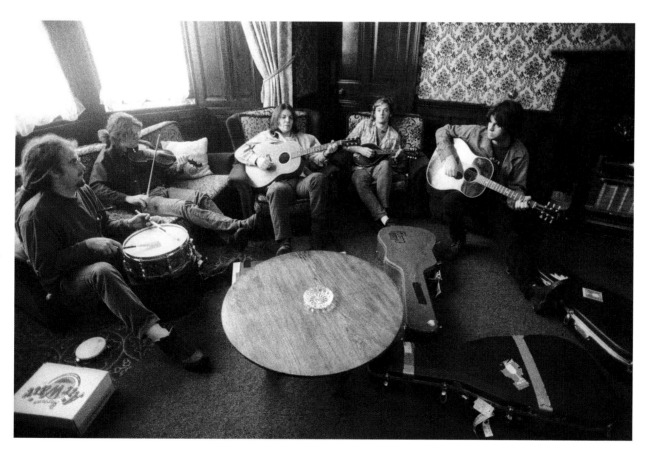

Uncle Tupelo in Scotland, November 1993

Son Volt, 1995

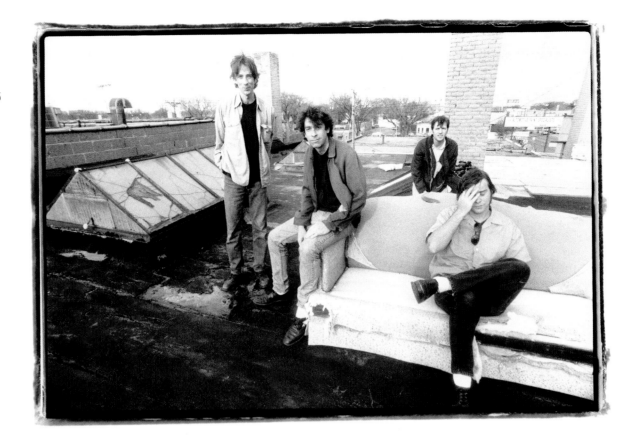

Son Volt
rehearsing, 1995

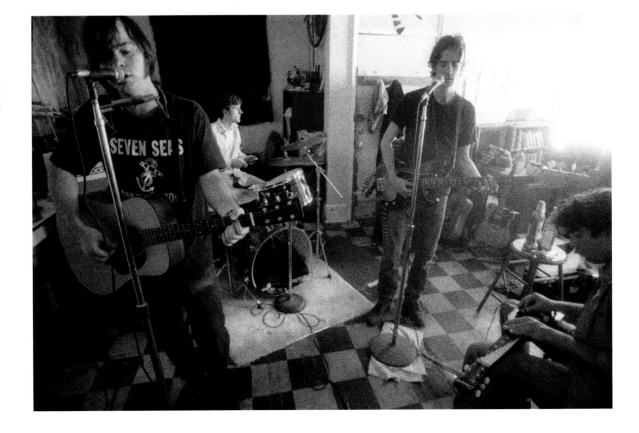

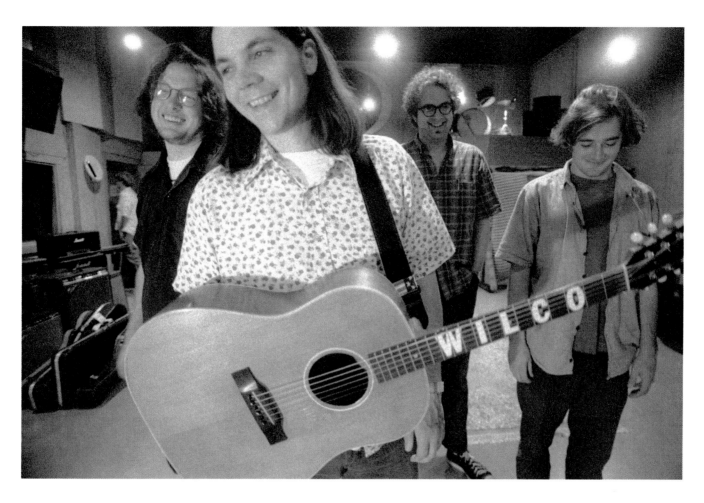

Above: Wilco, circa 1994

Left: Wilco at First Avenue, 1995

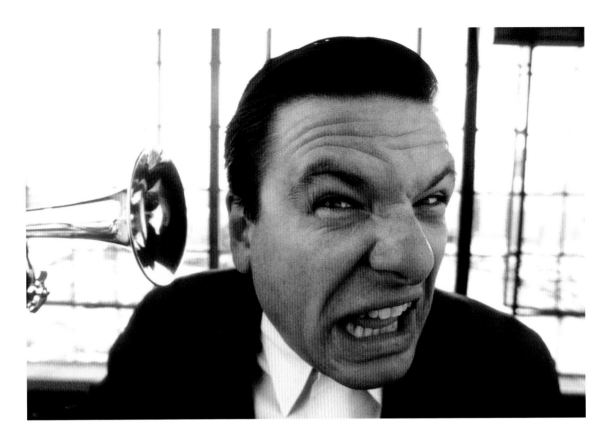

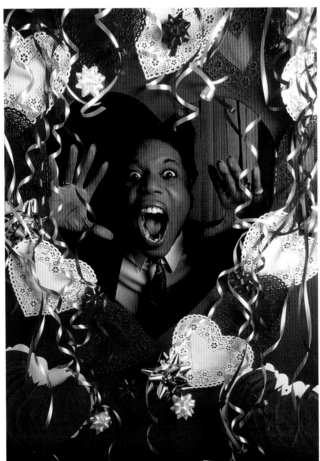

Above: Actor and producer Dr. Sphincter
(Rich Kronfeld), 1992

Left: Comedian and television personality
Fancy Ray McCloney, 1992

Music journalist Jessica Hopper, 1992

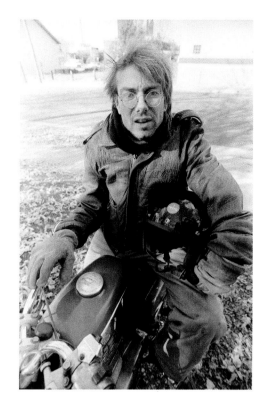

Author and storyteller Kevin Kling, 1997

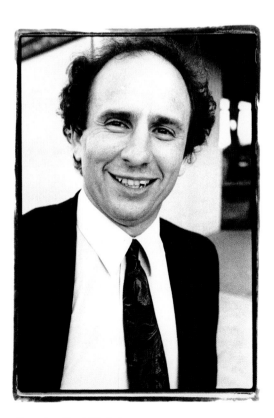

Senator Paul Wellstone

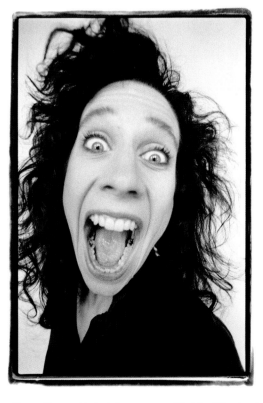

Comedian and television personality Lizz Winstead

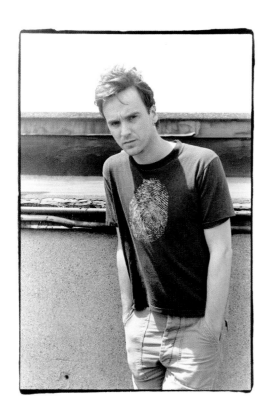

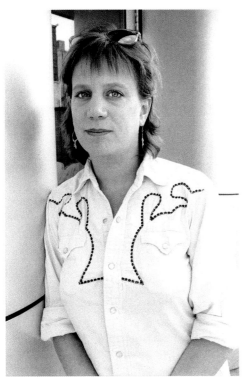

Top left: Manager and A&R man Dave Ayers

Top right: Engineer and producer Tom Herbers at the Terrarium
recording studio, 1994

Bottom right: Filmmakers Phil Harder and Rick Fuller, 2001

Left: First Avenue production manager and Uptown Bar music booker
Maggie Macpherson, 1990

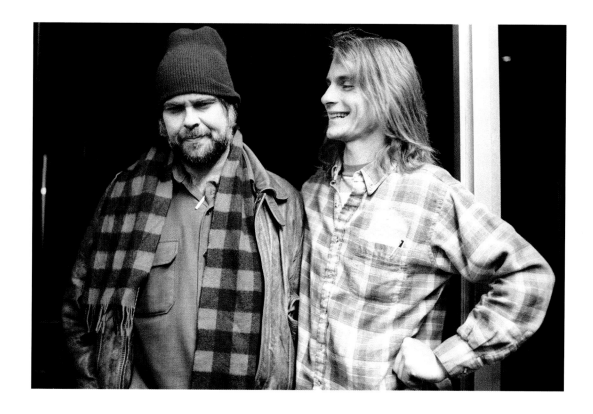

Steve McClellan and
Willie Wisely, 1990

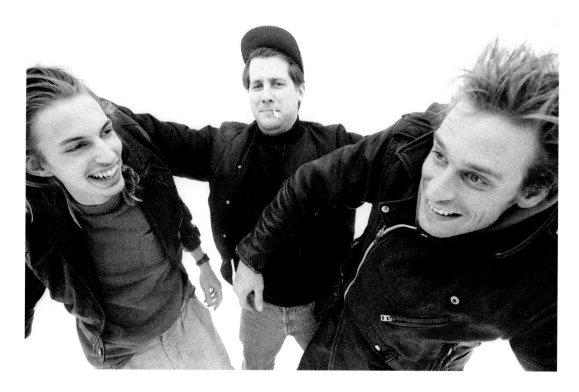

Jake Wisely of Red Decibel
records, Tom Hazelmyer of
Amphetamine Reptile Records,
and Chris "CJ" Johnson of Big
Money Inc. records, 1991

AmRep Records

In the mid-1980s, Dan continued to develop his style for cover art, and he worked extensively with Amphetamine Reptile Records, the notorious punk rock label started by Tom Hazelmyer in 1986. Hazelmyer, a graphic artist in his own right, often came up with the concepts for Dan to execute photographically.

What was essentially "grunge" before it became the term for the genre, the music of many of AmRep's roster of bands brought a sonic brashness characterized by loud riffing guitars, frenetic drumming, and aggressive and often crude or abstract vocal styles.

Bands like New York City's Helmet and Washington's Melvins became flagships for the AmRep label, but Cows, Janitor Joe, Guzzard, Hammerhead, and other local bands cemented the sound in the roots of the Twin Cities music scene. Dan would contribute visually and document much of the 1990s era of the AmRep label.

"I loved working with Tom," Dan says. "He was a hard-ass, but we always got along working together. Many of the things I did for the label, they knew exactly what they wanted."

Often embodying what Dan considers the "classic Twin Cities three-piece rock" sound, the AmRep bands fit right in with Dan's personal tastes.

"Guzzard and Hammerhead were bands that I would go see on my nights off, the kind of music I'd see on my own. The energy and speed, the aggressiveness of the music—I always liked that."

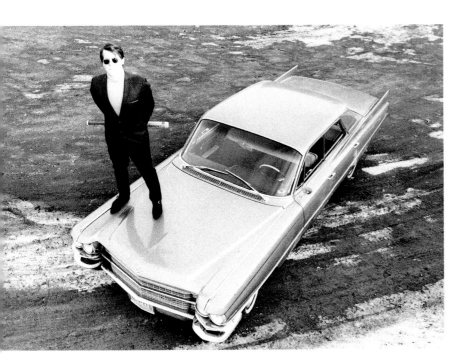

Tom Hazelmyer, 1991

Clockwise from top left: Chokebore's *Motionless*, 1993; Janitor Joe's *Big Metal Birds*, 1993; Guzzard's *Glued* single, 1993; Supernova's *Ages 3 and Up*, 1995, photos by Daniel Corrigan

Chokebore, 1993

Janitor Joe, 1992

Guzzard, 1993

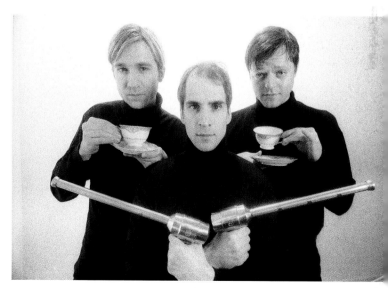

Hammerhead, 1996

125

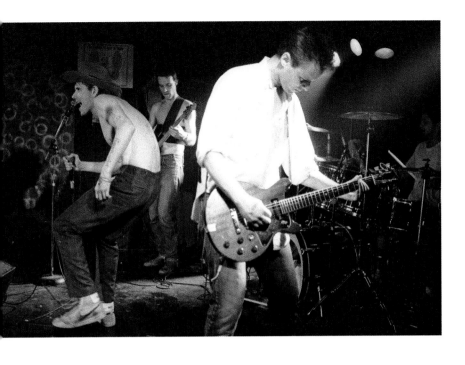

During their height, Minneapolis's Cows were unrivaled for their extreme volume and noisy, groove-based guitar riffs, and for lead singer Shannon Selberg, whose stage contortions and antics were unpredictable and endlessly entertaining. Like a circus freak show, Selberg was the consummate performer, often invoking harm on himself and provoking the audience.

Left: Cows, October 1988

Below right: Cows, 1988

Below left: Cows' *Cunning Stunts*, 1992; Cows' *Whorn*, 1996, photos by Daniel Corrigan

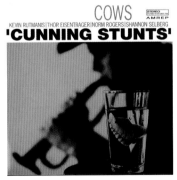

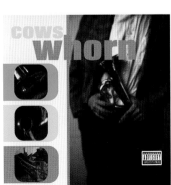

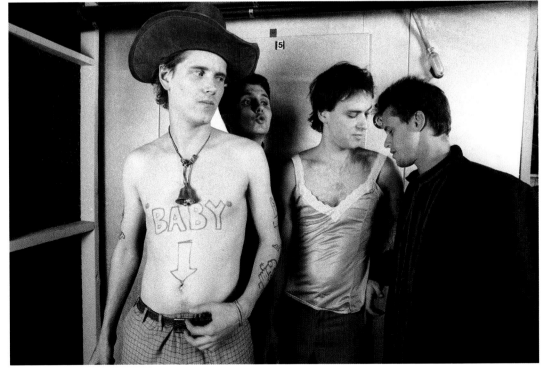

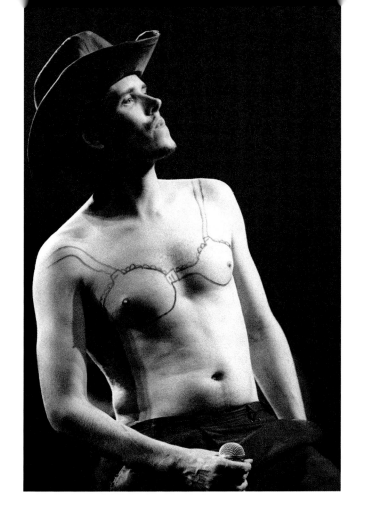

"Shannon is just like out of a comic book," said Dan. "Such an interesting brain on that guy. I loved his songs and his storytelling. There was something so surreal about Cows. I really got along with them. I made a really funny picture of them playing strip poker. Shannon was down to his cowboy hat."

Left: Shannon Selberg on stage, October 1990

Below right: Cows' *Sexy Pee Story*, photo by Daniel Corrigan, 1993

Below left: Cows playing strip poker, 1992

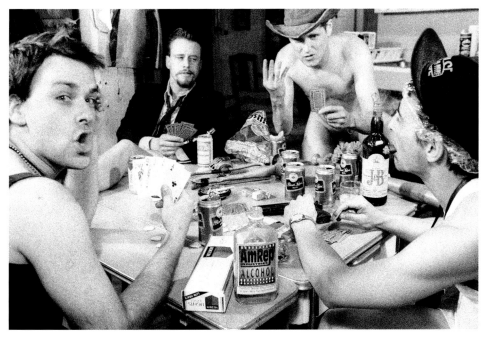

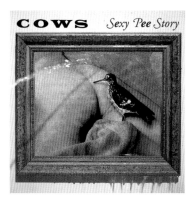

"The cover of *Sexy Pee Story* shows somebody pissing on a piece of art. We actually set up a water pump and set up the artwork and had a tray of dirty water to look like pee. It would circulate onto the painting and drip into this tray and then pump back up."

The Suicide Commandos, 1995

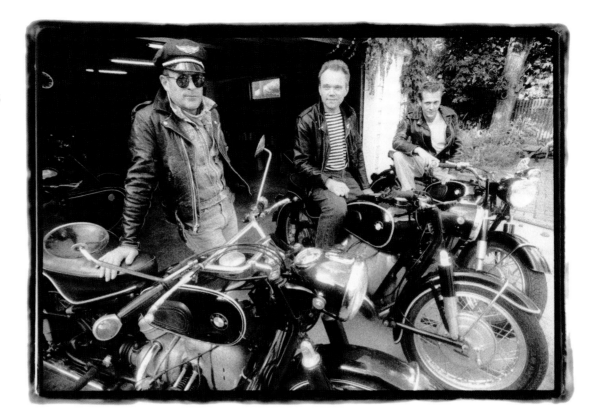

Smut, 1995

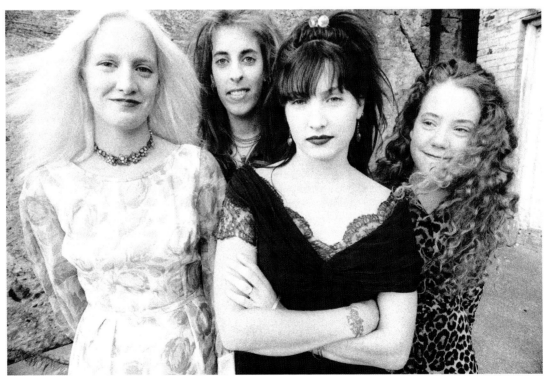

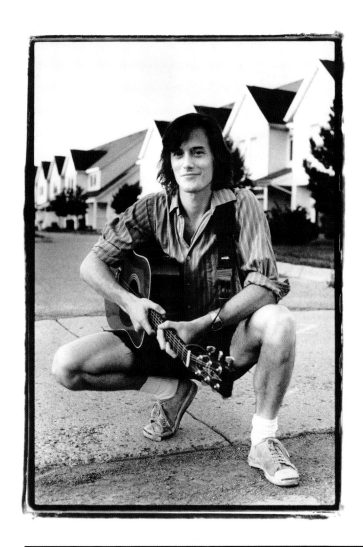

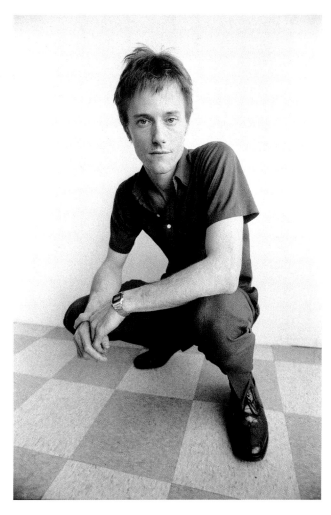

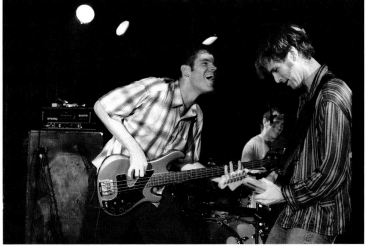

Above: Matt Wilson, circa 1990 and 1998

Left: Semisonic at 7th Street Entry, September 29, 1995

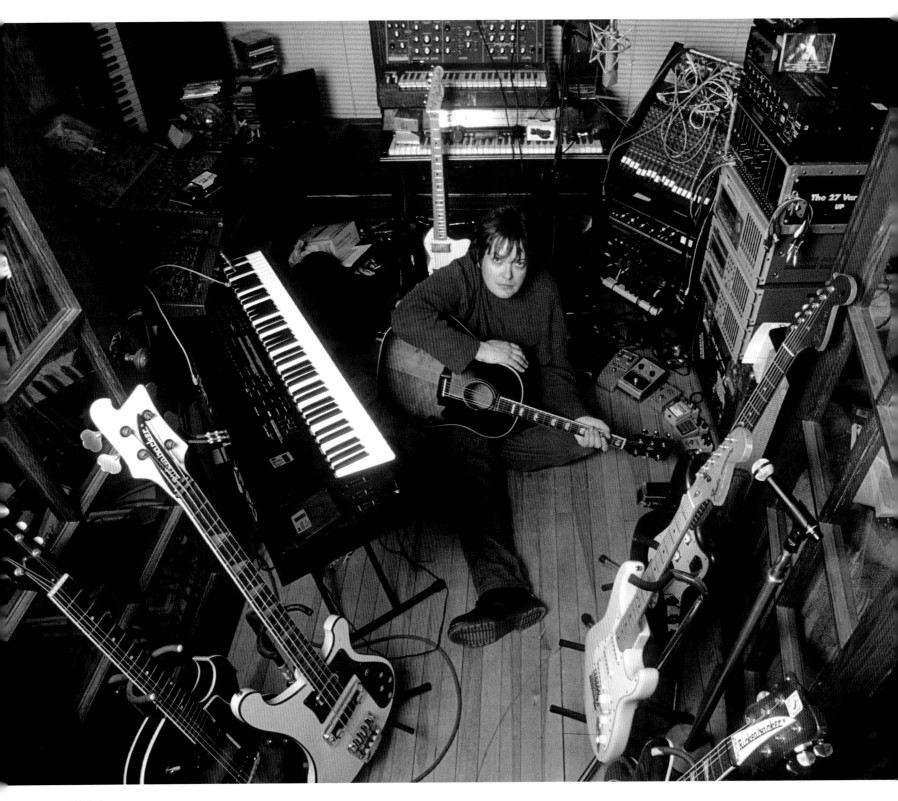

Ed Ackerson

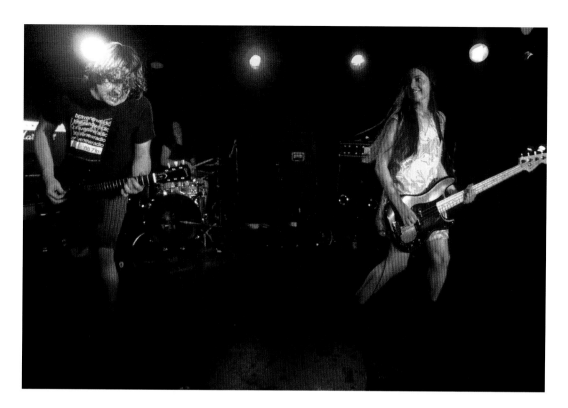

House of Large
Sizes at 7th Street
Entry, May 3, 1996

Mason Jennings,
1999

Will Oldham (Bonnie Prince Billy) of Palace Brothers, 1995

"I got a gig to shoot a portrait of him (Will Oldham) down at Cannon Falls at Pachyderm. He was so shy. If you add a camera to being already shy, it just adds another level. He was in the rec room there, and there was a TV in the background. While I was talking with him about what to do, I noticed his eyes kept going over to the TV. *Hogan's Heroes* was on. So I told him all he needs to do is sit in his chair and watch *Hogan's Heroes*. To just pretend I wasn't there, and that was how I ended up getting the shot."

Tiny Tim, 1996

Greg Brown, 1992

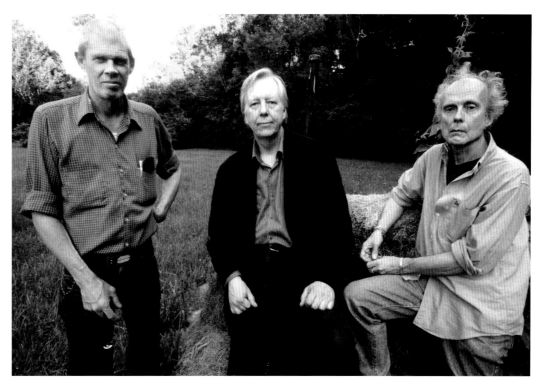

Spider John Koerner, Dave Ray, and Tony Glover, 1996

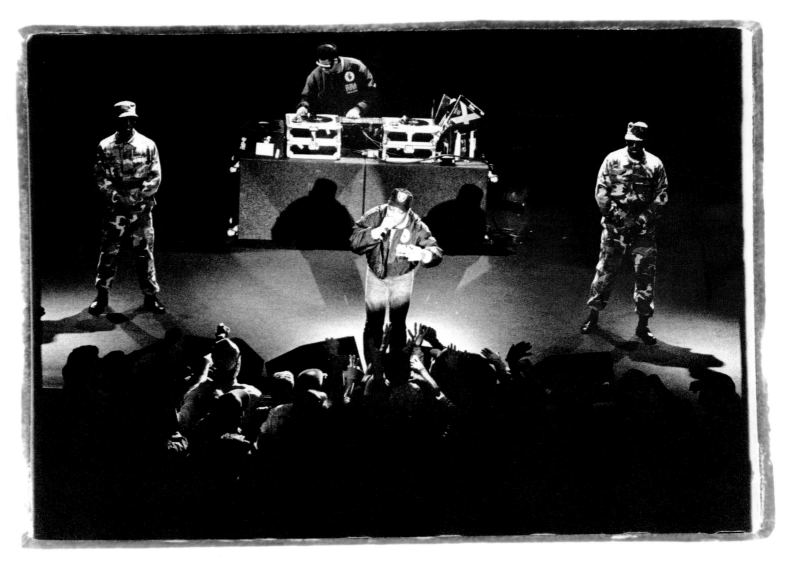

Public Enemy at Glam Slam

Right: The Abstract Pack, 1998

Below: Phull Surkle, 1995

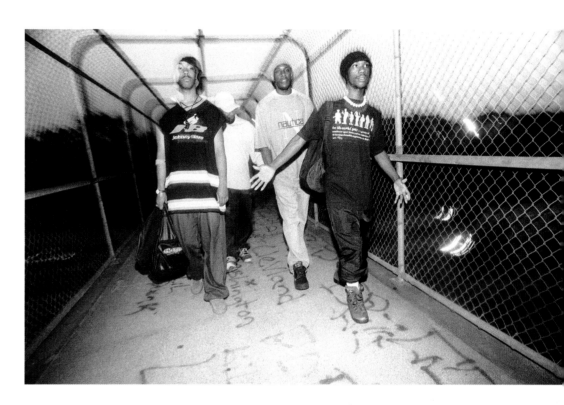

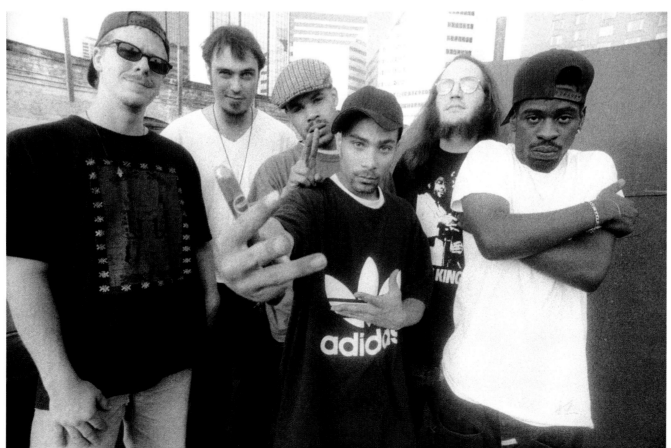

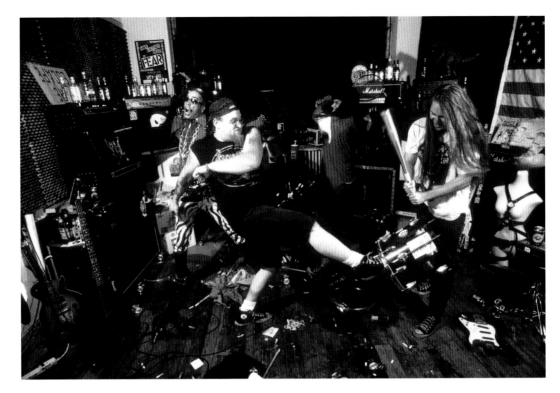

Quincy Punx, 1997

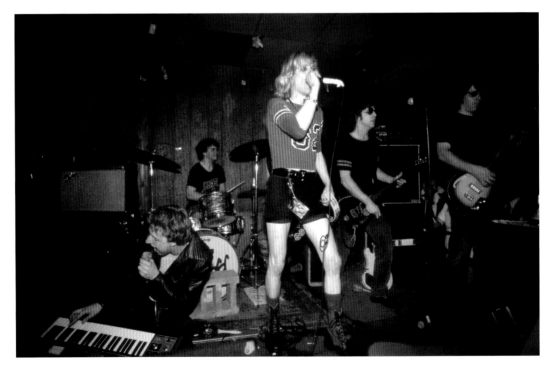

The Odd at the Terminal Bar, 1998

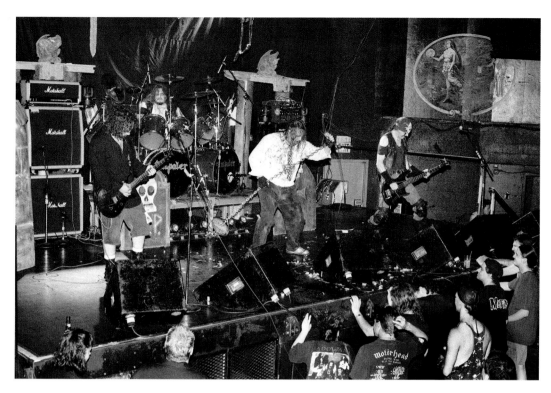

Impaler at First Avenue, 1999

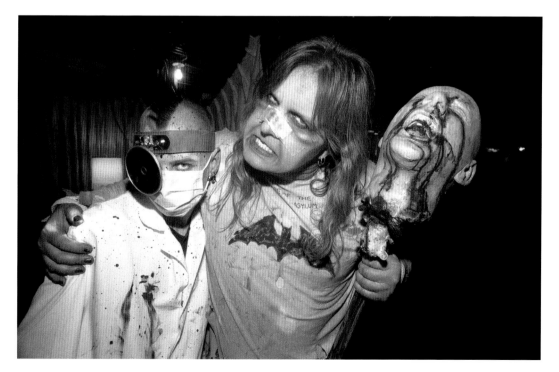

Bill Lindsey of Impaler and his son, Zach, known as Dr. Corpse, 1999

"I always thought Impaler had a really interesting show. I've shot them several times through the years. I got to do pictures with them and it's pretty cool because Bill's son is in the band. His son is now the same age Bill was when I first met them. It's amazing how similar they are."

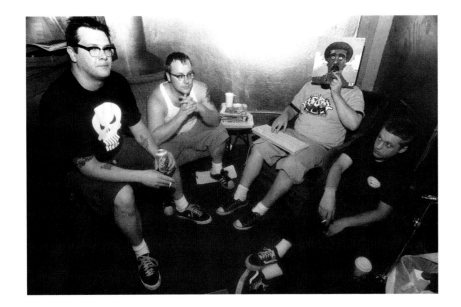

Dillinger Four, 2000

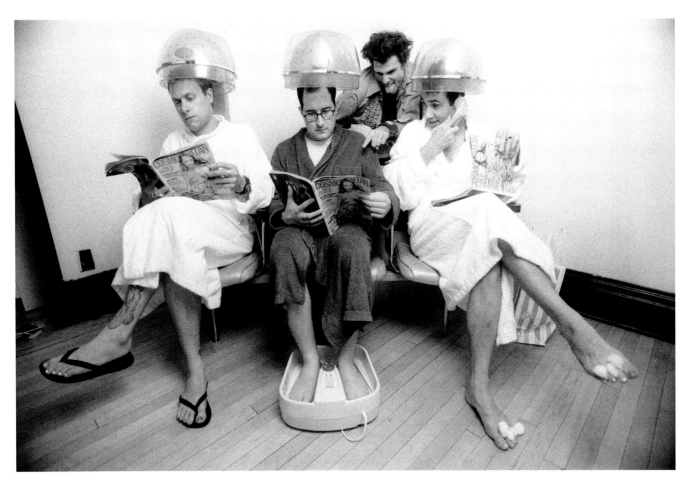

Lifter Puller, 1999

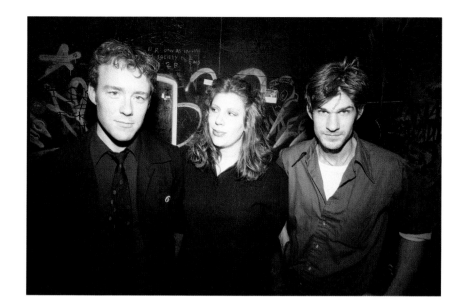

Low, 1999

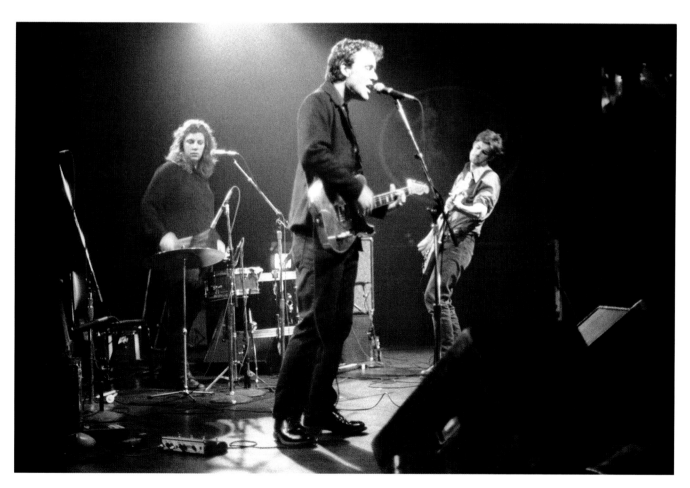

Low at First Avenue, December 11, 1999

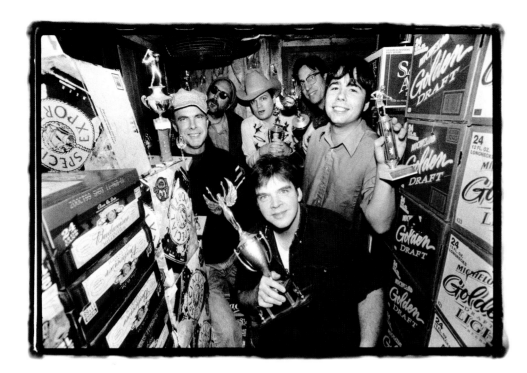

Trailer Trash in the beer cooler at
Lee's Liquor Lounge, 1999

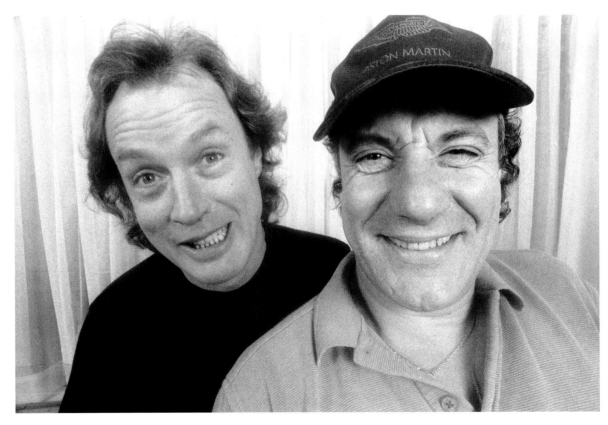

Angus Young and Brian Johnson of AC/DC, 2000

DJ ESP (Woody McBride), 2001

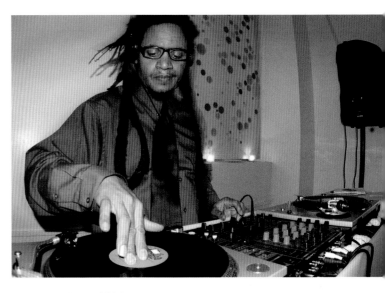

Kevin Beacham, 2006

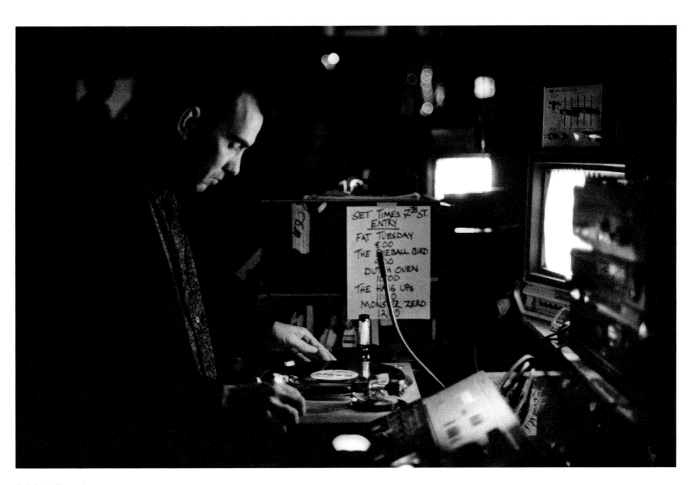

DJ Roy Freedom

Rhymesayers Entertainment and the Rise of Twin Cities Hip-Hop

Since the mid-1990s, there's been a natural progression in the Twin Cities as hip-hop gained greater prominence in the local music scene. One could point to the great influx of vintage record stores, the sonic pull from the roots of the "Minneapolis sound," and the influence of the DIY ethic championed by earlier punk generations as reasons to explain how hip-hop has so rapidly become a major part of Twin Cities music culture.

The chief architects of the local hip-hop scene—most notably Rhymesayers Entertainment and the Doomtree collective—have not only fostered lasting traditions within the Twin Cities, such as the annual Soundset festival and Doomtree's longstanding Blowout series, but they have made their marks in the international world of hip-hop.

Being front and center in the Twin Cities music scene for the last thirty-five years, Dan has witnessed firsthand the rise of Minnesota's vibrant hip-hop community and the role of Rhymesayers in that growth.

"I did some pictures of Rhymesayers when they were babies," Dan explained. "I think they had just started to do press. I did pictures of them at the Red Sea bar and restaurant where they were playing. I was doing a *City Pages* assignment and came up to meet those guys. Nobody knew who they were."

Left: The artists of Rhymesayers Entertainment, 2000

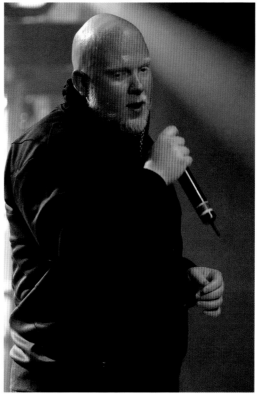

Clockwise from top left: Slug of Atmosphere, 2000; Brother Ali, at the Rhymesayers' Benefit for Haiti, February 9, 2010; Brother Ali and Slug, February 23, 2012

Sean Daley—better known as Slug from Atmosphere—was one of the founders of the Rhymesayers Entertainment record label and remains one of its biggest artists. Dan got to know Slug from his earliest days on Twin Cities stages. "I love Sean's sense of himself and what the music is. He's a consummate professional, a nice guy to work with.

"Rhymesayers is who you want to work for. They are good people. I love the idea that Quincy Jones offered them a million dollars, and they thought they were better off on their own. I love what they made. They've cultivated their own thing, and it really is just their own thing."

In the two decades since Rhymesayers began, they've continued to dominate. The label has nurtured and released recordings by some of the Twin Cities' most respected and popular artists, including Brother Ali, I Self

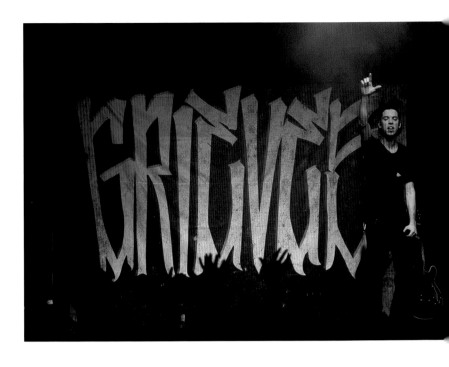

Clockwise from top: Grieves, October 11, 2014; I Self Divine, 2005; Aesop Rock, March 1, 2013

144

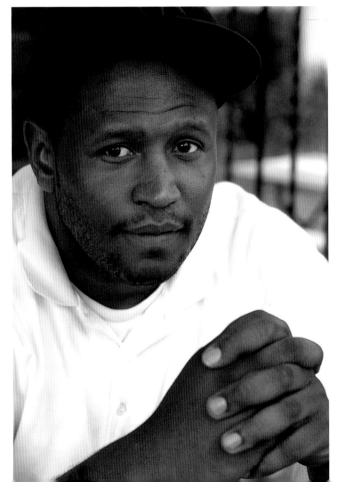

Divine, Toki Wright, and the late Micheal Larsen, who performed as Eyedea.

Establishing themselves as artists, musicians, producers, record labels, and overall brands, Rhymesayers and Doomtree have forged in directions that have allowed them to build their own audiences from scratch. Being along for the ride, Dan recognizes the need for pursuing one's own path in the modern era's splintering music industry and the encouraging signs it brings for local music.

"Now the technology that is given to musicians just makes everything easier. It makes everything more accessible. I think that the people who are really driven to do it, it's in their grasp now to actually do it. In the early eighties, if you wanted to put out an album, you had to have a bunch of people helping you. You had to have somebody record it for you, somebody to mix it down for you. You had to have somebody make artwork for you. Somebody to maybe make pictures of the artwork. Now a person can do the entire thing from their computer. And have it out the next day. And then, with social media platforms, have it in the ears of thousands of people the next day. That's amazing to me!"

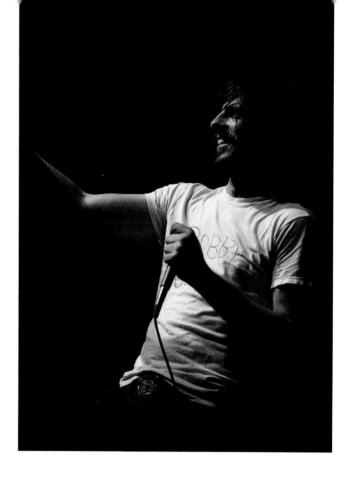

Above right: Eyedea, September 8, 2009

Right: Toki Wright, November 21, 2009

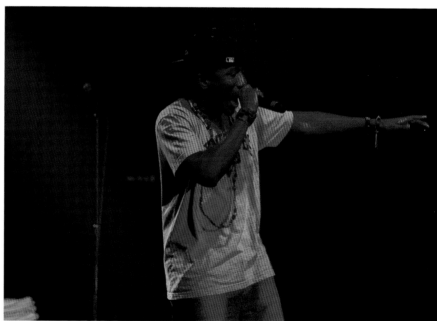

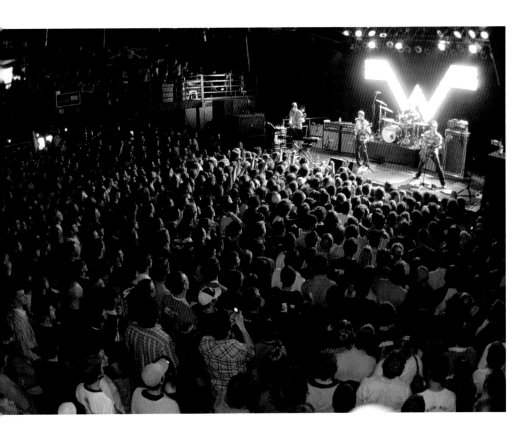

Above left: Weezer,
May 3, 2005

Above right: Patti Smith,
June 22, 2004

Right: The Pixies at the
Fine Line, April 13, 2004

Arcade Fire, September 25, 2005

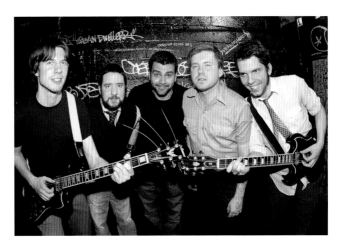

STNNNG, 2005

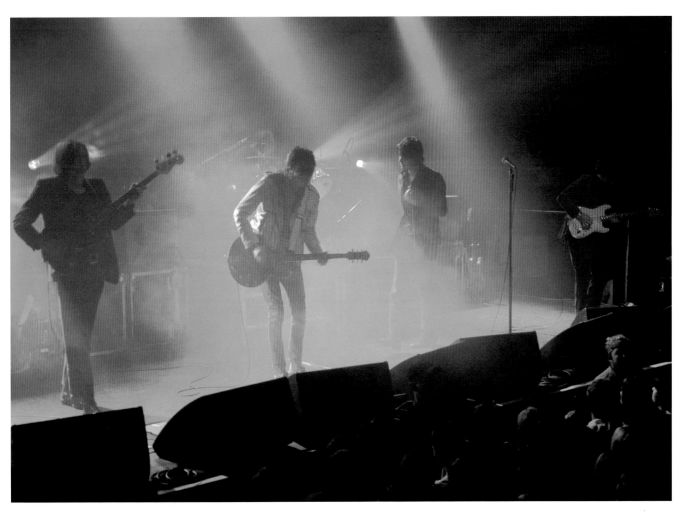

The Strokes, April 25, 2004

Nice Place, Nice Party, Nice Folks

The Midnight Evils, a garage-punk band from St. Cloud, Minnesota, burst on the local scene with their off-the-rails style in 1998. Propelled by their scrappiness and high energy, the band fast built a following and eventually signed with the indie label Estrus Records. They faded almost as fast, however, earning them the label "Best Band to Break Up in the Past 12 Months" from *City Pages* in 2006.

Embracing the same raucous, punk-rock influence, members of the Evils soon re-formed as Chooglin', and they became one of Dan's favorite Twin Cities acts. He went along for the ride, shooting a host of promo and live shots for the band.

When Chooglin' was preparing its live album, *Nice Place, Nice Party, Nice Folks*, Dan jumped at the opportunity to implement an idea for the album's cover that he had been conceptualizing for a long time. During a live performance at 7th Street Entry in December 2007, Dan set up a photo booth in the corner of the room where he would shoot portraits throughout the evening.

With the images laid out in a simple pattern on the cover, Dan captures band members, recording engineers, audience members, First Avenue staff, and any other willing participant who was at the show—effectively blurring the line between audience and performers with this unique cover concept.

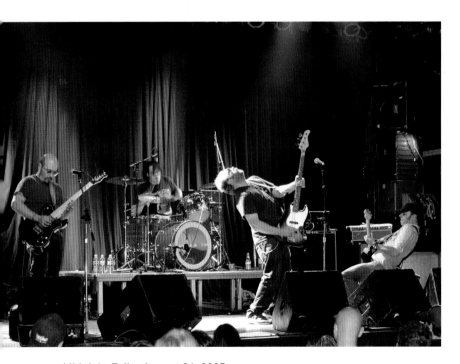

Midnight Evils, August 24, 2005

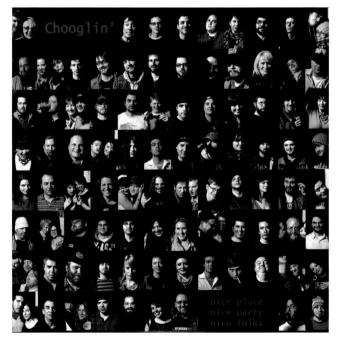

Chooglin's *Nice Place, Nice Party, Nice Folks*, photos by Daniel Corrigan, 2009

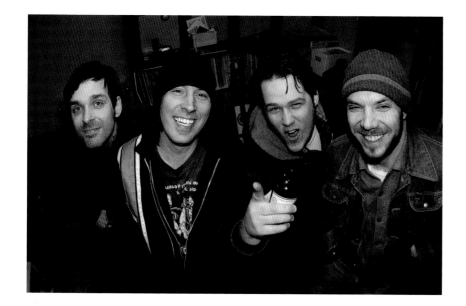

Chooglin', 2006

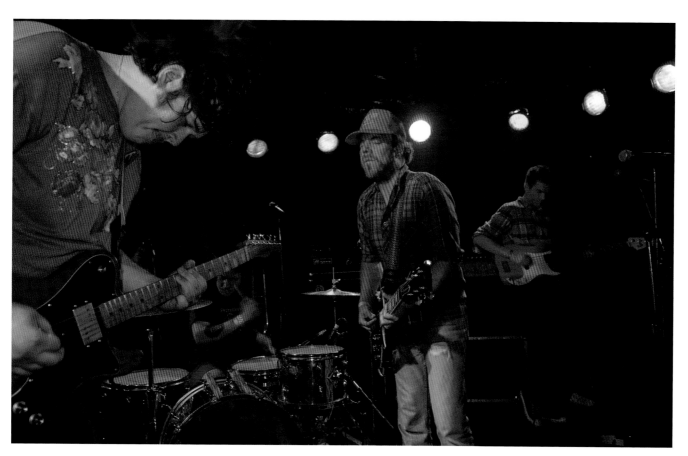

Chooglin' at 7th Street Entry, July 11, 2009

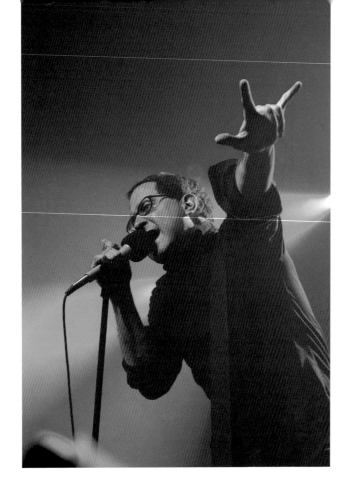

Left: Craig Finn of the Hold Steady,
November 15, 2008

Below: The Hold Steady, December 29, 2010

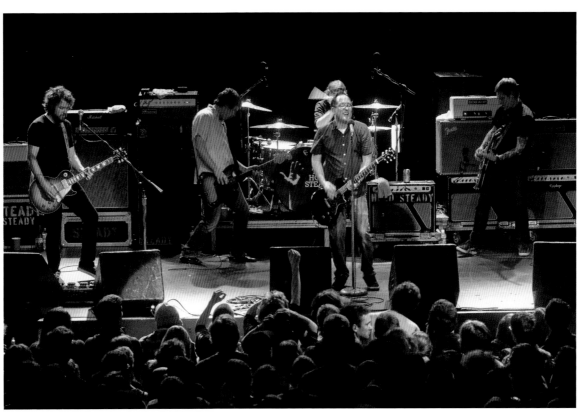

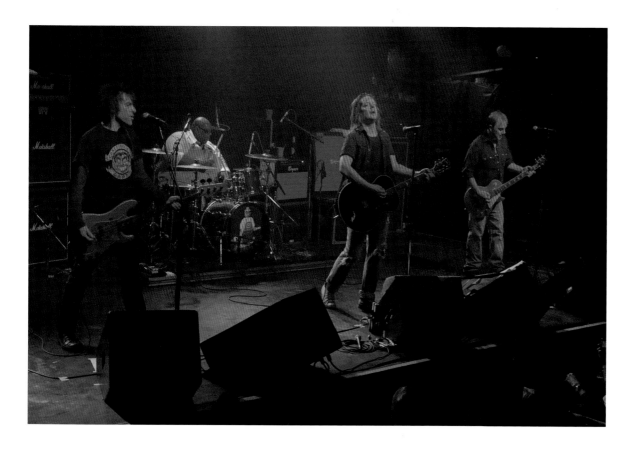

Soul Asylum—
Tommy Stinson, Michael
Bland, Dave Pirner, and
Dan Murphy—December
20, 2008

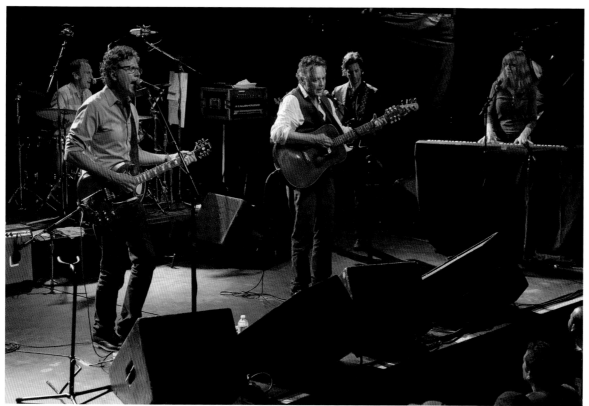

The Jayhawks,
June 20, 2010

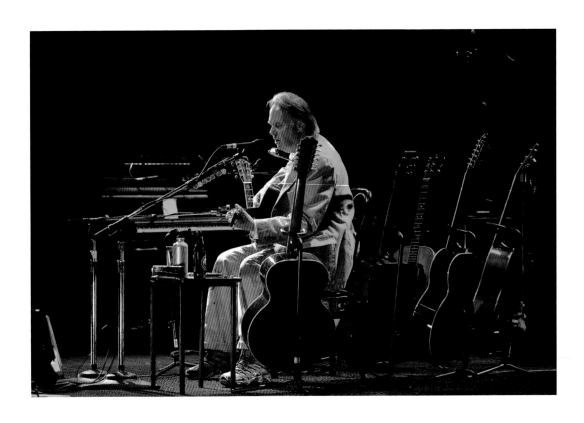

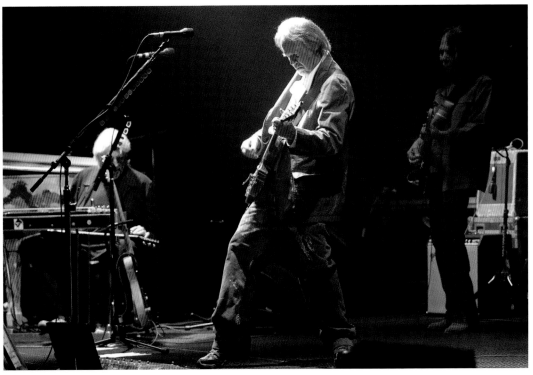

Neil Young at Northrop Auditorium, November 8, 2007

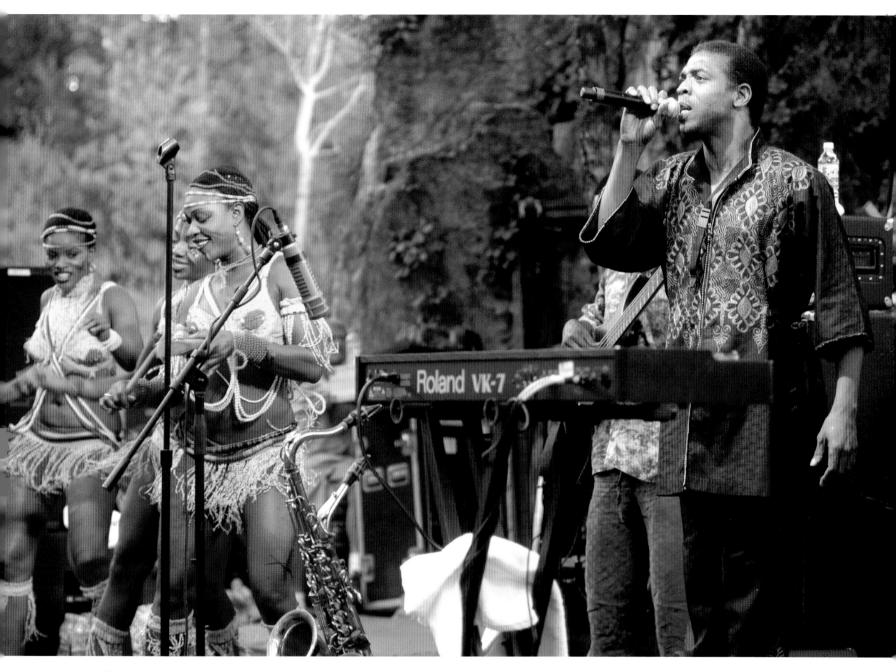

Femi Kuti at the Minnesota Zoo, August 2, 2007

Bon Iver at Rock the Garden,
Walker Art Center, June 21, 2008

Andrew Bird at Rock the Garden, Walker Art Center, June 21, 2008

Liz Phair,
October 4, 2008

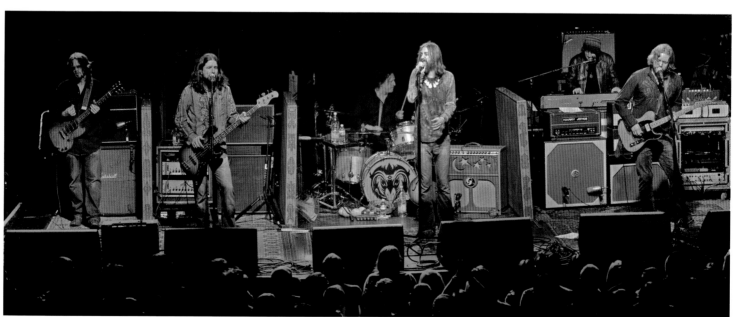

The Black Crowes, December 11, 2008

Slick Rick, August 21, 2005

Karen O of the Yeah Yeah Yeahs, April 18, 2006

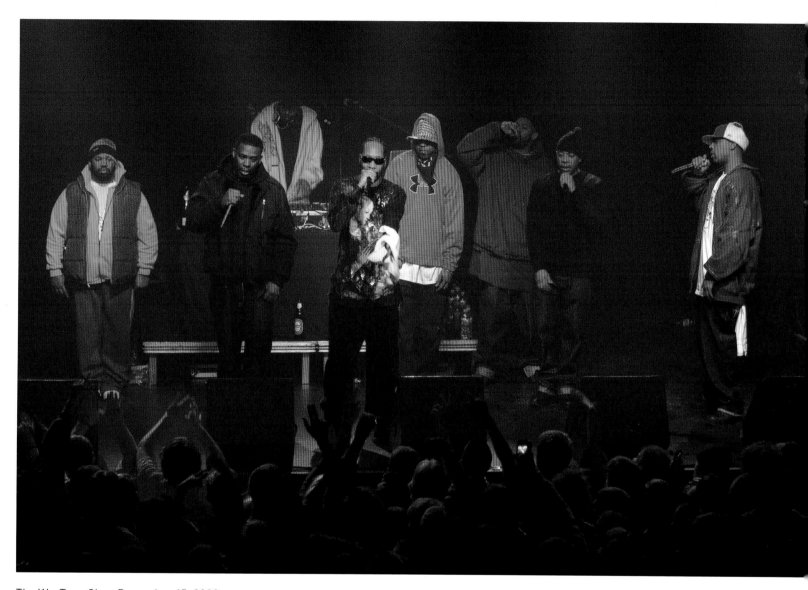

The Wu-Tang Clan, December 15, 2008

Left: Estelle, February 27, 2009

Below: Solange Knowles,
February 27, 2009

Jenny Lewis, June 3, 2009

Emily Haines of Metric, June 13, 2009

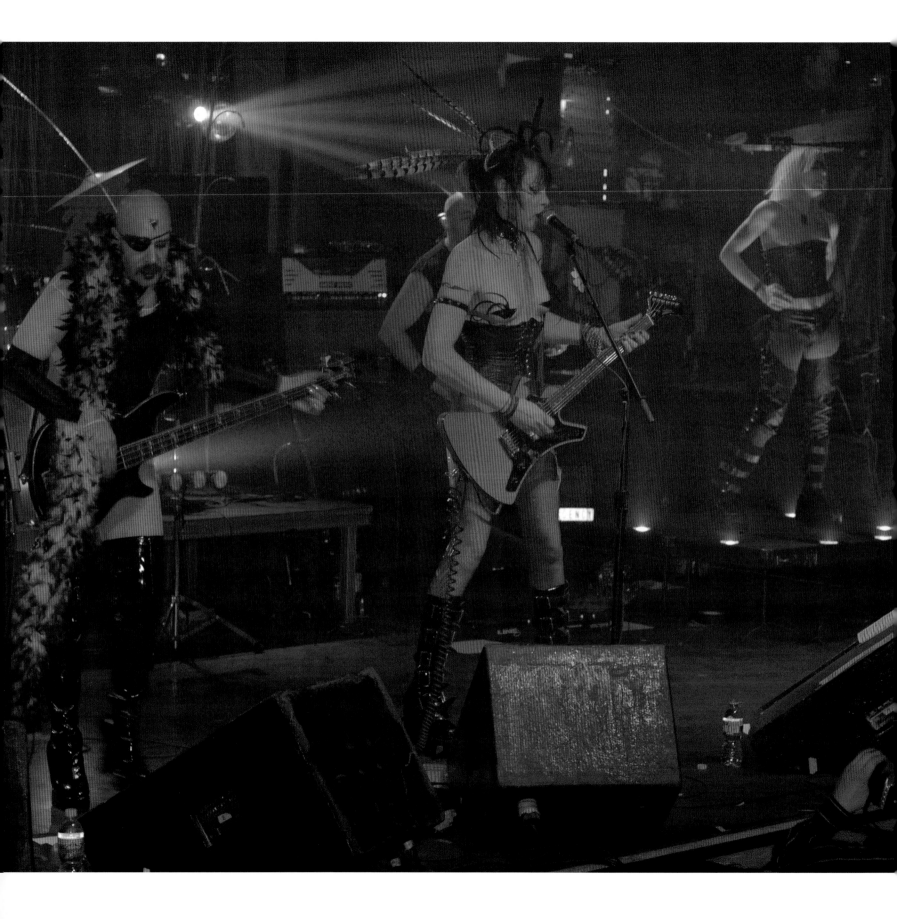

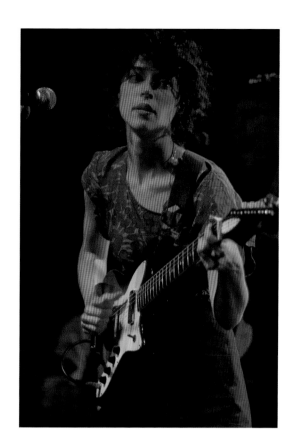

St. Vincent, June 4, 2009

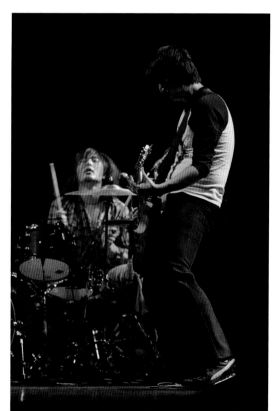

Birthday Suits,
October 11, 2009

Opposite: All the Pretty Horses,
February 13, 2008

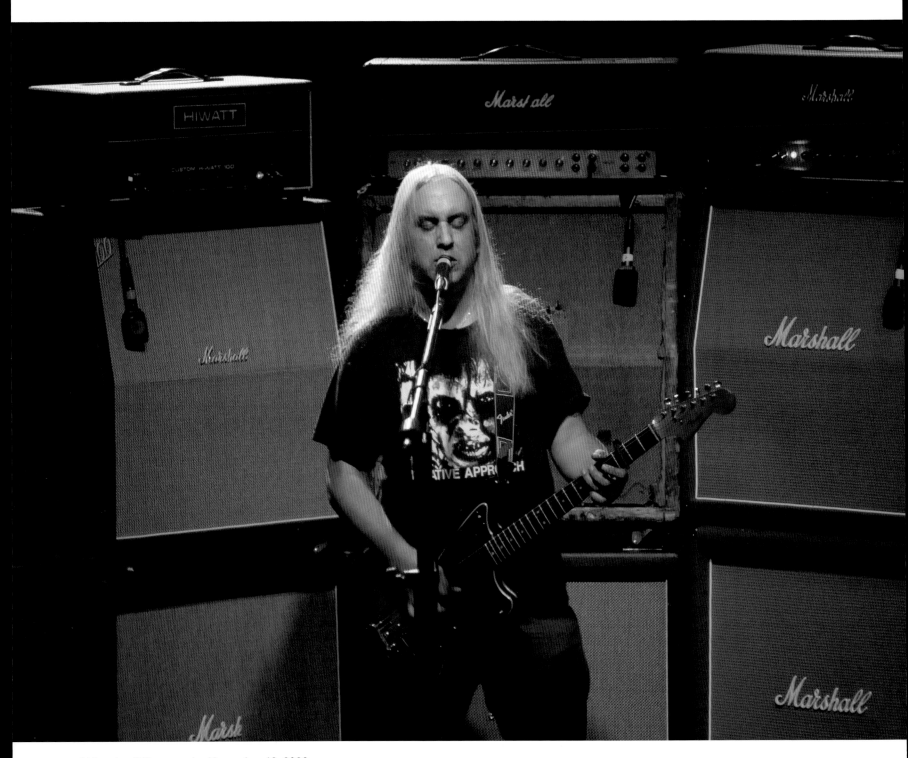

J Mascis of Dinosaur Jr., November 18, 2009

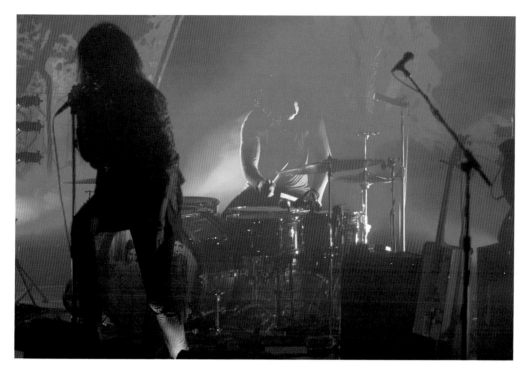

The Dead Weather,
July 27, 2009

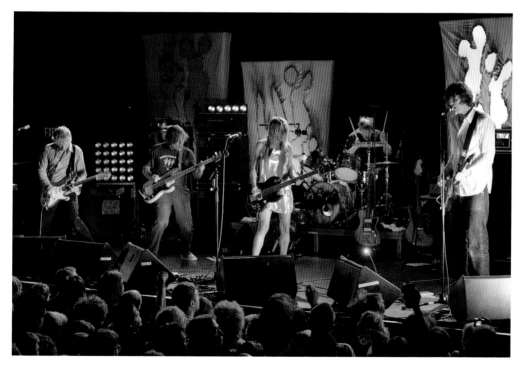

Sonic Youth, July 21, 2009

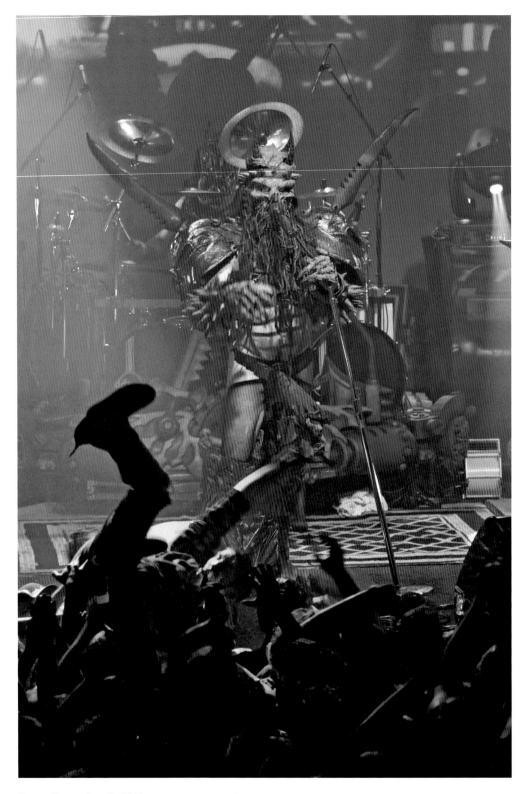

Gwar, November 2, 2011

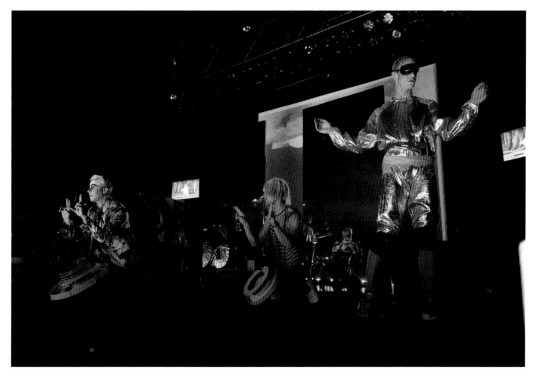

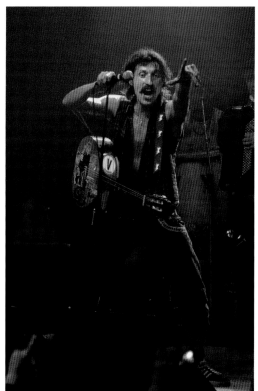

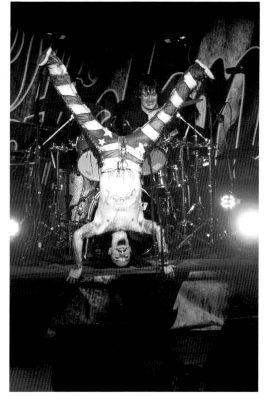

Clockwise from top left: Fischerspooner, May 29, 2009; The Darkness, February 12, 2012; Gogol Bordello, April 24, 2010

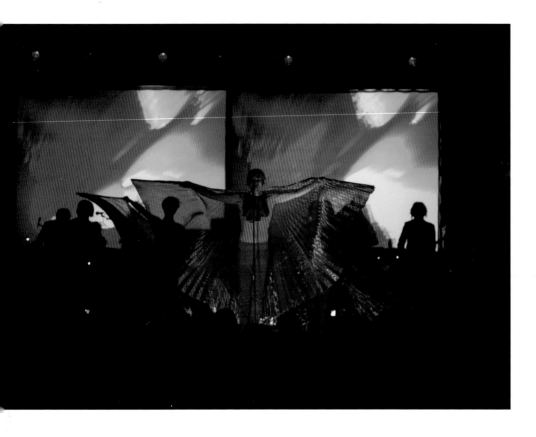

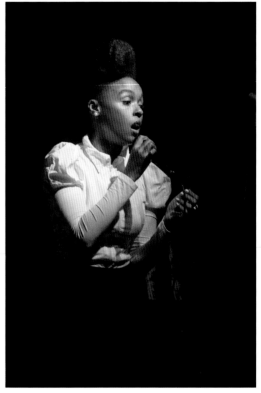

Above left: Of Montreal, September 23, 2010

Above right: Janelle Monáe, September 23, 2010

Right: Janelle Monáe joins Of Montreal onstage,
September 23, 2010

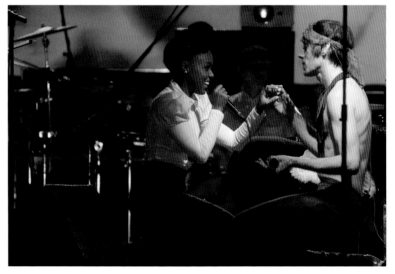

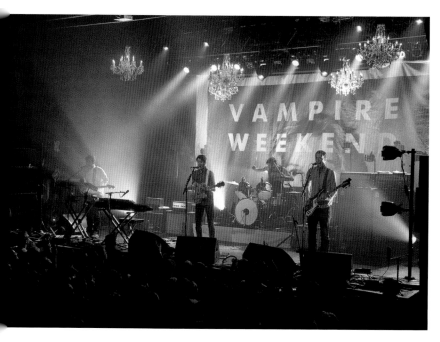

Vampire Weekend, March 22, 2010

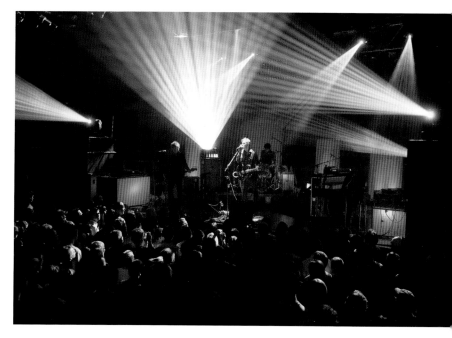

Spoon, April 3, 2010

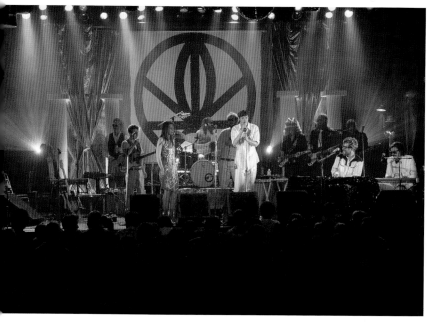

Gayngs, May 14, 2010

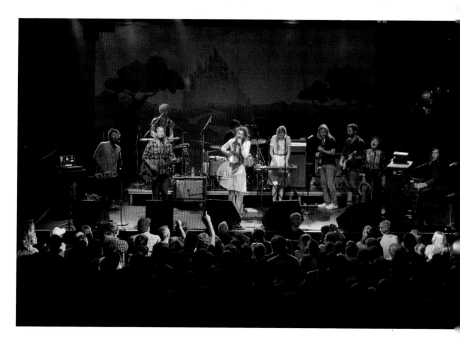

Edward Sharpe and the Magnetic Zeros, June 6, 2010

Trampled By Turtles, after earning their First Avenue star, with Conrad Sverkerson, April, 2010

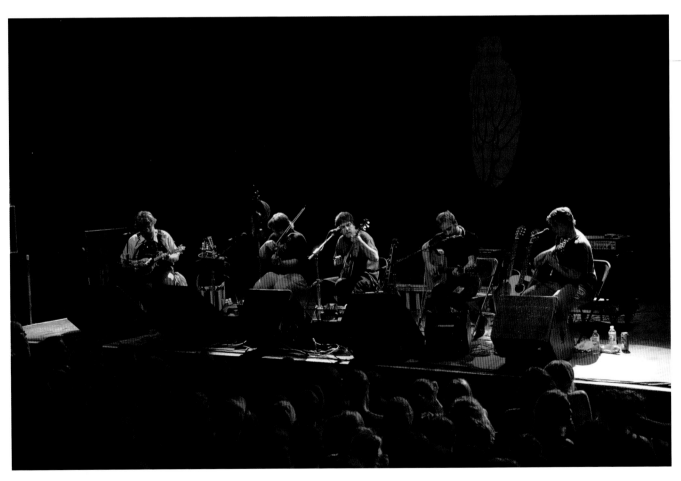

Trampled By Turtles, April 9, 2010

Left and below: Mumford & Sons,
October 29, 2010

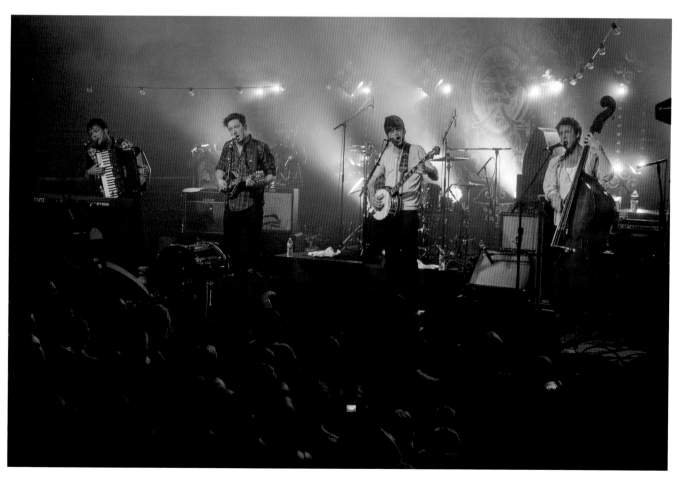

The Suburbs, 2010

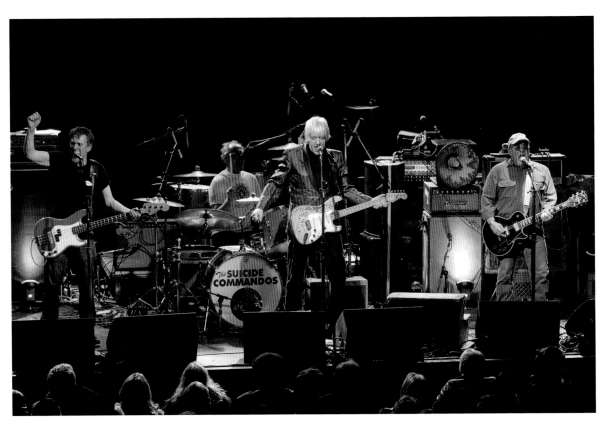

The Suicide Commandos with Curtiss A, March 1, 2014

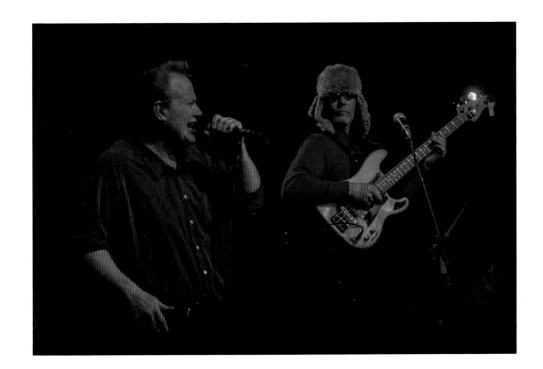

The Mighty Mofos at First Avenue's 40th birthday celebration, December 15, 2010

Mark Mallman, in 7th Street Entry, at First Avenue's 40th birthday celebration, December 15, 2010

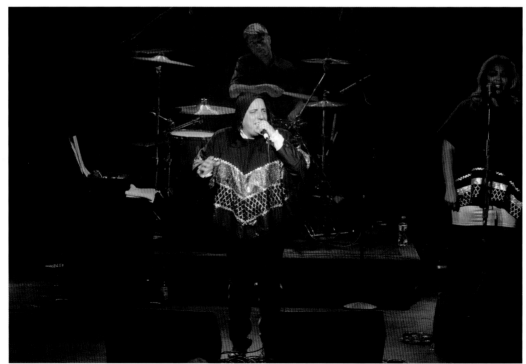

Clockwise from top left: Har Mar Superstar at First Avenue's 40th birthday celebration, December 15, 2010; Har Mar Superstar (Sean Tillmann), 2011; Har Mar Superstar, September 20, 2013

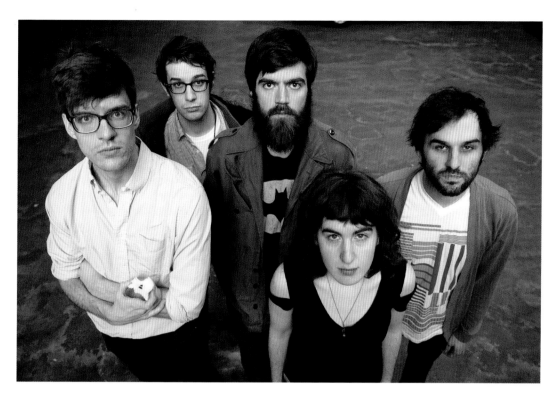

Titus Andronicus, 2011

Dosh, January 7, 2011

Communist Daughter, at the Tribute to the Replacements, November 26, 2010

The Brass Messengers, January 25, 2011

Caroline Smith,
January 14, 2011

Dropkick Murphys, March 3, 2011

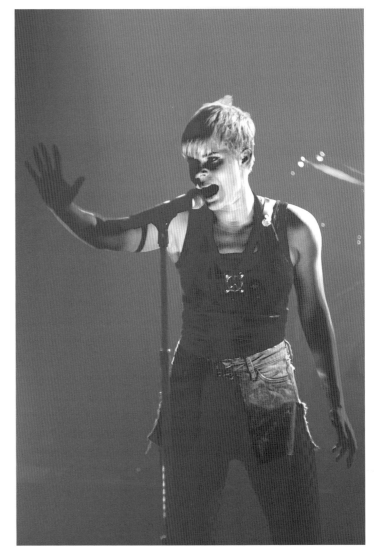

Robyn, February 13, 2011

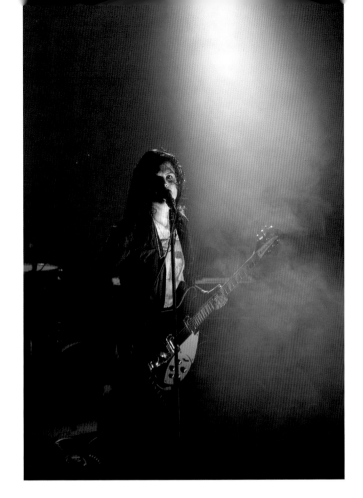

Left: Alison Mosshart of the Kills, May 5, 2011

Below: The Ting Tings, April 2, 2012

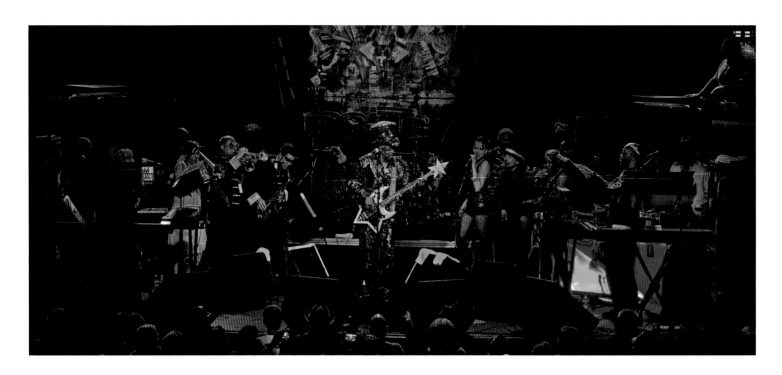

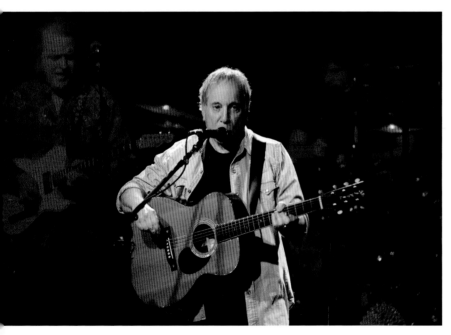

Above top: Bootsy Collins, June 30, 2011

Above: Paul Simon, May 3, 2011

Right: Antibalas, September 11, 2012

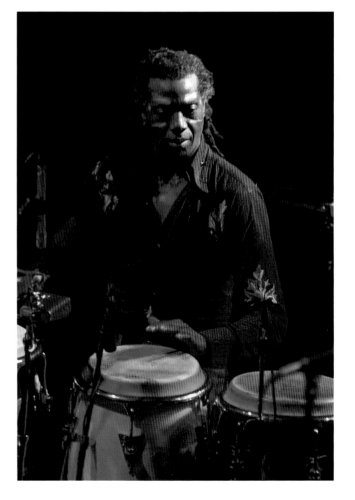

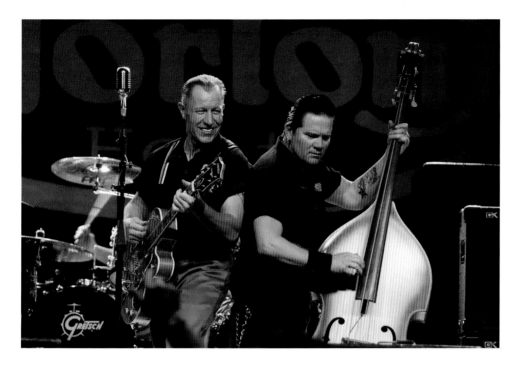

Left: The Reverend Horton Heat, March 1, 2012

Below: Social Distortion, October 19, 2010

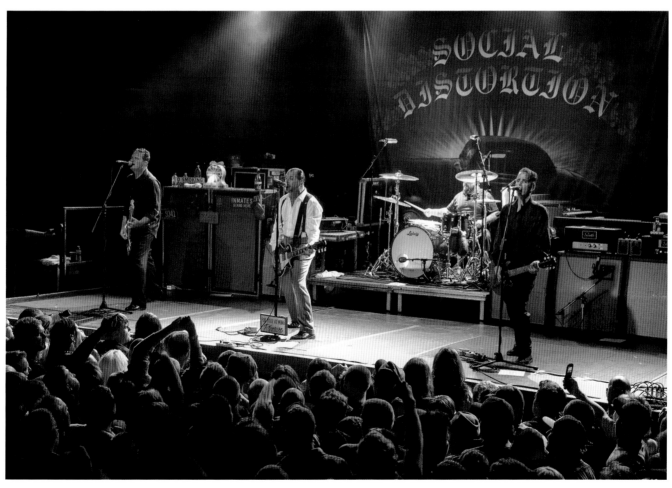

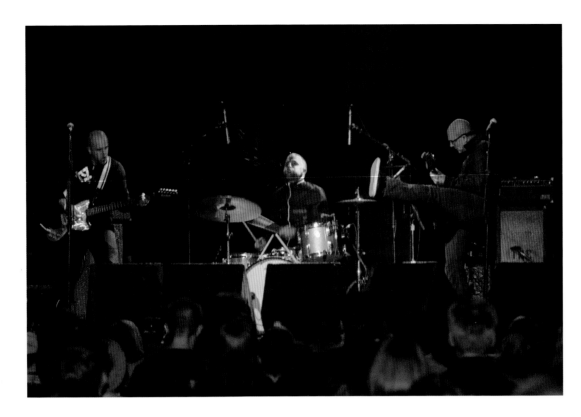

The Blind Shake at
the "Are You Local?"
showcase, March 2, 2012

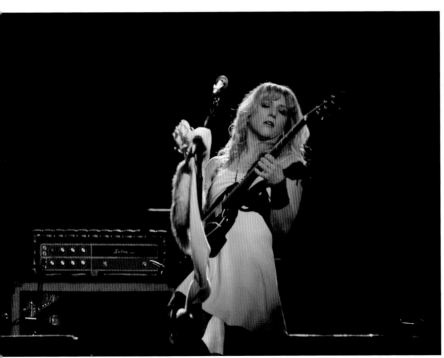

Christy Hunt of Pink Mink at the "Are You Local?" showcase, March 2, 2012

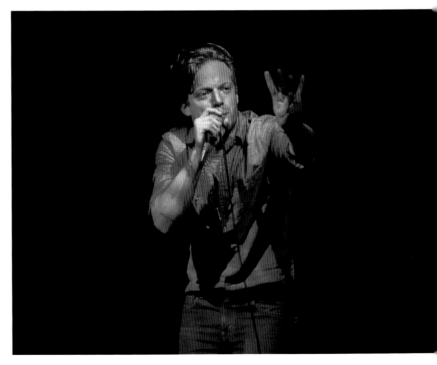

Astronautalis at the "Are You Local?" showcase, March 2, 2012

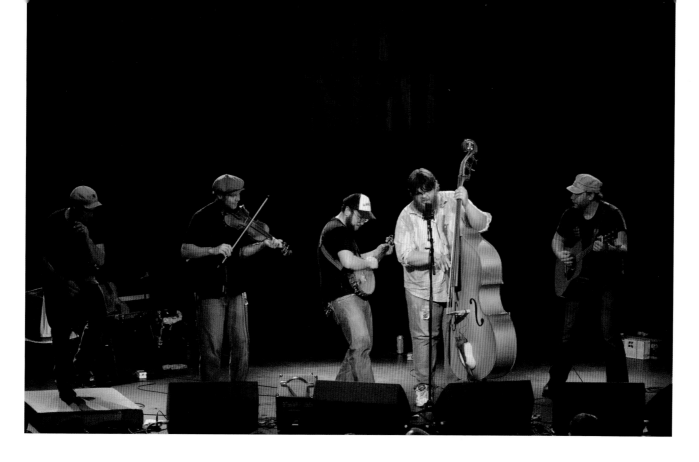

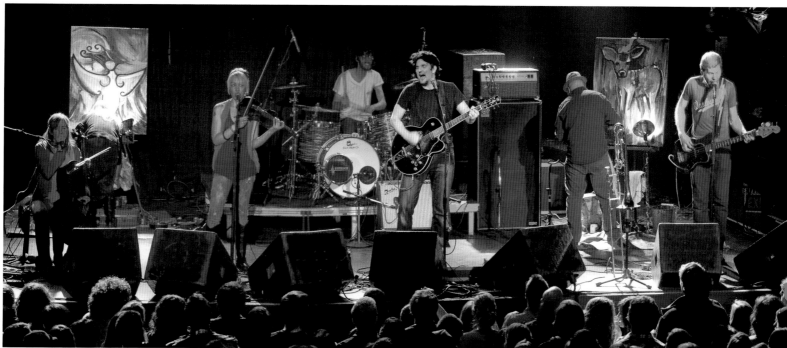

Above top: Pert Near Sandstone, April 6, 2012

Above: Cloud Cult, February 27, 2012

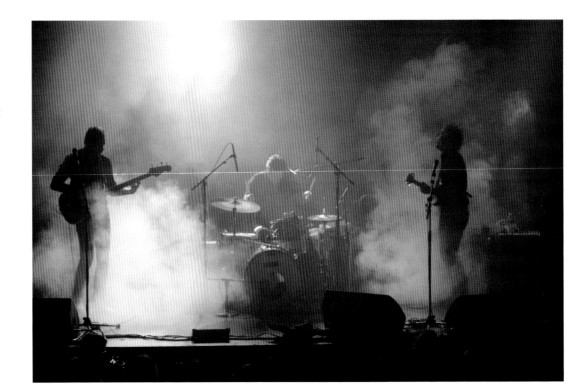

Retribution Gospel Choir,
October 12, 2012

The 4onthefloor,
October 12, 2012

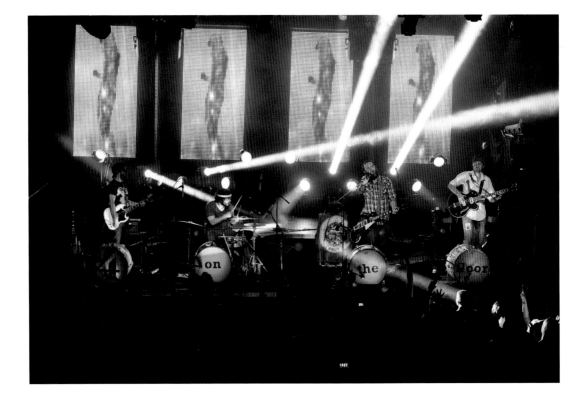

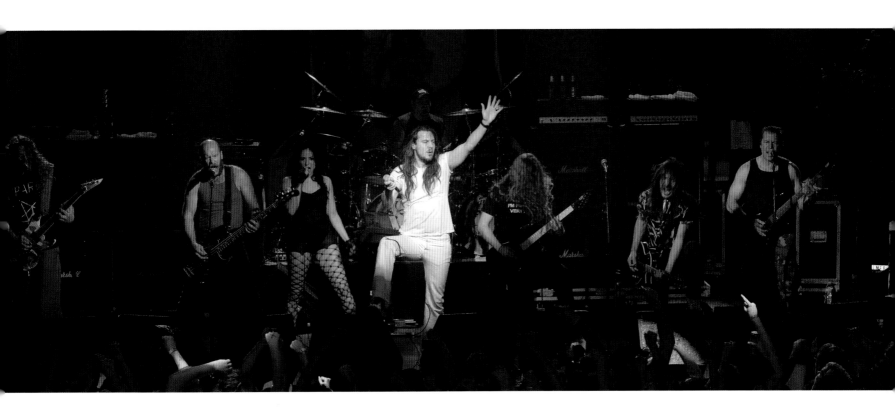

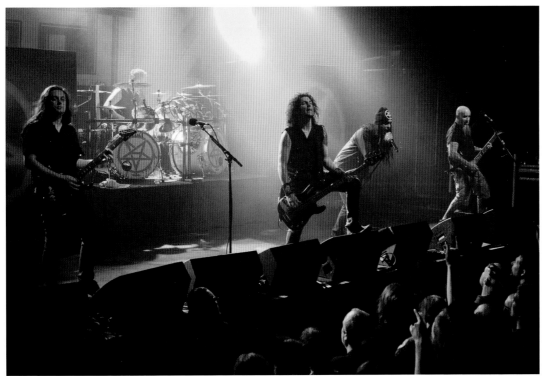

Above: Andrew W.K.,
March 23, 2012

Left: Anthrax,
April 4, 2013

G. Love of
G. Love & Special Sauce,
March 16, 2012

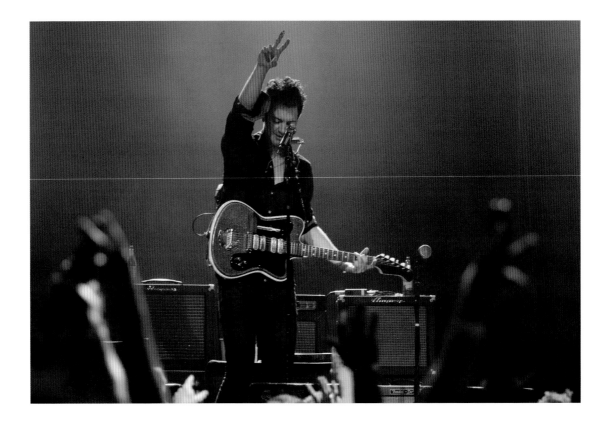

Matisyahu, August 9, 2012

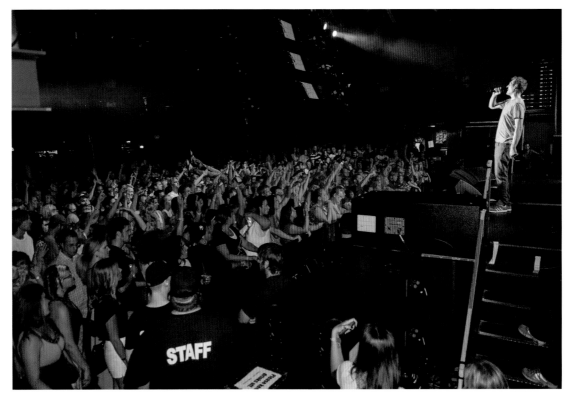

Far left: Buckethead,
April 17, 2012

Left: Amanda Palmer,
October 3, 2012

Yolandi Visser of
Die Antwoord,
August 4, 2012

Channy Leaneagh of Poliça, April 24, 2013

Nicholas David, May 11, 2013

Chvrches, September 9, 2013

Alt-J, September 7, 2013

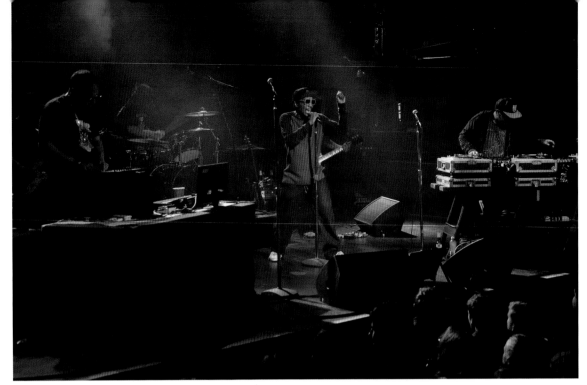

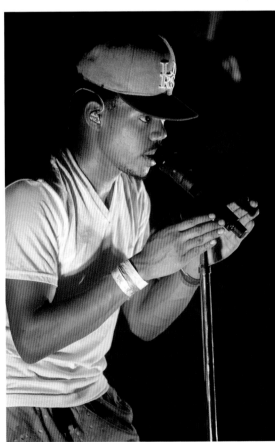

Clockwise from top: Deltron 3030, October 20, 2013; Ludacris, September 12, 2010; Chance the Rapper, December 9, 2013

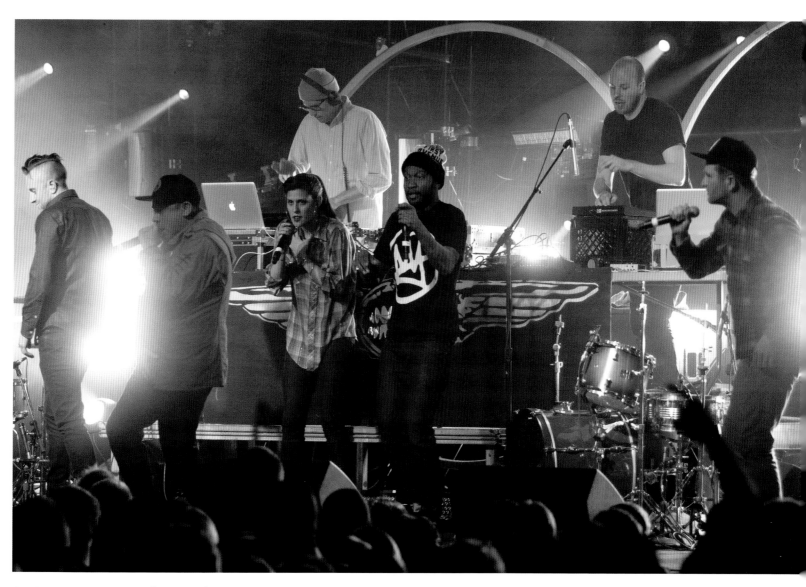

The Doomtree collective—(front row) rappers Sims, Mike Mictlan, Dessa, P.O.S., and Cecil Otter and (back row) producers Paper Tiger and Lazerbeak—at Doomtree's Blowout 8, December 14, 2012

P.O.S., October 24, 2009

Dessa, December 15, 2010

Sims (*left*), Mike Mictlan
(*bottom left*), and Cecil Otter
(*bottom right*) at Doomtree's
Blowout 9, December 15, 2013

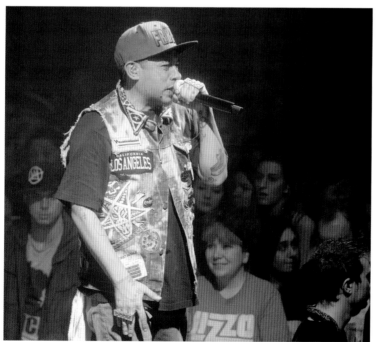

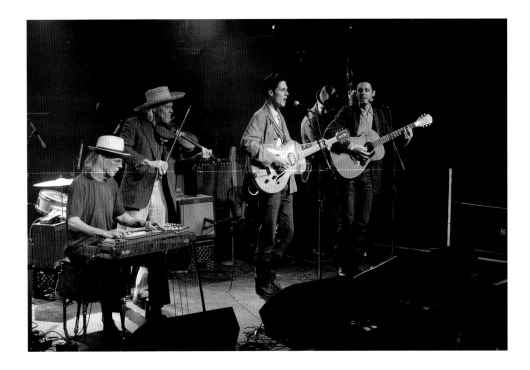

The Cactus Blossoms, May 4, 2013

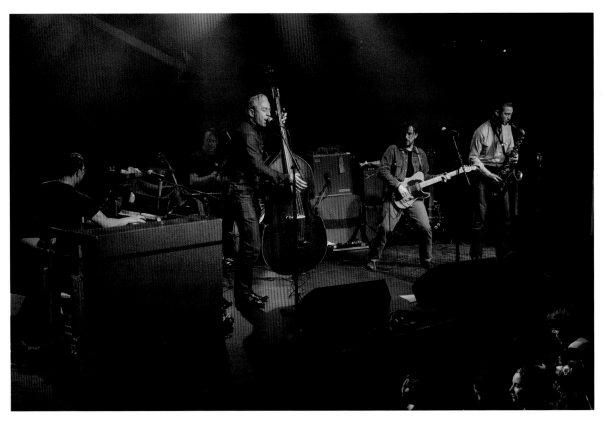

JD McPherson, May 4, 2013

Charlie Parr, April 19, 2013

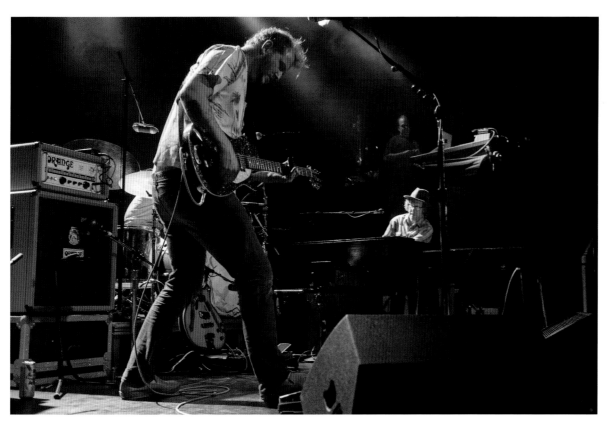

The Shouting Matches, August 2, 2013

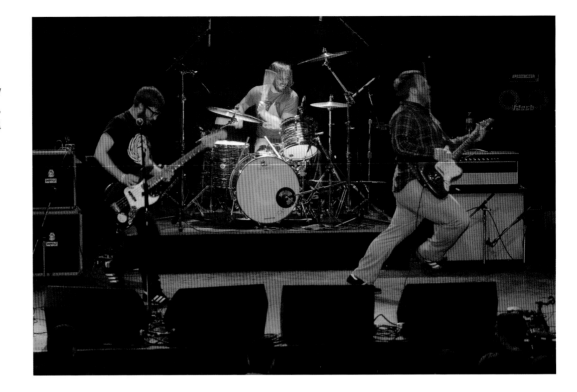

Fury Things at the "Best New
Bands of 2013" showcase,
January 30, 2014

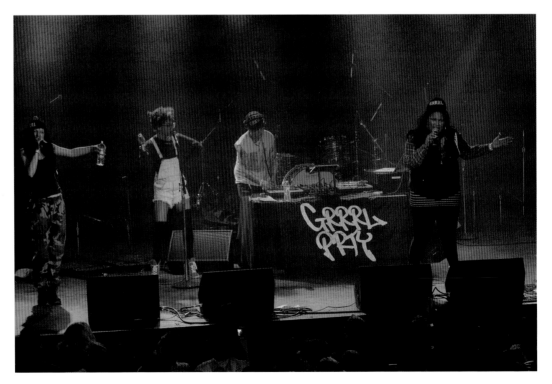

Grrrl Prty at the "Best New
Bands of 2013" showcase,
January 30, 2014

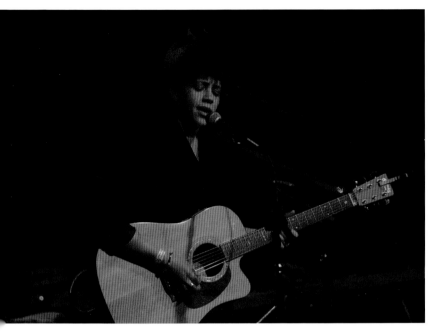

Chastity Brown, January 18, 2013

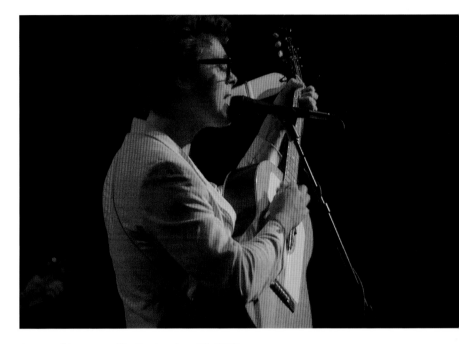

Jeremy Messersmith, September 18, 2010

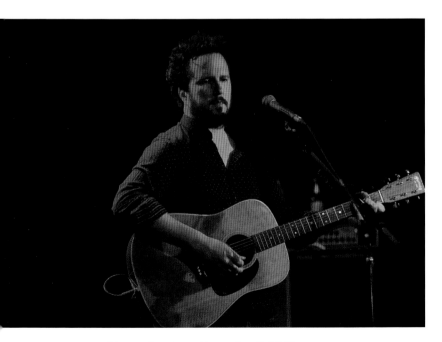

Mason Jennings, December 5, 2015

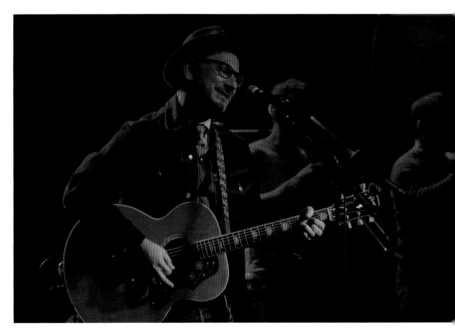

Adam Levy of the Honeydogs, November 27, 2013

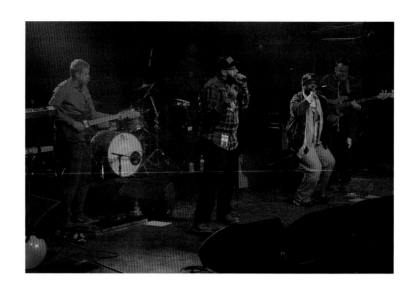

Right: Heiruspecs at 89.3 The Current's
8th Birthday Party, January 25, 2014

Below: Allan Kingdom at 89.3 The Current's
9th Birthday Party, January 23, 2015

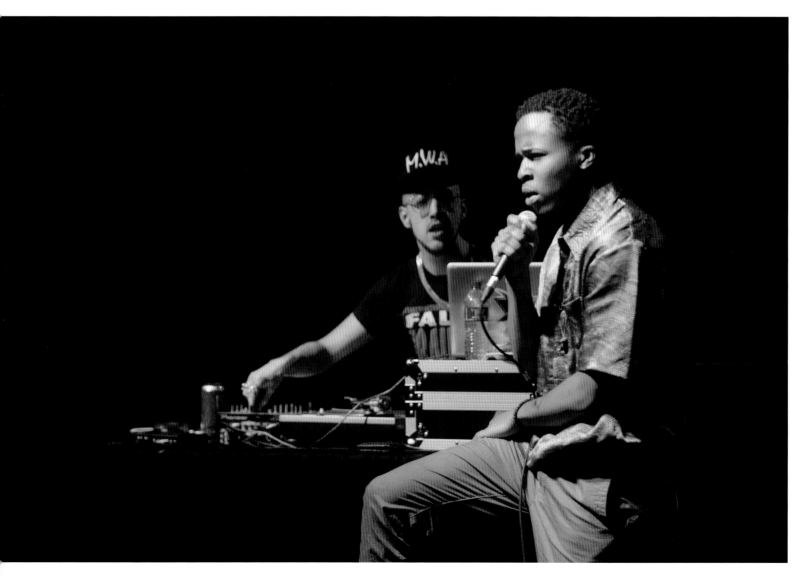

Above: Hippo Campus at 89.3 The Current's 9th
Birthday Party, January 23, 2015

Left: Haley Bonar of Gramma's Boyfriend at 89.3
The Current's 11th Birthday Party, January 23, 2016

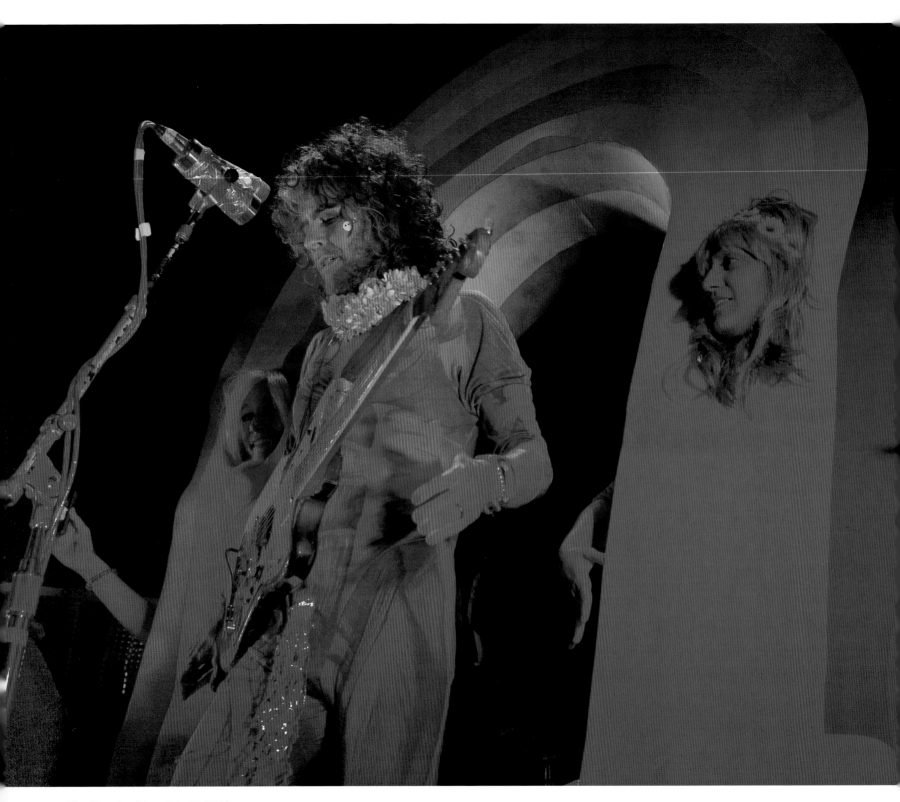

The Flaming Lips, July 15, 2014

Haim, May 19, 2014

Tegan and Sara, June 16, 2014

Lauryn Hill, June 30, 2014

tUnE-yArDs, July 17, 2014

G-Eazy,
November 15, 2014

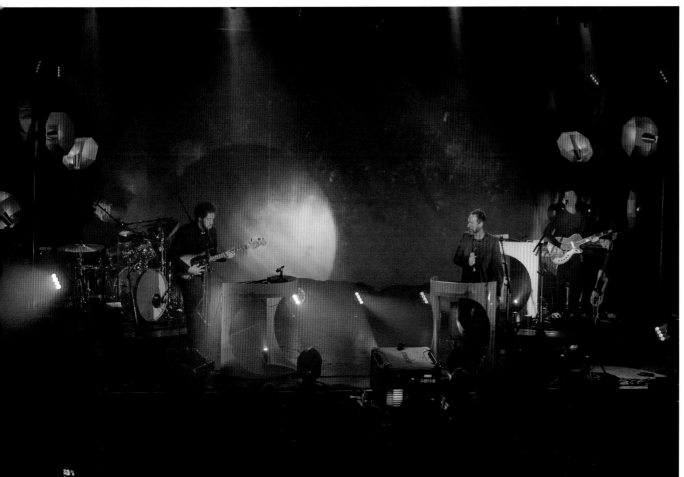

Broken Bells,
February 28, 2014

Odesza, November 24, 2015

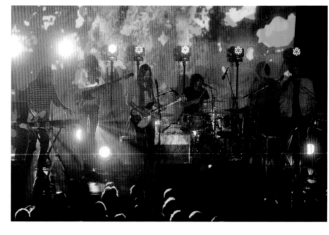

Tame Impala, May 13, 2015

Twin Shadow, April 13, 2015

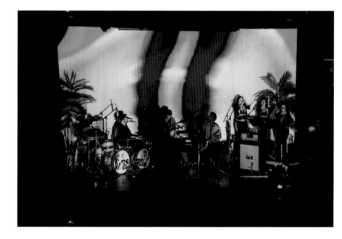

The Arcs, December 1, 2015

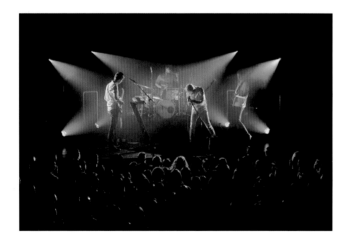

El Vy, November 21, 2015

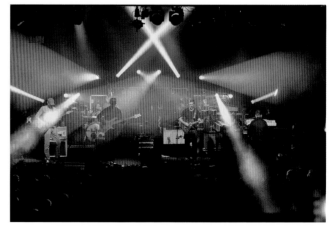

Umphrey's McGee, April 25, 2015

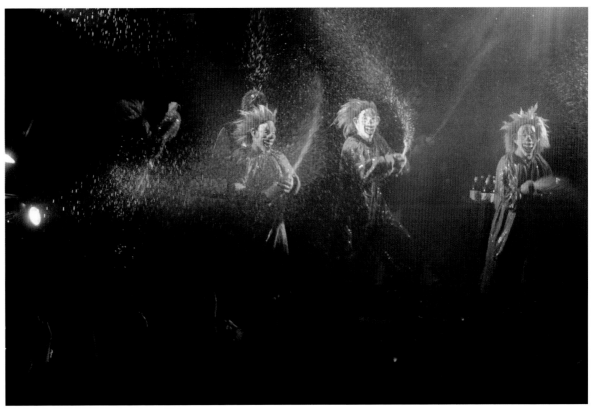

Insane Clown Posse, November 5, 2015

Leon Bridges,
October 28, 2015

Low, January 22, 2016

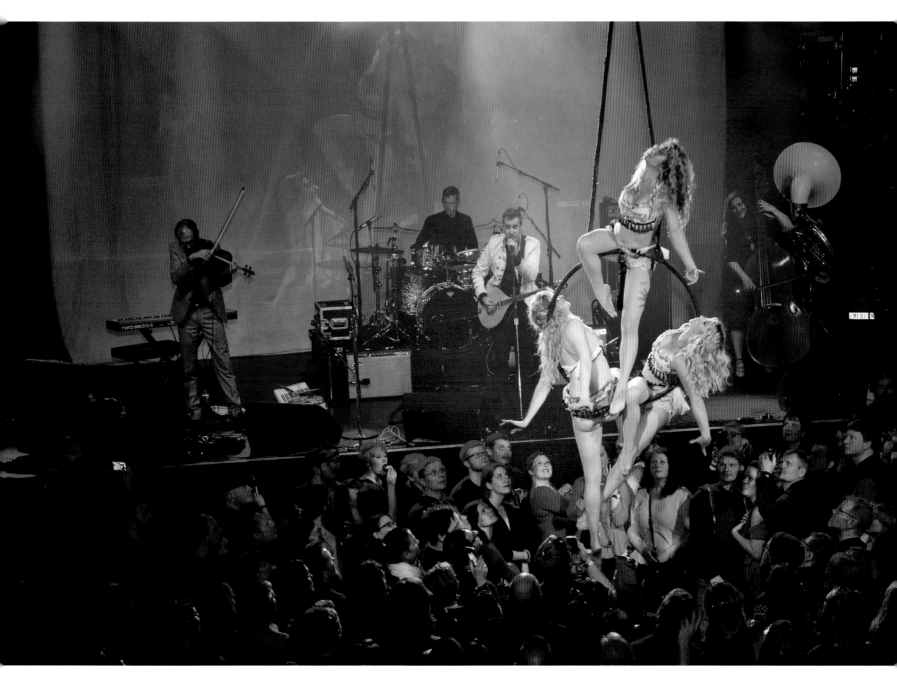

Devotchka, February 13, 2016

First Avenue

While working at the *Minnesota Daily* as a photo editor in the early 1980s, Dan had ingratiated himself with the staff at Minneapolis's burgeoning music venue First Avenue. Dan was able to pick and choose his assignments for the paper, and like any music enthusiast would, he gave himself any jobs that involved live music at First Avenue.

"I didn't start out being 'Dan Corrigan at First Avenue,'" he explained. "I just started hanging around, and all of a sudden I'd been around so long people assumed I worked there. I was really just another face in the crowd. When I was there to shoot photos, I hung out and got to know everyone. We talked and joked around, but when I was done, that was it. I was gone. That was how my job came to be: I just loved being there."

As his familiarity with the club grew, Dan developed and refined his instincts for getting the best pictures in the live music setting. His bag of tricks expanded, and his style for shooting live performance took form. As he found the right angles around the room and placed himself in the right position in relation to the stage in order to get the best shot, he fostered a growing partnership with the club.

"I always became friends with the lighting guys. When I would be working in the Entry, I would show up for sound check and see how the bands were going to set up, and then I'd ask the sound guy if I could move the lights around. I'd get up there and put the lights where I wanted them for that night."

After about a decade shooting pictures at the club for various publications, Dan's relationship with First Avenue became official when Molly McManus, the club's director of operations, proposed that since Dan had been around so much shooting shows, he should work for the club to create an ongoing archive.

Dan holds the position of First Avenue's house photographer to this day, shooting about a half dozen shows per month and building the club's ever-expanding archive of live performances seen through his eyes.

First Avenue after hours

"I've been shooting at First Avenue for so long, and there's a lot of different angles for taking pictures. The stairs used to come down differently on the stage left side. The stairs came down mid-room, and there was a platform where I could sit cross-legged on the floor and have an unimpeded view of the band. I was out of everybody's way. I would set my bag down and go to work. That changed, however, and they moved the stairway to improve the crowd's view."

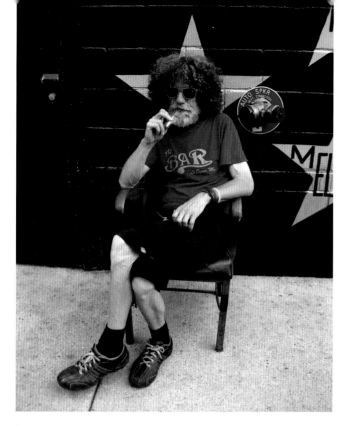

Stage manager Conrad Sverkerson, another longtime fixture at First Avenue, in 2012

Over the years, Dan attained more and more responsibilities working at First Avenue. Tapping into his love for production and for assembling shows, Dan took on the role of stagehand for some of the bigger shows that came through the venue. From loading in the bands in the morning to sweeping the stage at the end of the night, Dan developed a love and respect for First Avenue that went beyond photographing the performers. He became an integral part of the ship and its cast of characters.

"Our co-worker Mika once said, 'First Avenue is a pirate ship that doesn't go anywhere.' I think that rings true on so many levels."

"First time I sat down with Conrad to have a beer he basically told me he hates photographers. He said that right to my face. I know where he's coming from. In a way I completely agree with him. The way photographers feel entitled to stand in front and block the show. That's bullshit. Conrad has always appreciated that that isn't my style. Hopefully I've changed his attitude about photographers."

And it takes a lot of work to keep that pirate ship afloat. "It's always being cleaned, painted, and patched.... That's something you can't take for granted. First Avenue has a reputation to live up to. That doesn't just happen."

Dan recognizes the spiritual balance of First Avenue, believing that the club's unique shape contributes to the magic that happens on stage.

"First Avenue is all circles. The front of the building is curved, and the space behind the stage is too. I believe that acts as a parabolic mirror—not just for reflecting sound but for reflecting psychic energy. It focuses the energy of the performance out onto the crowd. I think it's that weird architectural fluke that makes the room so special. It really wasn't designed for that."

A fixture at the club for three decades now, Dan continues to work on staff, assisting the facility manager on anything and everything that needs to be done at the venue on a daily basis. Taking care of every nook and cranny of the building, Dan will tell you with pride that his job is essentially "painting First Avenue black."

"I really love taking care of First Avenue. I probably know the building as well as anybody else." ★

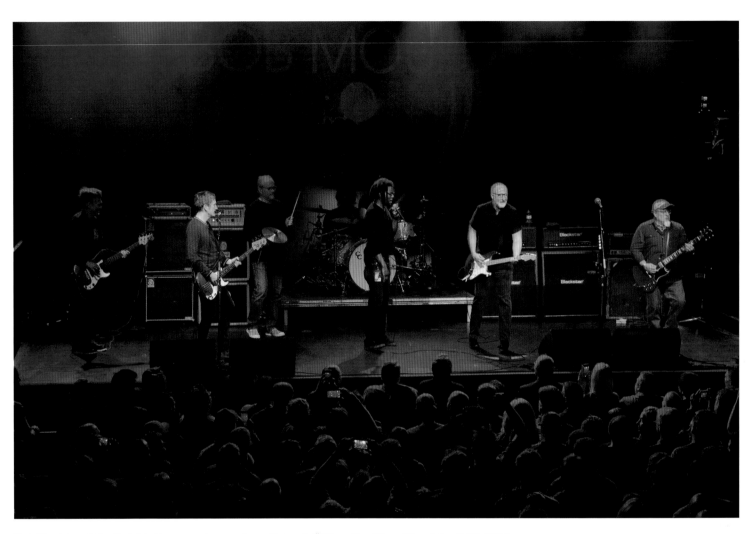

Bob Mould and the Suicide Commandos perform Prince's "When You Were Mine," April 23, 2016

Postscript

With the publication of the first edition of this book, Dan Corrigan and his work reestablished their place in the hearts and minds of music lovers everywhere. Like a yearbook of sorts for the Minnesota music scene, *Heyday* sparked countless memories through the album covers, press images, and concert photos he'd shot over the course of nearly four decades. The images highlighted many notable artists as well as some who were only a flicker on the concert calendar but who now live forever on these glossy pages. This connection between Dan's images and other people's experiences was an especially rewarding, and somewhat surprising, consequence of putting this book together and sharing it with the community.

While such real-life connections evoked by still-life images are commonplace in the age of social media, this book put a spotlight on the distinctive style that Dan developed as a professional, semi-professional, and hobby photographer over the decades. In the modern digital world of perpetual documentation, we too often lose the soul of the person behind the lens trying to present just the right shot to tell a specific story. Ultimately, *Heyday* revealed Dan Corrigan's ability to tell a good story.

This new edition of *Heyday* brings together some gems from the cutting-room floor as well as new photos that illustrate what Dan has been shooting in the years since the book was first published. He also reflected on what publishing *Heyday* has meant to him and how his perception of his life's work may have changed now that it is immortalized on the printed page.

Danny Sigelman: It's remarkable that two years have passed since we started working on the book, but it's a lot of fun to think back to all the events and the ripple effect following the release of *Heyday*.

Dan Corrigan: Doing the press for the book and telling stories was a huge deal. It made me realize even more how much I love telling stories. I loved having the chance to tell a bunch of stories while discussing the book, and I think my life has turned even more that way. I think doing the tours at First Avenue is part of that, too.

At the same time, it's interesting that I've fallen even further away from my photo career. I still do pictures here as the house photographer shooting live shows. But I've been looking at that more and more as part of the production aspect of my gig here. I get a lot of requests for prints of some of my past work, but I really have drifted away from my photographer life.

DS: You did start more as a behind-the-scenes technical guy, and it's almost like you've come full circle here. But you said you are still shooting photos. Do you still get excited about it?

DC: It's curious that's where I'm ending up, and I'm completely happy with that.

I still love seeing shows. One of my favorite things to do here is shooting from up top in the owner's booth, where the lighting guy sits. From up there I can get a shot looking down on the stage. I love getting a shot of everyone on stage and all the equipment. I love having all the details of who and what. In a way it's evidentiary. There are still fancy light shows that you can really make some art out of the image. There's two missions: to document

The Black Angels at First Avenue, March 23, 2018

but also to present the feeling of the show. That's maybe more subtle than it was when I was younger.

DS: What do you think you may have learned about yourself from digging up these photos? This is stuff that you'd seen through the years, but they were dusted off and now they live on forever in *Heyday* and are exposed to a lot of other people for the first time.

DC: Yeah, I'm really proud of it, no doubt. I still have this feeling—and particularly with Chris Riemenschneider's *First Avenue* book, which features some of my photos as well—that the best pictures are of the audience and not always what's on the stage.

DS: Your love for and familiarity with the building allows you to find angles that incorporate the audience more.

DC: If you look at my pictures now, that's a huge part of it. That's the magic, when the club is full of people. I'm usually the first one here in the morning, and there's no one

here. When this room is empty, it doesn't seem that big. But when you fill it with fifteen hundred people, the room takes on a different weight. It seems much bigger. If you have a spectacular performance going on as well, it seems even bigger. It's like wow! That always strikes me.

We're lucky: people love playing in this room. It's a great room to see a show in, and those two things work together so nicely.

DS: It seems you are drawn to things that are more of a production. With some of your earlier photos, it seems it was sometimes your job to create the energy, taking photos of people in flannel shirts pretty much just standing around.

DC: Son Volt—whom I love—they just stand there and play. And that's okay. But it isn't the most fun show to shoot in the world. But something like Mac Sabbath, that was a spectacle, and I always love that. That was a blast! It was like, holy shit, bring it on! I love the big productions.

There's this guy, Paul Guthrie. His nickname is "Arlo," everyone knows him as that. He is a top-of-the-heap professional, concert lighting guy. He toured for twenty years. Toured all over. He's basically retired from touring now. In his retirement, he's started a lighting company and now does stuff for Doomtree and others. Last time I saw him he did Marijuana Deathsquads and Low. His lighting is so amazing. When I see Arlo pull up with some lights, I get so excited. He puts on such a beautiful show. It's so fun to shoot.

I still get gassed to shoot shows here at First Avenue. It's an experience, it's a show. I guess there is varying degrees of show.

DS: A lot of bands now that are just showing up with laptops and don't have many instruments and whatnot really need to put on a show, since there isn't that much to watch.

DC: There has to be something really amazing. I think when there's some interpersonal connections within the band, or a front person with a big personality, that's part of the craft as well. But you can't just come in and push a button. They did a contest here for producer of the year. It came down to the top finalists, and they literally just walked up and pressed a button to start the song. That was it. I mean, I guess it is what it is.

DS: You've said before you are the "intern for the ghost of First Avenue." What do you mean by that?

DC: Being a photographer, I kind of took on a character. There's a character I play. I still like being this character, but what is it now? It's not just Dan the photographer. In 2004, when the ownership changed at First Avenue, I made a distinct commitment to the club. In the time since then I see that I have been able to develop that character, doing the tours of the club and showing off this place. I really love what I'm doing now. It's also the storyteller thing. I've always liked telling stories.

Like the story of Scheherazade [from *One Thousand and One Nights*]. The king would take a wife, sleep with her that night, then kill her. He went through like hundreds of wives, and when he got to Scheherazade, she knew what was going to happen to her. So, she started telling him a story, and she just kept on going and going. The king was taken in by the story, and when he finally was about to fall asleep, she told him they would continue the story the next morning. Basically, she kept on telling the story. She stayed alive by just telling the story until the king fell in love with her, and all was well.

DS: So, telling stories keeps your character alive?

Man descending a staircase, 7th Street Entry

DC: I still have a huge interest in photography, I just don't have much interest in it being a job. Working here is my job, and the photography I do for the club is part of telling the stories.

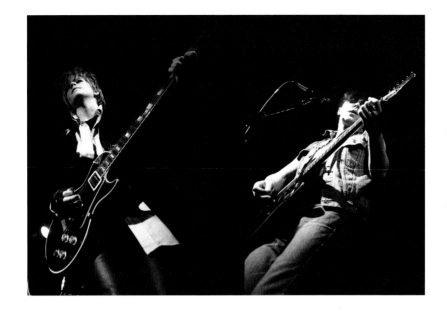

Left: The Flamin' Oh's, 1985

Below: The Plastic Constellations, 1999. "I was so convinced the Plastic Constellations were going to be the next huge thing out of Minneapolis. I loved them so much; they were everything I wanted out of a band. Turns out that really wasn't where Aaron Mader was going." (Mader, better known as Lazerbeak, would go on to be a founding member and DJ/producer for Doomtree.)

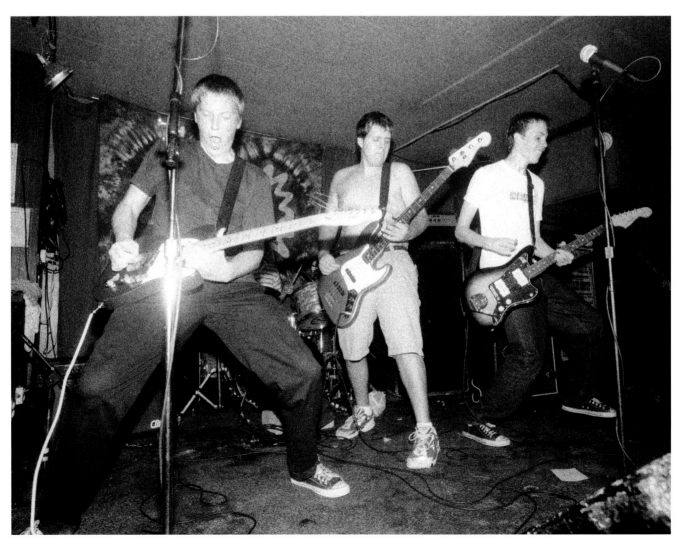

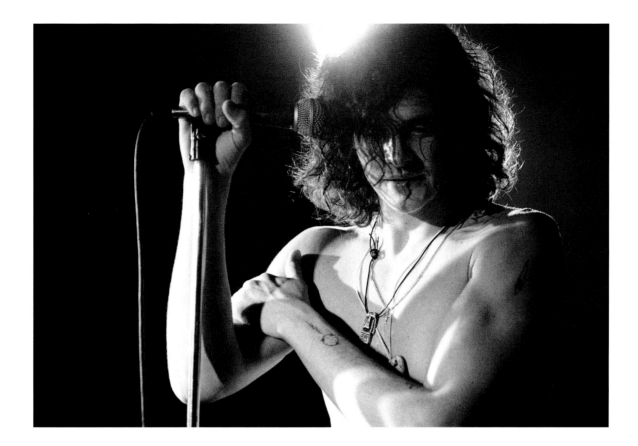

Last Crack, 1990

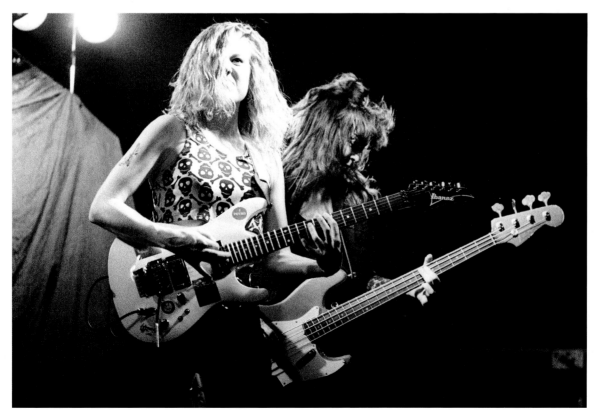

No Man's Land, 1991

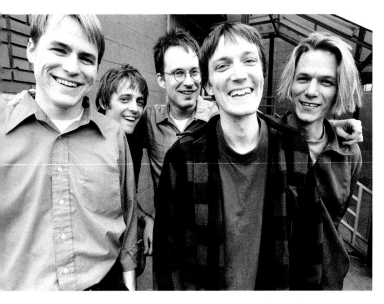
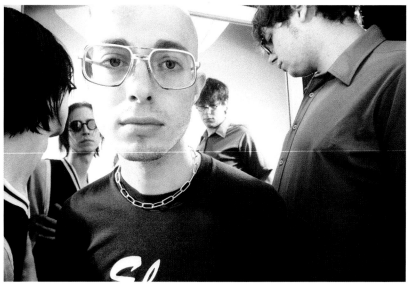

Clockwise from top left: The Hang Ups, 1997; 12 Rods, 1998; Kristin Mooney, 1999; Anne Deming, 2000

Clockwise from top left: The Blind Shake, 2016; Porcupine, 2016; The High 48s, at Aster Café, 2018

"When I started photography, people were what interested me about it. I loved doing simple headshots. When I first got a job at the *Daily*, because I was the rookie, they would send me out to do the headshots. We called them 'mugs.'

"No one really liked doing those, but I loved it. It's so simple. You find some nice light to put your subjects in and make them feel comfortable enough. Part of my technique is I can do that fast. That's part of the photographer character. That's a way in and part of my shtick. I really like the close but brief interaction.

"It allows them to be a little vulnerable for that quick second, give them some room to breathe. I love that. You know: stand there, look here. Especially today, profile pictures are hugely important. You get one shot to tell your story. Looking at people's Facebook profile pictures can be agonizing for me. All I want to do is ask nicely, 'Can I please help you?'"

Left: Jillian Rae at 7th Street Entry, July 19, 2017

Below: Surfer Blood at 7th Street Entry, June 14, 2017

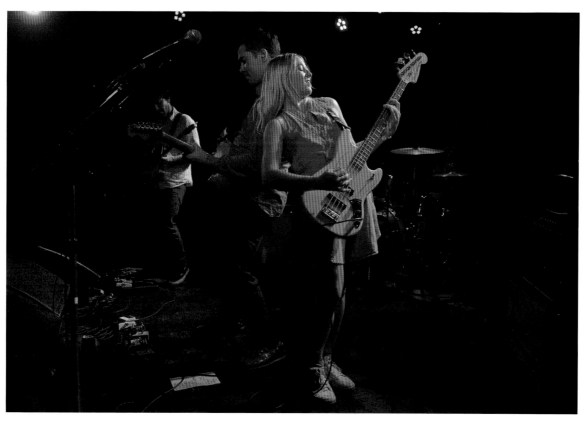

Børns at the
Palace Theatre,
January 24, 2018

Portugal. The Man at
the Palace Theatre,
February 9, 2018

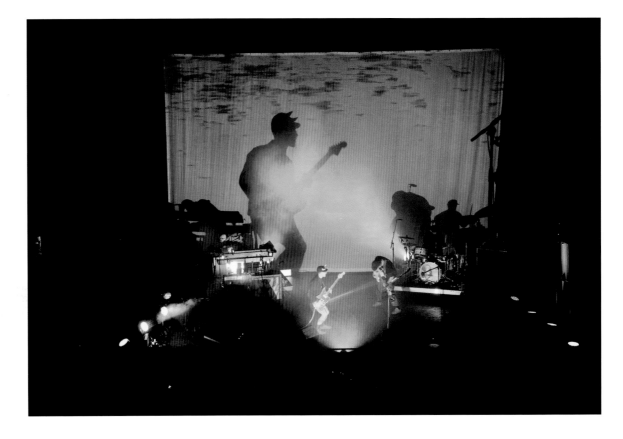

The String Cheese Incident at the Palace Theatre, April 5, 2017

Index

"There's something infinite and timeless about Daniel Corrigan's photos, and in this long-awaited collection, you can almost hear the sounds of music erupting off the pages. Corrigan has always been an artist capturing artists, and *Heyday* is stuffed with so many moments of joy, passion, chaos, and rapture, it's difficult to believe it's the work of just one photographer. All in all, a glorious chronicle of some of the greatest times of our lives."

—**JIM WALSH,** journalist, songwriter, and author of
Bar Yarns and Manic-Depressive Mixtapes and
The Replacements: All Over But the Shouting: An Oral History

"Daniel Corrigan's iconic photos first appeared to me as a window into an exciting music scene happening in my hometown. He took the pictures I most associate with my favorite bands, and captured both the cool and the intimate moments of rock-and-roll bands and their audiences. Years later, in my own band, I was thrilled to be photographed by Dan. These images tell a story of a rock scene that is still important, influential, and timeless."

—**CRAIG FINN,** singer/songwriter/guitarist
for the Hold Steady

"I remember the first photo shoot we did with Dan. It was over in the warehouse district. He put us on a pile of tires. I like that he doesn't just think three women need to be in a flower garden or all dolled up. I thought right away, I like this guy already."

—**LORI BARBERO,** drummer/singer/songwriter
for Babes in Toyland

"When Dan came along on our European tour, he jumped in faster than Hunter S. Thompson joining a motorcycle gang. With his camera, Dan has always been a 'gonzo' guerilla photojournalist—not to mention his work as a studio photographer and filming Soul Asylum's first major label video. Dan is always up for an adventure and risking his life and financial livelihood to get *the* shot. Soul Asylum and every other Minneapolis rock band are in debt to Dan."

—**DAVE PIRNER,** singer/songwriter/guitarist
for Soul Asylum

"I always appreciated the way Corrigan captured us. He makes it look similar to how it feels."

—**SLUG,** rapper/songwriter for Atmosphere